CW00665873

The Mermaid
HANDBOOK

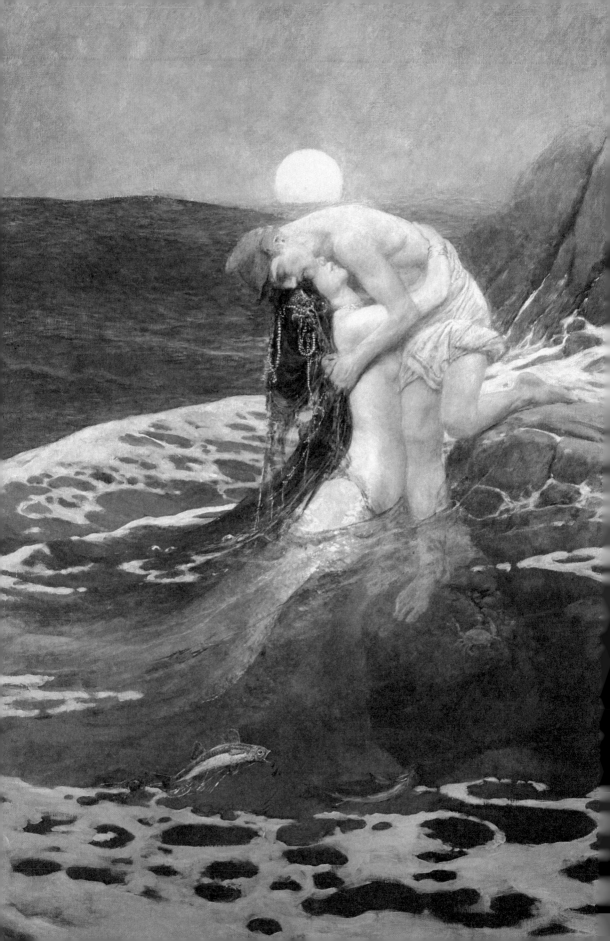

The
Mermaid
HANDBOOK

An Alluring Treasury of
LITERATURE, LORE, ART,
RECIPES, and PROJECTS

CAROLYN TURGEON

HARPER
DESIGN
An Imprint of HarperCollins Publishers

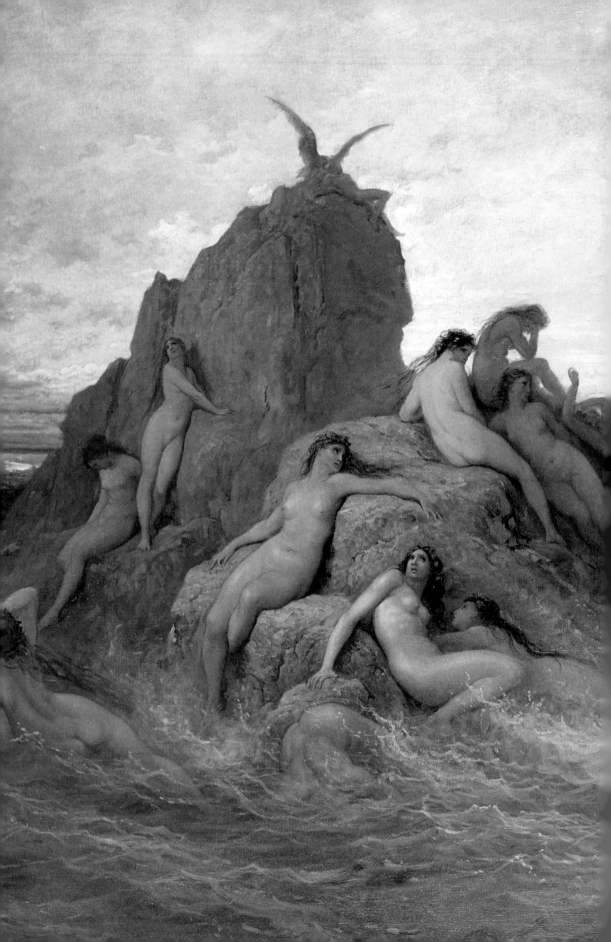

My gentle Puck, come hither. Thou rememberest

Since once I sat upon a promontory

And heard a mermaid on a dolphin's back

Uttering such dulcet and harmonious breath

That the rude sea grew civil at her song

And certain stars shot madly from their spheres

To hear the seamaid's music?

—WILLIAM SHAKESPEARE
A Midsummer Night's Dream, Act 2, Scene 1

CONTENTS

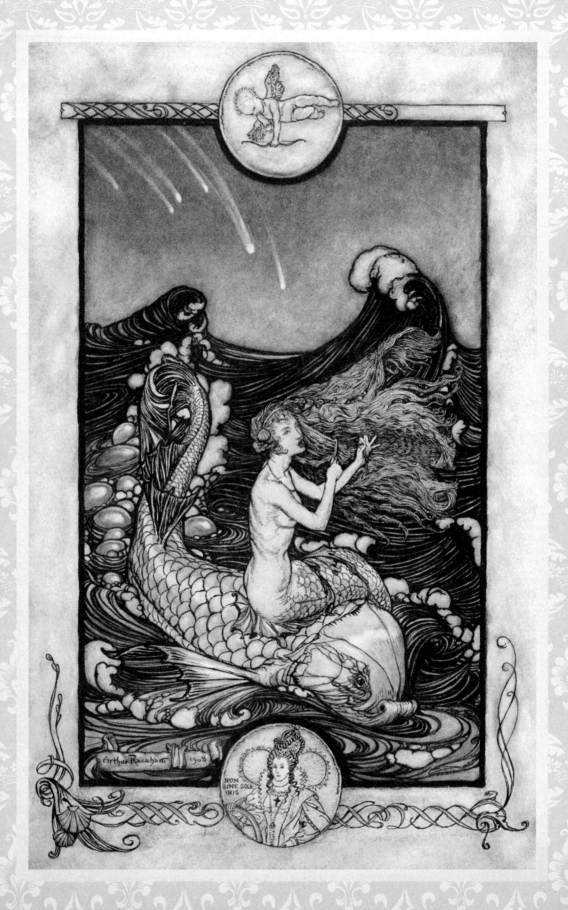

INTRODUCTION

HIS BOOK IS FOR MERMAIDS, AND FOR EVERY-
one who loves mermaids, and for everyone who secretly wants to be a
mermaid, deep down. It's for all those who hold conch shells to their ears
to hear the ocean and its secret messages; who love the soft iridescent beauty of a
shell's interior; who have a special affinity for pearls and sea glass and aquamarine;
who stalk beaches for a perfect washed-up treasure gleaming from the sand. It's also
for those who love the feel of salt on their skin and in their hair and who dream of
swimming—tail stretching out behind them—in the open ocean, alongside manta
rays, whales, and dangerous, glittering creatures who could pull you to the ocean
floor without a thought—and you'd almost let them.

I wasn't always one of these people. I wasn't a mermaid person and I never secretly wanted to be one, though I loved fairy tales. Like almost every other girl of my generation, I'd grown up loving *Splash* and Disney's animated film *The Little Mermaid*. I'd spent most of my life avoiding the ocean, though: I'm not only too pale for the sun but also have an abiding love of rain, cold weather, and generally nonoceanic terrains. When I visited the Arctic a few years ago, it was a dream come true. Plus, the ocean is terrifying. Who knows what's right there, below the surface?

I wrote my novel *Mermaid*, a reimagining of Hans Christian Andersen's story "The Little Mermaid," almost by accident. In 2008, a British publisher approached me about buying the UK rights to publish my novel *Godmother*, which was set to come out the following year in the United States, and asked to see what else I was working on. I detailed a few works in progress and then made a somewhat random dream list of other ideas, including something about a children's book about a mermaid. The publisher bought that idea, to my surprise, but wanted an adult novel instead. I wasn't opposed to the idea—who wouldn't want to write about mermaids? I thought—and spent some weeks trying to settle on a concept before my agent pushed me toward the Andersen tale as a source of inspiration. I loved "The Little Mermaid" but thought it was far too depressing—beautifully so—to do anything with until one day I had this image of the human princess come to mind. Although her character is barely in the story, she's the one who marries

PAGE 2: *The Mermaid*, Howard Pyle, 1910. + PAGES 4–5: *Les Oceanides*, Gustave Doré, c.1860–1869.
OPPOSITE: *To hear the sea-maid's music*, illustrated by Arthur Rackham for his 1908 edition of
A Midsummer Night's Dream.

the prince, leaving the mermaid brokenhearted. I imagined the princess standing on a cliff overlooking the ocean and seeing the mermaid for the first time, an almost-drowned man in her arms. That would be the kind of moment that changed a life, I thought—and I could imagine a whole book unfurling from that moment.

I began writing that book in 2009, and that's when I started seeing what had been invisible to me before: mermaids are everywhere. They peek out from subway posters, blink up from Starbucks cups, and lounge treacherously in the guise of statues, plaques, and murals in cities all over the world. When friends (and strangers on Facebook) learned I was writing the book, they sent me photographs of mermaids they came across, too: painted on a door in Santa Fe or on the side of a boat in Germany, sculpted out of snow in Alaska, and, in the flesh, posing in an old-time mermaid tank in Portland, Oregon.

I started a blog, *I Am a Mermaid*, to capture these mermaids from around the world. That's when I realized how powerful mermaids really are, how they have held humankind in their dangerous but incredibly glamorous thrall in one form or another for millennia. Through the blog, I slowly became aware of a whole culture of people who love mermaids. More than that, I became aware of a whole culture of people who *are* mermaids; who, when they put on a tail—and there are many dazzling, handcrafted, realistic-looking mermaid tails available today—literally and figuratively slip into a new skin. As I met them, as I interviewed them, as I watched their videos, I realized that something wonderful and wild was happening behind all the flash and kitsch. Women were tapping into some mystical, primitive part of themselves, something powerful and dangerous, even awe-inspiring.

I heard many wonderful stories, like that of septuagenarian Vicki Smith, who began swimming at Weeki Wachee Springs in 1957 and who performed for Elvis Presley in 1961. She told me that returning to Weeki Wachee in her sixties was a transformative experience—getting in that water, being weightless and free, made her feel seventeen again. Bambi the Mermaid, who's attended every Coney Island Mermaid Parade for more than twenty-five years, described how being a mermaid helped her during her bereavement after her husband's death. Plus, mermaids "never worry about their weight or growing old or become bogged down by insecurities," she said. And Raina the Halifax Mermaid told me how her mermaid persona strips away her usual shyness and insecurities and gives her confidence and daring; the powerful mermaid was, she realized, the outward expression of her true, tamped-down inner self. Mermaid after mermaid spoke to me of freedom and power and a feeling of pure bliss under the water, and the stories kept coming.

It's hard to talk to all those sea-loving ladies and not fall in love with the sea, too. Eventually I heard the siren song myself. In 2011, three months after *Mermaid* was published, I attended mermaid camp at Weeki Wachee Springs. While I was

ABOVE: Mermaids in the Deep, **Edward Coley Burne-Jones, 1882.**

apprehensive and awkward at first, and deathly afraid of the mossy-backed turtles in the spring, my first swim in a tail ended up being one of the most magical days of my life. I'll never forget the wild manatee that swam in from the adjoining river and spent all afternoon cavorting with me and a dozen or so other ladies in tails. I found that it's easy, and fast, to swim in a tail with your feet in a monofin, which propels you along, and I loved being in a community of women and immersed in the pure beauty of the spring. A few months after Weeki Wachee, I went snorkeling for the first time, in St. John, and was amazed at the array of fish and the way the warm light streams underwater, illuminating everything. Later that year, a friend and I planned a trip to Nicaragua—and she agreed to get scuba certified with me there on Big Corn Island, off the country's Caribbean coast.

Scuba diving was not something I'd ever thought I'd do—willingly get into the open, shark-filled ocean, especially with gear strapped to my back. When my dive instructor told me to sit on the side of the boat in my full scuba gear and just let myself fall into the water on my back, I thought she was nuts. "Be a mermaid," she said, seeing how scared I was. "You are a mermaid." For a moment I was stunned by the coincidental metaphor—until I realized it was what she said to all lady divers. So I grabbed my respirator and let myself fall, semiconvinced I would be snatched up by a shark in the process.

When I opened my eyes, I wasn't sure where the surface was. A swarm of transparent, ghost-like creatures surrounded me. Disoriented, I thought it was the light at first. I froze, alone in the water as these ghosts danced all around me. When I realized that the creatures were real (medusas, aka jellyfish, I'd later learn), and that they hadn't hurt me and weren't going to, I exhaled and looked down below, at the reams of spectacular coral stretching out along the ocean floor. My instructor appeared then, giving me the "OK" sign, which in scuba diving is a question:

"Are you okay?" I made the "OK" sign back to her, and we descended, jewel-covered schools of fish darting past us.

Everything seemed to break open then. I was weightless, flying through the water, as this new, silent world enveloped me, with its swaying seaweed, glittering fish, tiny floating medusas, the white rocks and reefs thick with coral. It was like being in outer space, except that it's right there, under the surface of the sea. I understood the breathlessness of all the mermaids I'd spoken to over those months, the profound experiences they'd had in the water, and I cried in my mask as I experienced all that otherworldly beauty up close.

I went on to scuba dive in St. Lucia and even dove with black-tipped reef sharks on a weeklong live-aboard diving trip with a boat full of mermaids in the Bahamas. I never would have imagined I'd be forty-one years old and diving with sharks and mermaids, but the world is like that sometimes, full of beautiful surprises.

I hope you will find some of your own beautiful surprises inside this book, which celebrates the mermaid—goddess, fashion icon, muse, kitschy entertainer, seductress, and destroyer—in all her guises. Perhaps if you hear the sea calling, it will help you tap into your own inner mermaid, too.

—CAROLYN TURGEON

I. Fashion & Beauty

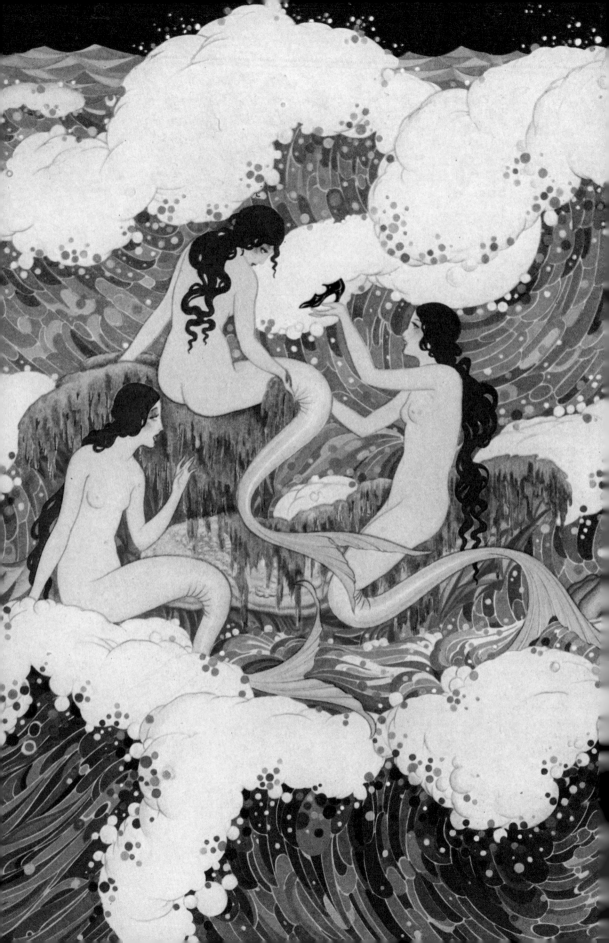

THE MERMAID:
A FASHION *and* BEAUTY ICON

THE MERMAID POSSESSES A NATURAL BEAUTY, but her aura is distinctively tinged with seduction and potential danger. After all, as some stories go, she might very well pull you to your death, whether she means to or not. And it's that combination of attractiveness, unpredictability, and mystery that has bestowed upon the mermaid a timeless allure. She is captivatingly beautiful and beguiling—and strong.

With her traditionally long, flowing, sumptuous tresses and an outrageously curvaceous figure that is never clothed, save for her iridescent, powerful tail, the mermaid has always been a formidable and fashionable femme fatale, inspiring artists and writers, fashion designers and stylists, and makeup and hair looks for centuries. Part of that draw is that she is an enigma—complicated, even contradictory. She's half human, a gorgeous seductress, beckoning you to come hither as she lounges seemingly casually on a bed of rocks overlooking the ocean, but she's also half fish, encased in shimmering scales, and sexually inaccessible. Despite all appearances that might indicate a human affiliation, she is otherworldly, dwelling in the depths of the sea. She joins us and then leaves us just as quickly, plunging back down into the dark ocean depths among the sunken ships and treasure.

Whereas a human who rises on the rungs of the best-dressed lists or makes waves on the red carpet often depends on a strong relationship with an individual couturier or stylist, the mermaid doesn't need outside help; her fashion sense is inherent. She was born with a sinuous, glittering tail that reveals her body's every curve and flares at the end with a flourish. Nonetheless, the tail is not for show, as much as it dazzles us; it allows her to move through the sea as powerfully as a shark or whale.

The mermaid has been a fashion icon for millennia, and her influence has made its way into nearly every culture and era. When *Project Runway* host Tim Gunn was interviewed for the *I Am a Mermaid* blog in 2011, he said: "When we consider the catalysts that are essential for inspiration in the fashion industry, few have the staying power or the potency of mermaids, owing largely to the fact that mermaids have been part of world literature, lore, art, and artifact for such a very long time. There will always be a place for

PAGES 12–13: A Merbella tail, inspired by the mandarin fish, designed and modeled by couturier Raven Sutter.
OPPOSITE: An untitled illustration by Felix de Gray for the British magazine *The Sketch*, June 16, 1937.

mermaid-inspired fashion, provided that the designs are conceived in a manner that's relevant to the current moment." And today, more than ever, the mermaid exerts her influence. Flowy, tangly tresses, sometimes tinted blue or green for extra oceanic flavor, are everywhere on social media, as are glitzy mermaid-queen crowns fashioned from shells and jewels. Gowns mimicking the mermaid's undulating shape are perennial favorites on the red carpet and the wedding aisle. The mermaid's allure can be au naturel or ultraglamorous, from Disney's showy Ariel, with her bright flaming hair, lavender shell top, and green tail, to Madison from *Splash*, with her more natural bronzed skin, pale flowing locks, and orange tail, to any number of other incarnations.

Sadly, the merman hasn't fared so well as an icon of any sort. The Irish male merrows, for example, "are nothing worth looking at," reports Katharine Briggs, referencing Crofton Croker's tale "Soul Cages" in *Fairy Legends of the South of Ireland* (1825), "for they have green hair and green teeth and little pig's eyes and long red noses, and short arms more like flippers than any respectable arm that could do a day's work."

She walks in beauty, like the night
Of cloudless climes and starry skies;
And all that's best of dark and bright
Meet in her aspect and her eyes . . .

—LORD BYRON
"She Walks in Beauty," 1813

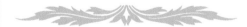

RIGHT: Grant Brummett captured this glowing image of mermaid Kathy Shyne for her book, *Twig the Fairy and the Mermaid Misadventure*, 2011.

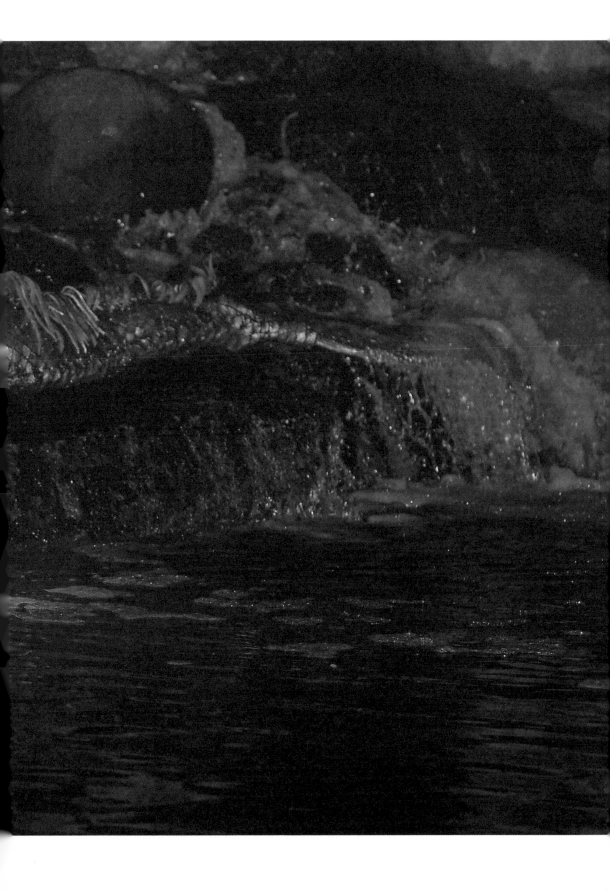

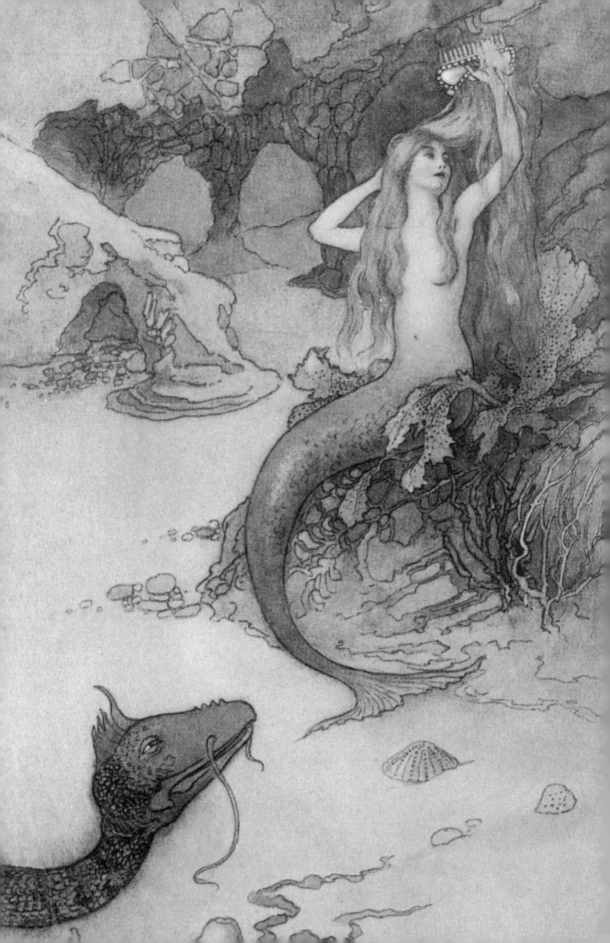

MERMAID TRESSES

O, train me not, sweet mermaid, with thy note,
To drown me in thy sister's flood of tears:
Sing, siren, for thyself and I will dote:
Spread o'er the silver waves thy golden hairs,
And as a bed I'll take them and there lie,
And in that glorious supposition think
He gains by death that hath such means to die:
Let Love, being light, be drowned if she sink!
—WILLIAM SHAKESPEARE
The Comedy of Errors, Act 3, Scene 2

One of the most enviable aspects of the mermaid's looks is her flowing mane, which twirls about her in the sea and serves as a makeshift cover-up when she washes up on land. A mermaid's hair is a vital part of her allure, and the girl knows it, which is why she's always sitting about on rocks combing it or adorning it with starfish or shells, checking out her handiwork in a mirror, seemingly unaware of the distracted sailors who cannot help but crash their ships around her.

If you desire shiny, luxurious mermaid tresses, you're in luck: a mermaid's hair is her most attainable human attribute. There are those who prefer locks of the lengthy variety, but any hairstyle will do, whether very short and spiked, dreadlocks laced through with beads and ribbons, a billowing Afro, or a flapper-esque bob. There are no color rules, either, for some mermaids sport locks in vivid hues of green, blue, or a flaming red, while others go for very dark or very light shades, and still others lace their hair with colored tinsel for a shimmery appeal. Whatever style she goes for, though, a mermaid's look is all about statement tresses.

OPPOSITE: An illustration by Warwick Goble for *The Book of Fairy Poetry*, 1920. + *ABOVE*: Moon Mermaid, posing here for photographer Cheshire Visions, is famous for her flowing blue tresses.

How to Create Mermaid Hair

—Nikki Verdecchia

To achieve a gorgeous mermaid mane, the most important tip is to keep your hair as healthy as possible, with regular trims and conditioning. Here are some more suggestions for styling watery waves and curls:

* Use a nonsilicone-based hair oil to make straighter locks shine or to achieve a wet look that makes you appear as if you've emerged straight from the sea. A shine pomade is another option to add a little more hold and a healthy sheen.

* Add highlights to get a sun-kissed look. If you're seeking multicolored mermaid hair and aren't blond already, go to a professional for bleaching so that you don't damage your tresses.

* You can also create highlights with glitter. If your hair is dark, try some bold jewel tones; if your hair is light, pastel glitter can be stunning.

* For extra sparkle, try applying glitter eyeliner along your part. For a more emphatic effect, sprinkle extra glitter on top before the eyeliner dries.

* To get a more intense sparkle, use glitter hair spray or add glitter to hair gel (as much or as little as you'd like) and apply normally.

* Entwine ribbons through your tresses (and even add a shell or two) to create a seaweedy, I've-just-been-hanging-out-in-a-shipwreck look.

* Hair tinsel—thin, colorful strands tied around the roots of several hairs—can add mermaid bling. Try a bright blue or green for some seaside sparkle.

Above: Traci Hines's flaming locks are positively Ariel-esque.
Opposite: The quintessential ocean tresses: blue, glittery, and flowing.

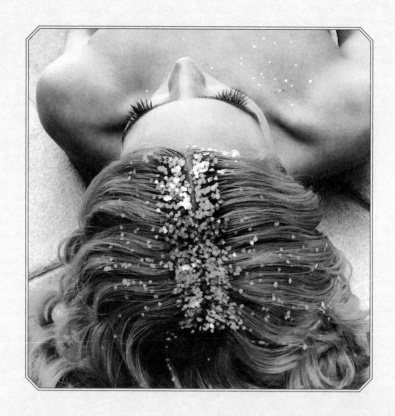

MAKE YOUR OWN SALTWATER SPRAY

—RONA BERG

SALT WATER MAY BE DRYING FOR HUMAN HAIR, BUT IT also makes it voluminous: think about how wild and sexy hair looks after a day at the beach. Many products are available that will give your hair a natural, tousled look. Here's a do-it-yourself saltwater spray that gives tresses extra mermaid glamour. Be sure to condition your hair well after washing out this spray to counteract the drying effect of the salt.

MATERIALS

- 3-ounce spray bottle
- 3 ounces of water
- A few drops of rose or lavender essential oil
- A few pinches of fine sea salt

DIRECTIONS

1. Fill the spray bottle with warm water.
2. Add drops of rose or lavender essential oil.
3. Add sea salt.
4. Shake the mixture well.
5. Spray sparingly on dry hair, then scrunch throughout.
6. Store in a cool place out of direct sunlight.

Make a Mermaid Hair Comb

—Jill Andrews

HERE'S AN ARTFUL WAY TO MAKE A GLIMMERING OCEANIC comb featuring shell "flowers" to hold back your hair. Use electroplated, gilded souvenir shells, typically sold as pendants with holes already drilled into them and jump rings attached; you can buy them loose and in necklaces in beachside souvenir shops or order them online from suppliers on Etsy or jewelry supply shops like www.nbeads.com or www.beadunion.com.

Tools and Materials

* **Wire snips**

* **Needle-nose pliers** (the slimmer, precision-point ones)

* **24-gauge wire to match the gold edge of the shells** (or pink-gold wire and copper edging)

* **A string of tiny predrilled shells or a souvenir necklace**

* **5 small, gold-electroplated or gold-dipped 1- to 1½-inch conch shells** (or whatever shell you prefer), **with jump rings**

* **5 to 7 gold-electroplated or gold-dipped 2- to 3-inch abalone shells to form the flower petals, with jump rings**

* **30 to 40 small crystals** (the ones pictured are 4mm Swarovski bicone crystals)

* **A French wire comb**

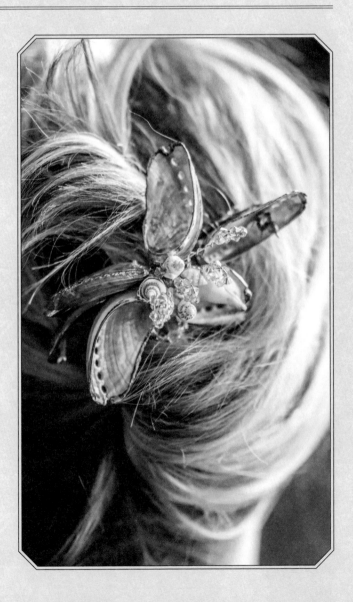

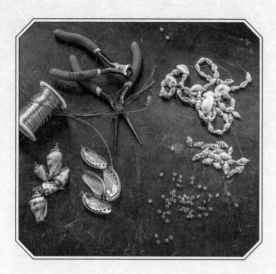

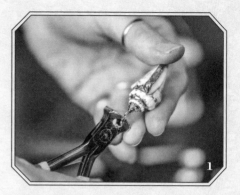

DIRECTIONS

1. Prepare your materials: Cut 12 to 14 pieces of wire 8 inches long. (Note: If the shells have an extra jump ring, remove it so there is only one ring on each shell.) Remove the tiny shells from the string.

2. Start creating the center: String 5 to 6 crystals, one tiny shell, and 5 to 6 more crystals onto a pre-cut wire. Repeat this step at least 3 or more times, depending on how sparkly you'd like the center of your flower to be. String 5 or 6 tiny shells onto a pre-cut wire. Isolate the crystals on the wire and twist to form a loop. Make a couple of these so that you have a total of 6 or so shelled wires.

3. Twist all of the wired tiny shells together to form a stem. It will look like a starburst when you are done.

4. Gather these stems together to form the flower center. Give them a gentle twist to hold them together temporarily.

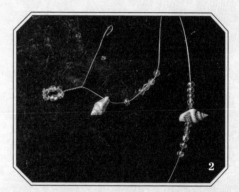

5. Wire up a few of the conch shells and add them to the center of the piece.

6. Make the petals from the abalone shells: Loop a wire through the attached ring on each abalone shell. Wrap it through a few times so that the wire is secured firmly to the ring on the end. Try to use an odd number of petals—say 5—depending on the size of your comb; an odd number will look better.

7. Once the abalone shells are wired, place them together around the center of the flower (7A). Don't worry about the shape yet, as you will fan everything out into a flower shape once everything is in place (7B). Be careful not to twist and untwist the wire too often, as this could cause the wire to break.

8. The stem will be a bit thick at this point, so split it into two groups of wires and trim them to even them out. Use one of the original wires you cut to wrap everything up into a tidy bundle.

9. These finished wire bundles are now quite easy to wrap with a length of the cut wire onto your comb. Wrap the wires onto the comb, tooth by tooth, for a pretty finish.

10. Crimp the ends tightly so that no wires are poking out. Fold any sharp ends under and make sure they are not facing the inside of the comb, where they could poke your head. Adjust the shell flowers as desired; your mermaid comb is ready to wear.

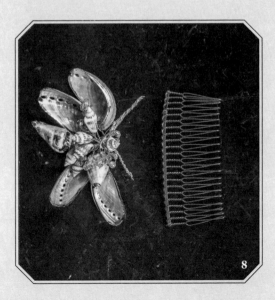

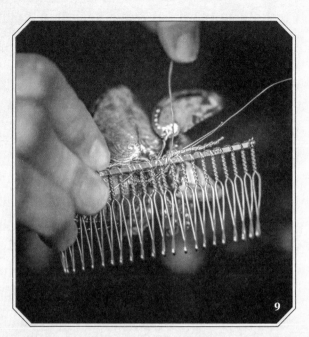

9

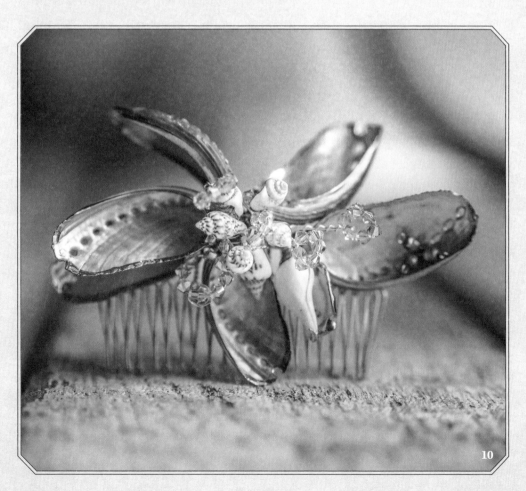

10

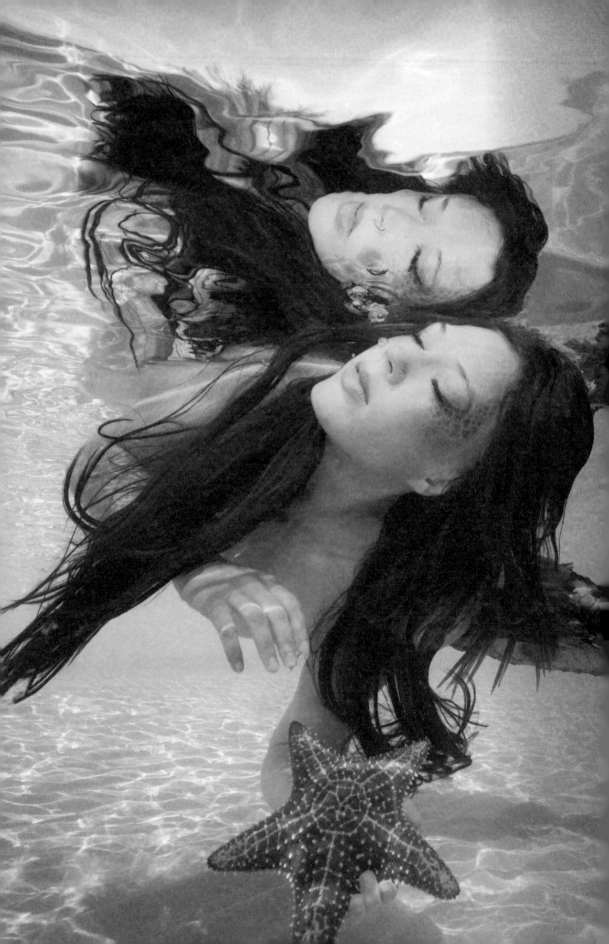

MERMAID MAKEUP
and BEAUTY

NOT UNLIKE HUMAN MAKEUP, MERMAID MAKEUP runs the gamut of personal taste, from a California-girl vibe, as in the bronzed natural look of Daryl Hannah's Madison in *Splash*, to a more fairy-tale-like, even gothic, approach through the use of layered blues and greens, whether soft pastels or metallics or a mix of the two, by way of mascara, liner, shadow, and jewel-like accoutrements. A bright red lip, or another intense color, also adds a level of drama, if you're inclined. Naturally, shimmering pearlescent hues, crystals, glitter, and gems—possibly influenced by all those treasure chests littering the sea floor, not to mention all that fashionable bioluminescence surrounding them—are all irresistible to mermaids.

Classic mermaid art can offer a wealth of inspiration, too. When makeup artist Carmindy donned a mermaid look for Halloween some years ago, she told the *I Am a Mermaid* blog in a 2011 interview that she took her cue from "old illustrations" and used "a deep blue eyeliner, then layers of different hues of turquoise—darkest at lash line and getting lighter towards the brow bone and iridescent under the brows. When I was all done, I added a wash of iridescent glitter across the entire lid."

A wealth of beauty products rely on sea magic as well—particularly the incorporation of algae. Possibly the most iconic is the *très chère* Crème de la Mer (literally, "Cream of the Sea"),

which, according to brand legend, physicist Dr. Max Huber invented after experiencing burns in a laboratory accident in the 1950s while working on a rocket stabilizer. Over the course of twelve years after his accident, he experimented with sea kelp found near his California home, ultimately creating a magical elixir that erased all evidence of the accident and seemed to change the texture of his skin for the better. (It's also been said that he ate the "miracle broth" with a spoon.) Huber started selling the cream in 1965; in 1991, after his daughter sold the brand to Estée Lauder, La Mer became—and continues to be—one of the most coveted products in the world.

OPPOSITE: **Iara Mandyn wears mermaid makeup in this Chris Crumley image.**

The Mermaid Look:
Eye Makeup for Day and Night

— NIKKI VERDECCHIA

WHETHER FOR DAY OR NIGHT, MERMAID MAKEUP IS essential to get that sea-siren look. Take a softer approach during the day, with deep blues and icy metallics. For extra drama at night, use bold fake eyelashes and add cosmetic jewels, available for purchase online or at specialty cosmetic stores.

TOOLS AND MATERIALS

For the Day Eye

- **Soft silver metallic eye shadow**
- **Blue-green metallic eye shadow**
- **Shimmery deep-blue eye shadow**
- **Black eyeliner**
- **Purple glitter eyeliner**
- **Black mascara**
- **Medium eye shadow brush for the lid**
- **Small eye shadow contour brush for the crease and corner**
- **Blending brush**

For the Night Eye

Same makeup and materials listed for the Day Eye, plus the following:

- **Silver eye glitter**
- **Blue-green eye glitter**
- **False eyelashes and eyelash glue**
- **Cosmetic jewels**

DIRECTIONS

For the Day Eye

1. Apply a light silver shimmer on the lid and through the crease.
2. Apply that same shimmer on the brow bone and into the inner corner of the eye.
3. Apply a metallic blue-green shadow at the outer corner of the eye and above the crease.
4. Add a deeper blue over the blue-green for depth and bring the color under the lower lash line.
5. Apply black eyeliner on the upper lash line.
6. Apply purple glitter eyeliner on the top lash line.
7. Apply mascara.

For the Night Eye

Follow steps 1 through 6 for the Day Eye, then:

1. Add silver glitter to the lid.
2. Add blue-green glitter on top of the blue-green shadow. Use either a glitter gel or a fine glitter powder that will stick to the eye shadow and bring extra shimmer to your face. For loose glitter, pat a gel moisturizer (like Aquaphor) gently onto the eyelid; then apply loose glitter with a finger or small makeup brush.
3. Attach false eyelashes and apply mascara.
4. Use eyelash or cosmetic glue to add jewels around the outside of the eye and onto the outside of the lid. Apply the glue to each cosmetic jewel and then adhere to the skin.

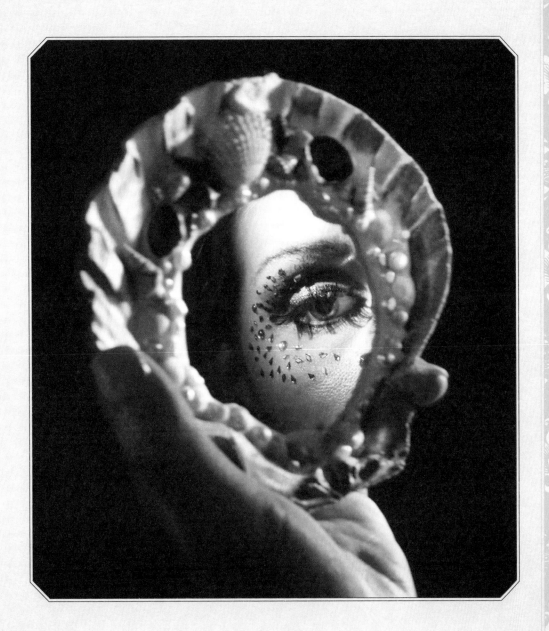

MERMAID NAILS

You can't go wrong with short nails in solid or glitter aquatic colors, from pale to dark blues and greens. But if you're feeling wilder, there's nail art galore available to stick on or get done by a professional. For inspiration, look online—there's a lot to choose from. And if you're going to get your nails done at a salon, bring pictures with you.

Above: Rows of jewels add mermaid drama in this photograph by Steve Parke.

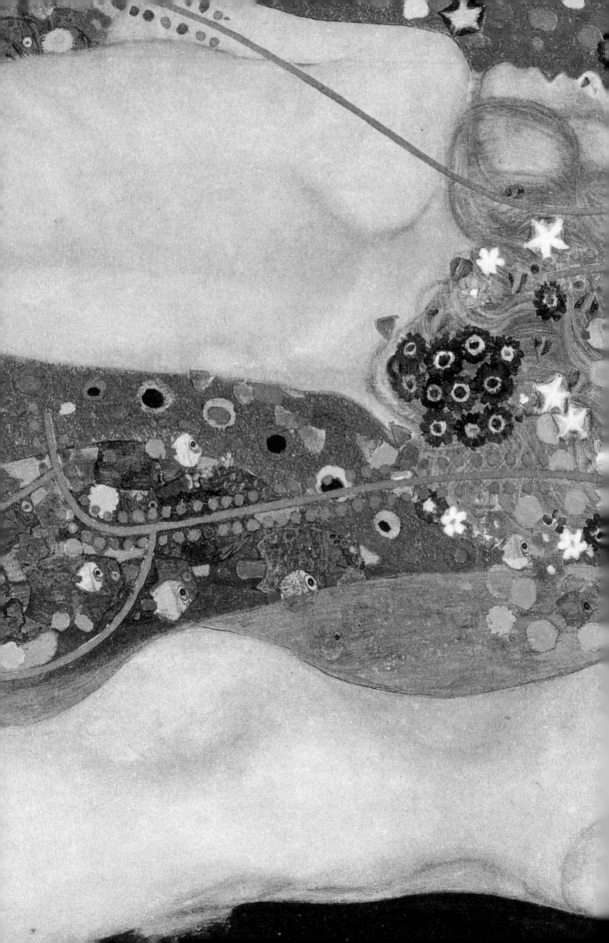

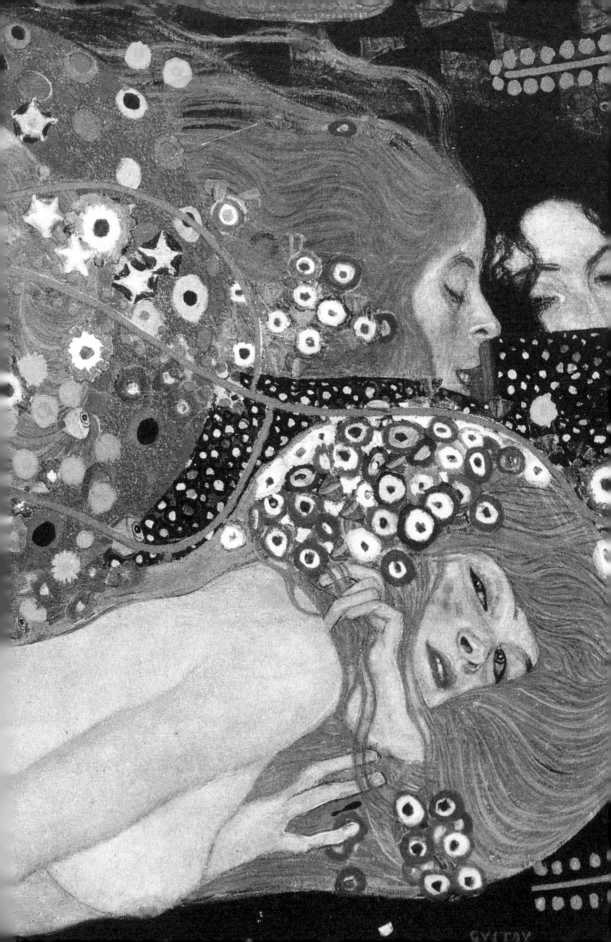

The MERMAID GOWN

ANDLOCKED MERMAIDS HAVE ALWAYS SOUGHT ways to achieve an oceanic effect on land—often through mounds of sequins and paillettes. And the modern-day red carpet is consistently awash in the mermaid silhouette—a gown, usually strapless, that hugs the body and then flares out at the knee, sometimes with a train of sorts trailing behind.

According to Colleen Hill's *Fairy Tale Fashion* (2016), the mermaid silhouette came into prominence in the 1930s, when long slinky gowns were first described as "mermaid" dresses in fashion magazines. A 1933 *Vogue* editorial included a black silk "mermaid" halter dress from Jean Patou, with a long train flaring from the back waist. Marcel Rochas used mermaid details (a mermaid-shaped button, for example) in his spring 1936 collection. Charles James debuted his "La Sirène" in 1937, a form-fitting full-length draped evening gown that flared just above the ankle. Using hat-making techniques, he created the effect by draping silk over a dress form that widened into a fluke shape at the bottom.

That same year, Elsa Schiaparelli teamed up with Salvador Dalí to create what was to become the most famous of their many collaborations: the "lobster dress." The gown features an elegant lobster prominent on the front of the full white organdy skirt, its antennae stretching to the hem and sprigs of parsley scattered about. It's been said that Dalí wanted to include real mayonnaise on the dress, but that Schiaparelli would have none of it. Wallis Simpson immortalized the dress; it was one of eighteen pieces Schiaparelli designed for Simpson's trousseau when Edward VIII abdicated the British throne to marry her. The dress created a scandal in and of itself—as it was perceived to evoke an illicit sexuality—after *Vogue* published an eight-page feature of Cecil Beaton's photographs of Simpson strolling casually by a lake in the creation. Schiaparelli went on to include a mermaid silhouette in her 1940 summer collection, "a shape she helped along by an eight-ounce girdle she had designed with the American corset company Formfit," according to Schiaparelli expert Dilys Blum, as quoted by Hill.

Across the pond, American designer Norman Norell's "mermaid sheath" made its first appearance in 1949. Gleaming with sequins hand sewn onto jersey fabric, the dress eventually became his signature garment. Norell made countless versions of the gown until his death in 1972. According to a *New York Times* article that year, women treasured their Norells "as if they were emeralds or Renoirs." Fashion writer Bernadine Morris said that the dresses "made everyone who wore them glow like a mermaid." Screen siren Marilyn Monroe was especially fond of them.

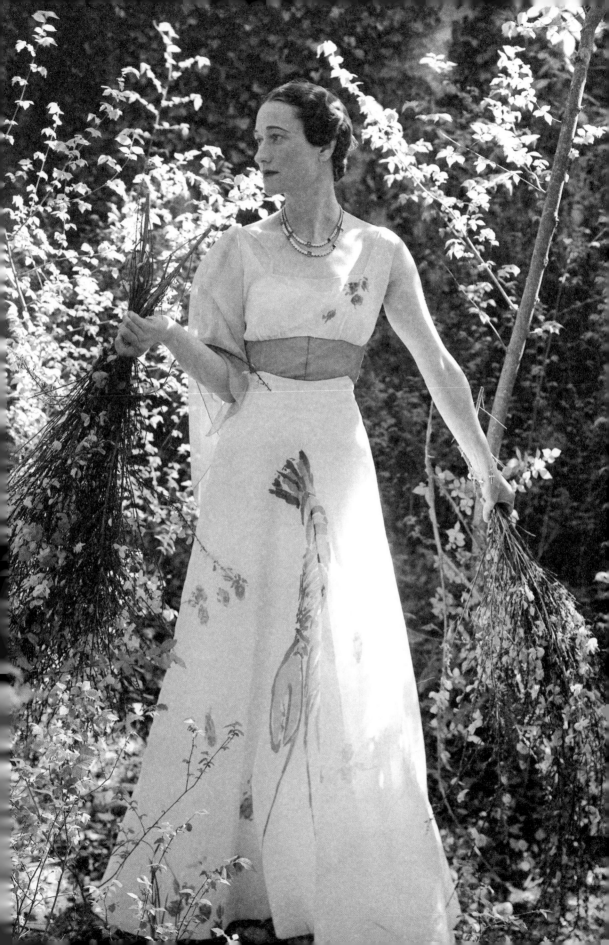

In the last few decades, couturiers have returned again and again to the sea for inspiration. Thierry Mugler devoted his 1989 collection to the lost city of Atlantis, filling it with clothing that drew on the silhouettes of mermaids and other creatures from the sea for inspiration. Alexander McQueen's spring/summer 2003 "shipwreck" collection includes, among other things, an "oyster" dress, which creative director Sarah Burton described this way for the *Savage Beauty* exhibit in 2011 at the Metropolitan Museum of Art: "He wanted this idea of it—[it] was almost like she drowned—and the top part of the dress is all fine boning and tulle, and the chiffon is all frayed and disheveled on the top. The skirt is made out of hundreds and hundreds of circles of organza. Then, with a pen, what [McQueen] did was he drew organic lines. And then all these circles were cut, joined together, and then applied in these lines along the skirt. So you created this organic, oyster-like effect."

McQueen's spring/summer 2010 collection, *Plato's Atlantis*, featured aquatic, sea-creature-patterned clothes and ten-inch-high lobster-claw shoes that were actually carved from wood and covered in iridescent paillettes or python skin—which, if not a mermaid tail, might be the next best thing, though likely equally difficult to walk in. Lady Gaga seemed to manage to do it rather well.

Some designers take the mermaid/oceanic influence even more literally. Jean Paul Gaultier, for example, has always been fond of the mermaid silhouette. In 2008, he opened his runway show with model Coco Rocha as a mermaid sitting on a rock, with bubbles floating around her.

According to Sarah Mower, who covered the show for Vogue.com, the designs featured, among other flourishes, "macramé made to look like fishing nets, plissé inserts suggesting underwater

RIGHT: **Marilyn Monroe wears a shimmering Norman Norell gown in this 1957 shot by Richard Avedon.** + *PAGES 36–37*: **Alexander McQueen's ten-inch lobster-claw shoes, spring/summer 2010.**

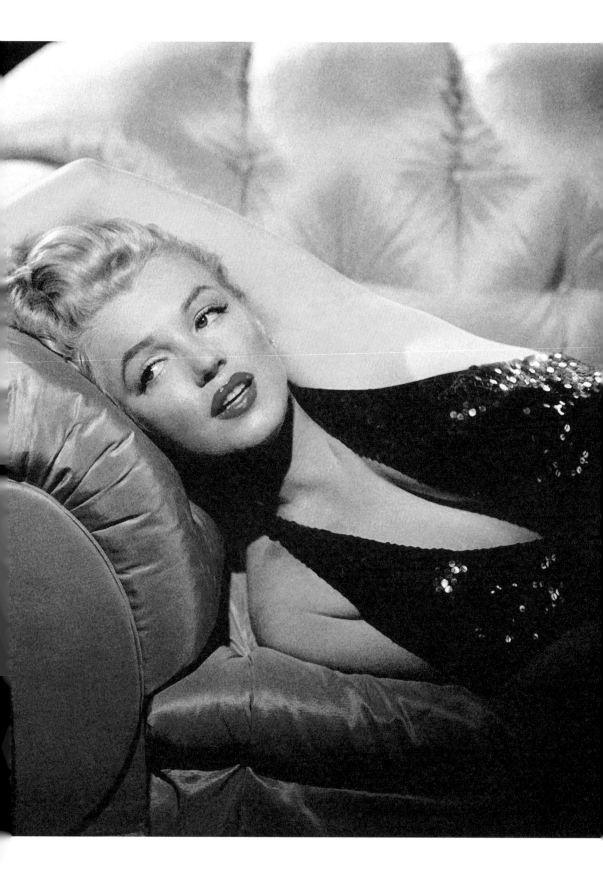

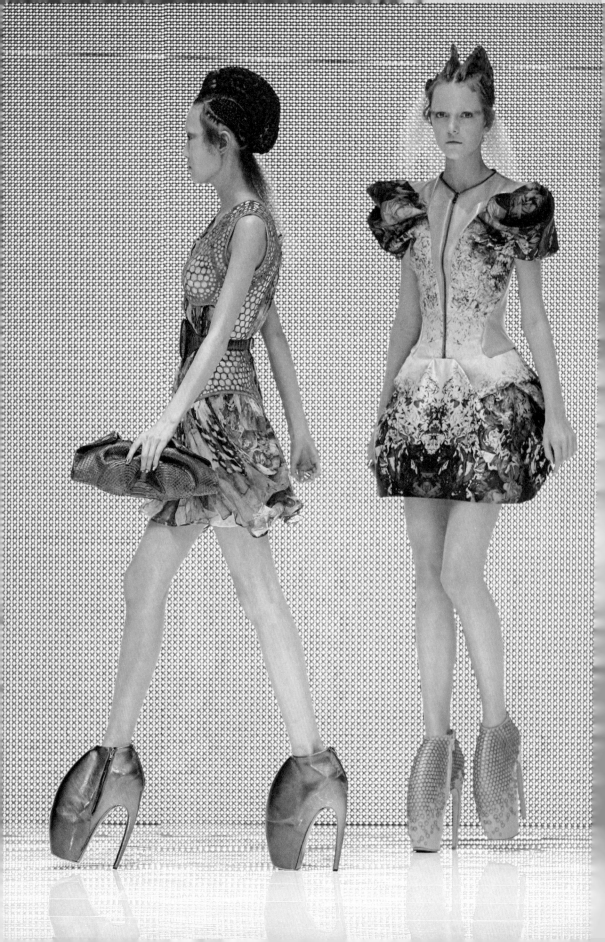

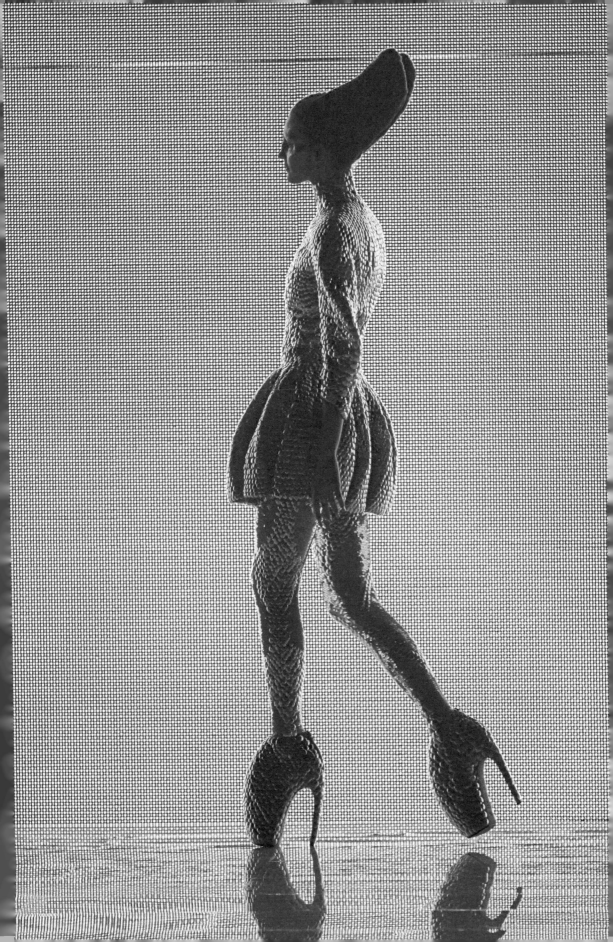

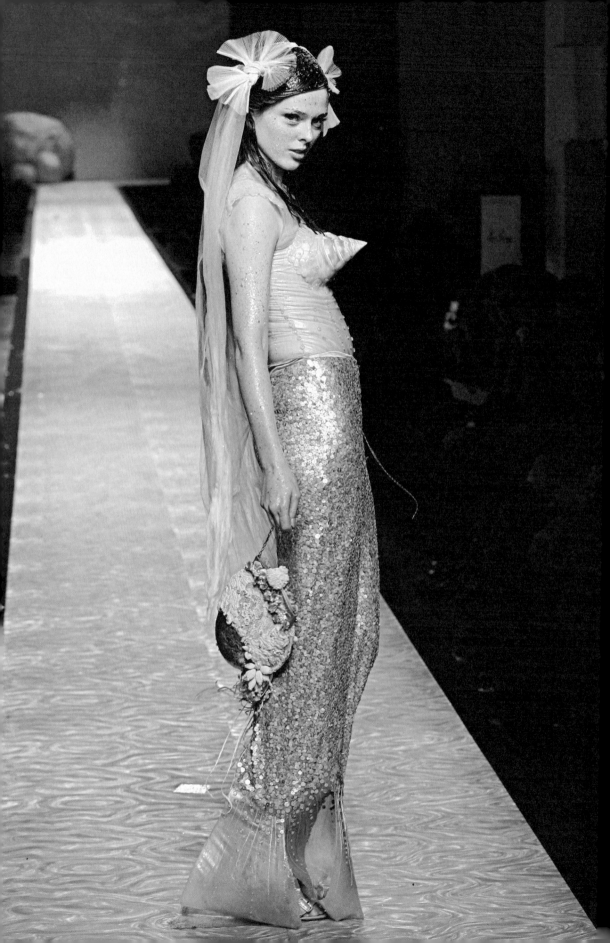

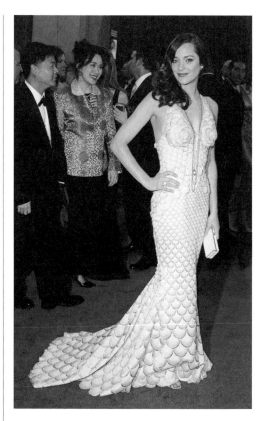

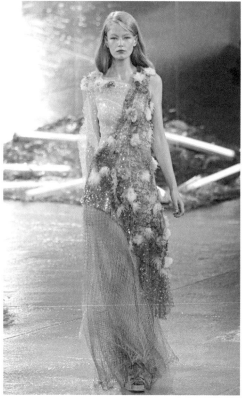

flora, chiffon fronds floating like seaweed, cascading paillettes imitating fish scales or mother-of-pearl, [and] necklaces fashioned into spongiform beads." At the finale, Rocha appeared on coral crutches, wearing a conical seashell bra. "Wherever there are sailors there will be mermaids lurking underneath," Gaultier said in an interview for this book. "The sailor imagery and all it represents—distant seas, different cultures, male friendship, tattoos—have been a constant inspiration for me and it's not surprising that a haute couture collection was inspired by mermaids. Coco Rocha was a perfect embodiment of a mermaid, Marion Cotillard as well. Maybe the lure of the siren's song will work its magic again and there will be more mermaids on my runway."

Rodarte created a dreamy 2015 collection in which the two sister-designers, Kate and Laura Mulleavy, channeled, according to *Vogue*'s Hamish Bowles, "childhood memories by creating richly layered and embellished pieces of clothing that suggested seaweed and algae swirled by the seawater and rocks thick with crustaceans" and featured filmy, tattered dresses "light-spangled with pearlescent sequins." The hem of one dress was even dipped in sand.

The sea and its most alluring inhabitant continue to influence designers of haute couture—and to beguile all those fashionistas who want nothing more than to look like a dreamy mythic icon come to life.

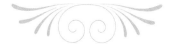

OPPOSITE: Coco Rocha in top mermaid form at Gaultier's spring/summer 2008 collection presentation.
ABOVE, LEFT: Marion Cotillard in a custom mermaid-inspired Gaultier gown at the Academy Awards, 2008.
ABOVE, RIGHT AND PAGES 40–41: Rodarte's hypnotic, sea-inspired spring/summer 2015 collection.

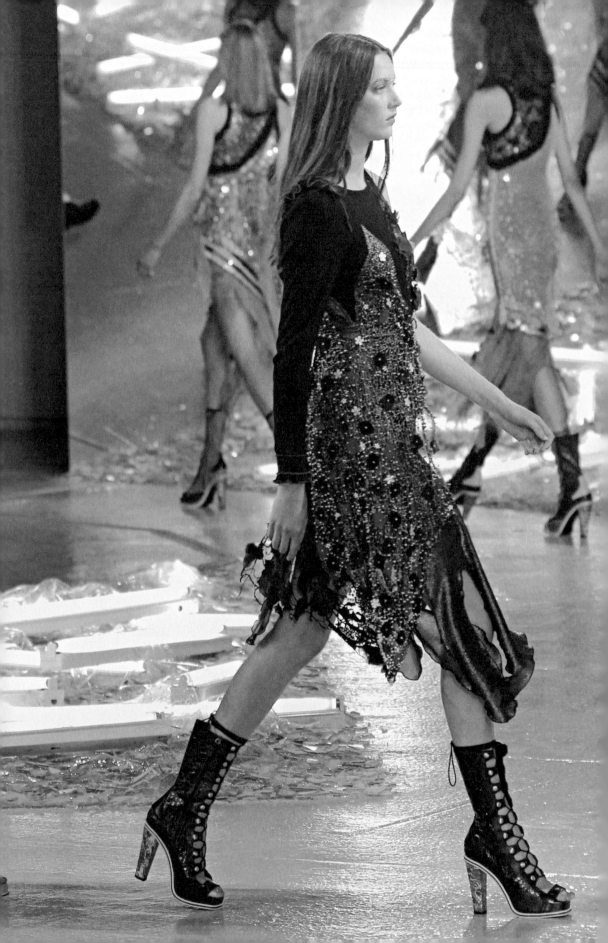

A HOLLYWOOD TAIL: ROBERT SHORT MAKES A SPLASH

T HE MOST IMPORTANT FASHION ACCOUTREMENT the mermaid has is her tail. Whether it's bright pink, muted blue, or a striped confection studded with gems, a mermaid tail is as much a fashion statement as a Céline bag or a pair of Louboutins. One of the most iconic mermaid tails of our time appeared in the hit film *Splash*, starring Daryl Hannah as Madison the mermaid. Ask any modern-day mermaid to tell you her story, and she'll name that bright orange wonder without fail.

The well-known professional mermaid and underwater performer Hannah Fraser (see "Modern Mermaids," page 146) says, "When I saw the film *Splash*, it made me realize I could make a tail and swim in it. It didn't have to be a fantasy in my head, I could actually embody it, in real life." As a child, Fraser had pictures of Madison all over her room. "That film and Madison's tail inspired me to re-create my first mermaid tail when I was nine—it was orange, black, and gold with sparkles."

Special makeup effects artist Robert Short was tasked with creating the tail for *Splash*. In preproduction, even before Daryl Hannah was cast in the film, Short began making sketches. He says he wanted to "expand upon what we think a mermaid looks like," so he developed some ideas of what humans might look like if they evolved into aquatic creatures—"something dolphin-esque and

strange, but still sexy and mermaidy." For research, he went to aquariums and pet stores to observe fish, and consulted resources at the library. This was all pre-Internet, he says, "so there was a lot of foot research." Director Ron Howard wanted the mermaid to have a more classic and romantic look, to feel realistic but also be rooted in fantasy. So Short sculpted three possible tail types on a Malibu Barbie: the first was a more "naked" look, with a sexy tail so sleek that it barely covered the skin and because of this, showed too much human knee, which is not a part of the mermaid anatomy; the second was a thick, chunky fishlike tail; and the third, a happy medium between the first two. Howard opted for the last.

The next step was to hone the general shape and proportions and do drawings of the tail in Pantone marker colors. Howard suggested using the bright colors of the koi fish. Short used a

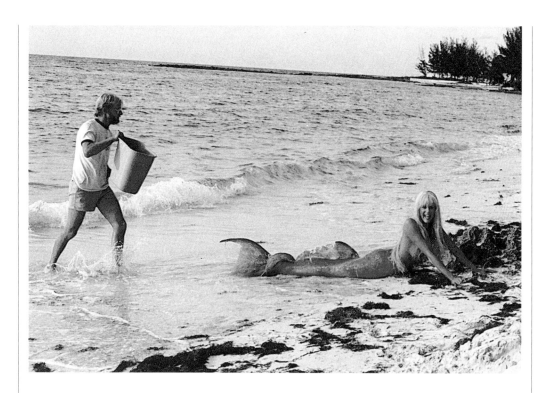

Pantone marker to draw the tail, front and back, in orange with yellow striping. He says that it "was the first and only drawing I did. I took it in and Ron said, 'That's it!'"

At the same time that Daryl Hannah was interviewing for the role, Short started designing the first prototype. He set up a shop in Marina del Rey and assembled a team to construct the first tail. One thing Short had noticed in all his fish research was that the fish flukes are often translucent, almost transparent, as they elegantly move through the water. That was his main concern. He also wanted to differentiate this tail from the tails he had seen in other mermaid films (*Miranda, Mr. Peabody and the Mermaid*, and *Mermaids of Tiburon*), which were made from latex and opaque. He knew the key to the design was a translucent fin.

It took a great deal of trial and error not only to find a material that would create that delicate effect, but also to create a monofin structure to fit easily inside that thin fluke to keep it from breaking. He found some clear sheet plastics on the market, but they were too brittle at the thickness needed. He cast around and found sheets made from clear butyrate that had the kind of strength and flexibility he needed. Eventually, the team had its first tail made of latex and clear urethane, with a monofin made of butyrate. Short and Mitch Suskin, the visual effects supervisor, who had also recommended Short for the project, brought the tail to Short's backyard pool for a stuntwoman to test out. "It was awful, a complete disaster," Short says. The unpainted tail looked great on land, but the moment the stuntwoman started swimming, the tail buckled behind the knees, sucking in over the fronts of the legs and knees. But the translucent, elegant fluke looked stunning.

They set about trying to find a solution to the tail-construction problems. Suskin recommended a new opaque urethane called

ABOVE: Visual effects supervisor Mitch Suskin with Daryl Hannah.

Smooth-On, thinking it would provide a solid thickness that foam wouldn't give and thus prevent folds from forming around the knees, suggesting human anatomy within the tail. The Smooth-On turned out to be too oily, however, and made the tails too slimy and too difficult to paint, but it did lead to finding a newly invented material called Skin Flex, which was being experimented with in theme parks for animatronic characters. Skin Flex solved the tail-construction problems by giving the team a material that was easily repaired with Krazy Glue, that could be painted, and that did not fold behind the knees. The team also integrated a very fine silk into the dorsal and pectoral fins to keep them as strong and as thin as possible, and there was a bonus: by extending the tendrils of silk beyond the urethane, they created the fluidity and soft, fluttering angel-fish effect that you see in the film.

Once the tail was perfected and painted that bright orange and yellow, the entire film crew met at a pool in Los Angeles to do test filming with a stuntwoman. Daryl Hannah had been cast by then and was there to observe; the swimming was to be done by a stuntwoman, and Hannah would only be in close-up underwater shots. With the whole gathering watching, the stuntwoman swam around the pool, looking very awkward in the tail. Hannah then asked Short if she could get in the tail and try swimming herself. She had Short and his team get her into the tail and then swam for the cameras, expertly doing the dolphin kick (the only way to swim in a tail) in front of Howard and a shocked crew. Hannah then made her case to perform all her own stunts in the film. Howard agreed as long as a stuntwoman was standing by. "It changed the whole film," Short says. "We never used a stuntwoman once."

The tail looked wonderful, and all was going swimmingly until a problem emerged from the Disney studio: the issue of exposed breasts. Howard and his longtime partner, producer Brian Grazer, wanted their mermaid to be the epitome of female empowerment, a force of nature who would not have a problem with modesty. As a mermaid emerging from the sea like Venus on the half shell, she would not be clothed in bikini tops or the like. The idea of including bare breasts in the film didn't sit too well with the studio, and though Howard and Grazer were determined to stand their ground, Short and his team did experiment with compromises: extending the tail scales up the side of her body and over to her breasts in one test, covering her breasts with natural-looking foam latex cups in another. Eventually, the Disney executives had to admit that mermaids do not have scales on their breasts, so they came up with a new solution: create a new studio. They called it Touchstone Pictures.

As any fan knows, *Splash* is anything but lascivious. The mermaid is indeed topless, though a long wig artfully placed with a lot of glue to secure it solves the modesty problem for the most part. It also demonstrates that, for the mermaid, hair is more than hair: it's an essential part of her wardrobe. Glue was key to the costume in other ways as well. The tail itself took forty-five minutes for Hannah to shimmy into. It included a zipper and an inside belt. Short also left about four inches

Above, clockwise from top left: Director Ron Howard, makeup artist Karen Kubeck, special makeup effects artist Robert Short, and Daryl Hannah on the Bahamas set of *Splash*.

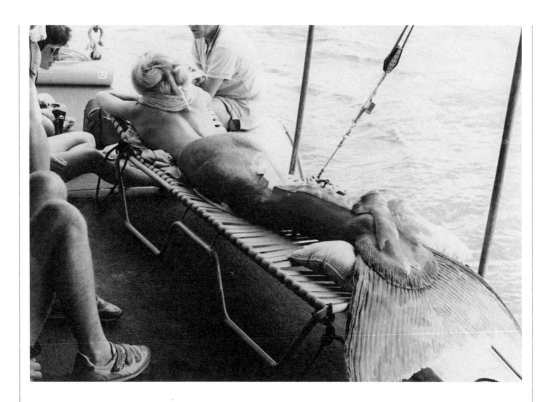

loose on top that was cut open and then superglued back together (but not to Hannah's body) each day to get the seal just right. The inside belt sat just below the four-inch opening and was cinched tight so that the tail would not slip down Hannah's hips; it also took on the weight of the tail so that the blend piece that seamlessly joined Hannah's body and the tail would have nothing pulling against it.

Which brings us to makeup: fashionistas the world over, tails or no, understand how much work it can take to look "natural." For the underwater scenes, Hannah wore a blend piece that wrapped around her waist like a belt, the material overlapping in the back. The piece was about three inches wide, with bronze at the top to match Hannah's bronzed skin and orange at the bottom to match her tail. It was glued to the tail and, using a surgical adhesive, affixed directly to Hannah's skin. According to Short, Hannah was wearing bronzer (developed by his makeup artist and fabricator, Karen Kubeck) so thick you could write in it. The makeup department developed a more subdued variation for her scenes on land. A two-toned bronze nail polish and bronze face makeup rounded out the effect.

The whole look worked even better than intended. When Hannah was alone underwater (she was lowered in a beach chair from the production boat), pilot fish swarmed around and followed her just as they would with any larger fish; then they would disappear when less alluring wet-suit-wearing divers were close by. And who could blame them?

ABOVE: **Hannah on the chaise lounge that was used to lower her in and out of the water.**

MERMAID TAIL COUTURE

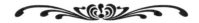

THANKS TO A SURGE IN MERMAID TAIL COUTURE, today's fashion-loving mermaids can swap out tails as easily as humans do shoes, with a tail to match every mood or hair color. Modern tail makers offer tails in inexpensive fabric and midrange neoprene, and more lavish custom creations that are hand cast in silicone molds, then painted by hand. All tails have a monofin in the base that magically transforms human feet into a fluke that can power the wearer through the water.

Every tail maker has his or her own signature silhouettes, color palettes, and painting styles. Aspiring mermaids can typically choose from a number of styles, colors, and embellishments; some choose a classic clean tail, others a much more elaborate tail with extra fins and detailing, others something in between. It's not unusual to wait a year or longer for a dreamy custom-made confection. It's also become de rigueur for modern mermaids to broadcast the unveiling of each shimmering, long-awaited new tail to their friends and admirers through social media.

Meet the three most in-demand mermaid couturiers at work today. All of them are constantly innovating and perfecting to create tails that are as much works of art as they are functional swimming accoutrements, and that are as stunning in the water as they are on land.

MERTAILOR ❧ The Mertailor, Eric Ducharme, is a sartorial wunderkind, raised in the shadow of old-school mermaid attraction Weeki Wachee Springs, where he started attending mermaid camp at age eight. "My first memory at Weeki Wachee," he says, "was standing in front of the glass, so close I could hear and feel the bubbles as I watched a dark-haired mermaid swim by in a gold lamé mermaid tail." Former Weeki Wachee mermaid Barbara Wynns, his "mermaid mother," took him under her wing, giving him his first tail when he was nine and helping him get scuba certified when he was thirteen. Wynns would pick him up on weekends and after school to bring him to the park to swim and practice his underwater ballet. "I learned from the best," he says.

To this day, the old-time glamour of the legendary park and its performing mermaids infuses Ducharme's vision of the world—and his high-end tails, which have been worn by everyone from Lady Gaga to model Kristen McMenamy in a mermaid-themed shoot by Tim Walker for *W* magazine's December 2013 issue. His grandmother taught him to sew when he was a boy, and after that he started making tails. In 2006, when he was just sixteen, he founded Mertailor LLC. Today he has a showroom in Crystal River and a team of more than a dozen seamstresses, fabric cutters, mold makers, and shippers to execute his vision and

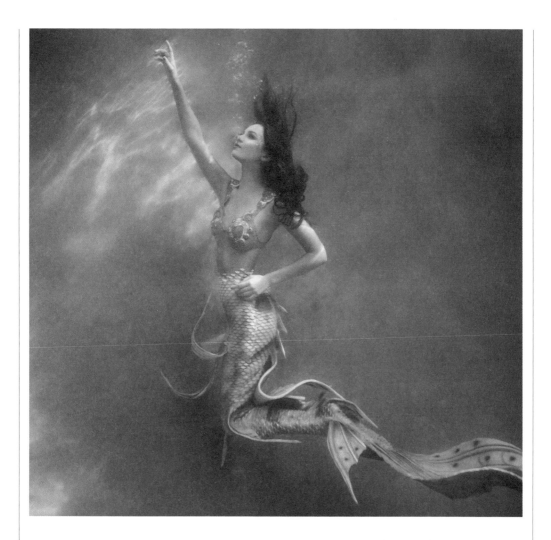

satisfy the fashion needs of mermaids and mermen worldwide.

Ducharme's most recent innovations include a design that integrates a monofin and mermaid tail into one mold of soft platinum silicone, which is as comfortable and flexible as it is stunning. The Allure features individually sculpted scales so realistic they look like fish scales under a microscope. The Spellbound is a more straightforward silicone tail that comes in bright yellows, pinks, blues, and greens and is a lower-priced option for budget-conscious mermaids, as is the "eco" fabric tail that skims the body like a Givenchy gown.

Ducharme's tails have clean lines and tend to be more masculine—that is, they have less frou-frou and bolder, more daring lines in the fluke. He cites as an influence the house of Versace, with its use of jewel colors and flashy design. Of all the mermaid designers, he is the most focused on bringing mermaid style to the two-legged masses. He recently released lines of underwater-themed women's and men's swimwear, and is working on dresses, pants, leggings, shorts, and tank tops, all in bright ocean-inspired colors with names like Sea Grape or Kelp and featuring abstract patterns that mimic fish scales, ocean waves, and seascapes.

Aʙᴏᴠᴇ: **The Leaf, a full silicone Mertailor tail.** + *Pᴀɢᴇs 48–49:* **The Mertailor (second from left) poses with models; all are wearing his signature Spellbound Triton silicone tail.**

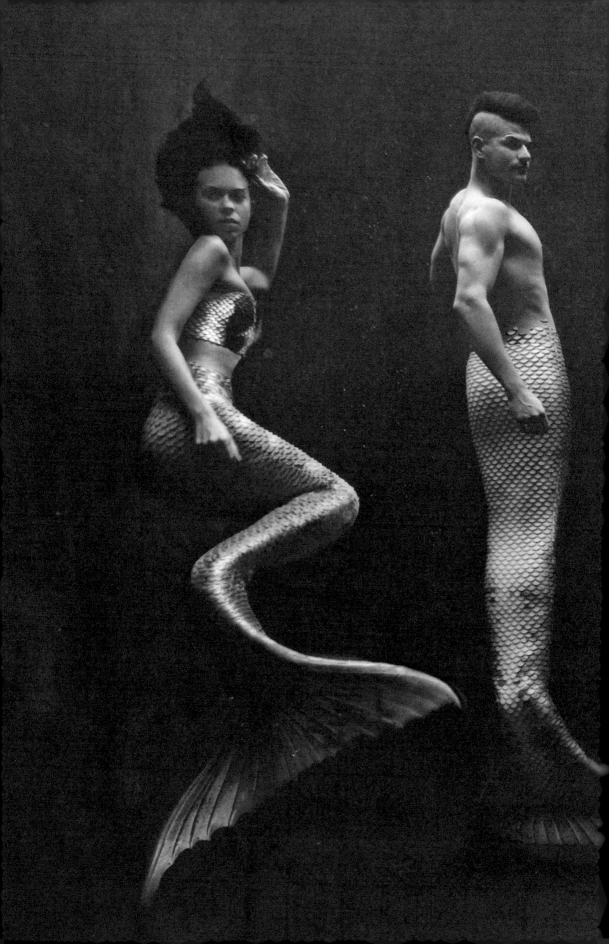

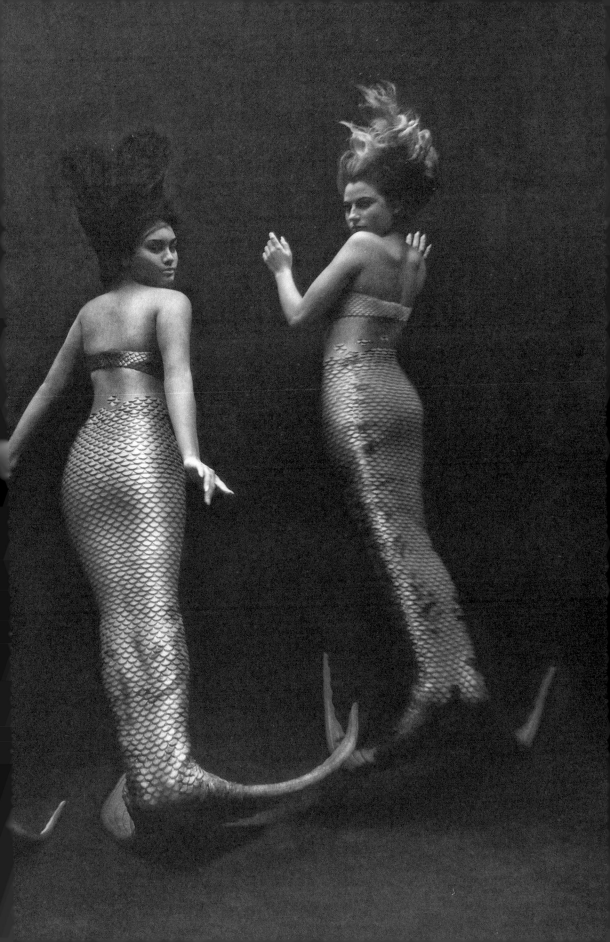

FINFOLK 🐟 Identical twins Abby and Bryn Roberts grew up loving mermaids as much as any other girls, but only crafted their first mermaid tails when, in 2012, the Minnesota Renaissance Festival put out a call for tails to outfit their new half-fish, half-lady attraction. Though the duo had never made anything of the sort, Abby had a background in textiles and Bryn in the arts generally, and the two volunteered their services, since Abby could "sew anything." When they realized the request was for silicone tails and not fabric ones, they did their research and decided to tackle the job. With some start-up money from the festival, they made five tails in their garage over six weeks that summer, experimenting with various molds and processes. The tails turned out beautifully; not only did the festival's mermaids wear them to dazzling effect, but news of the unique flukes made its way to modern mermaids worldwide. Soon the duo started getting requests for custom tails on a regular basis. The girls were nineteen at the time and still in college, but business was so good that they left school to found their couture mermaid design house, Finfolk Productions LLC, in 2013.

Finfolk's main inspiration comes from naturally fashionable ocean denizens. A bass-inspired tail features neutral greens and golds; a goldfish tail is soft and fabric-like in texture; a betta fish tail has large spiky fins and rich hues of blue and purple; a lionfish tail is all stripes and swagger and ruffled fins; a parrotfish tail is a rainbow of glimmering pastels: To date they've sculpted nearly twenty different fluke shapes.

While many of their clients want their tails to represent the ocean in some way, whether through shades of glimmering blue or the colors of a sea-dwelling icon, others want tails that might have emerged from a classic painting or fairy tale. Finfolk makes tails both realistic and fantastic. Its Mythic tail falls somewhere in between, with a neoprene base and individual iridescent scales sewn on by hand; it's also the first deluxe, ready-to-wear plus-size tail on the market. While the tail is fantastical and sequiny and would fit in perfectly at a mermaid discotheque, it captures the true iridescence of underwater life, too. Everyone knows that ocean creatures love to shine.

OPPOSITE: A mermaid relaxes on the sand in a Finfolk Mythic tail in this photograph by Savannah Kate. *ABOVE:* Mermaid Hyli wears a custom hand-painted silicone Finfolk tail in this image by J. Berendt Photography. + *PAGES 52–53:* Sisters Abby and Bryn Roberts pose with an array of Finfolk tails.

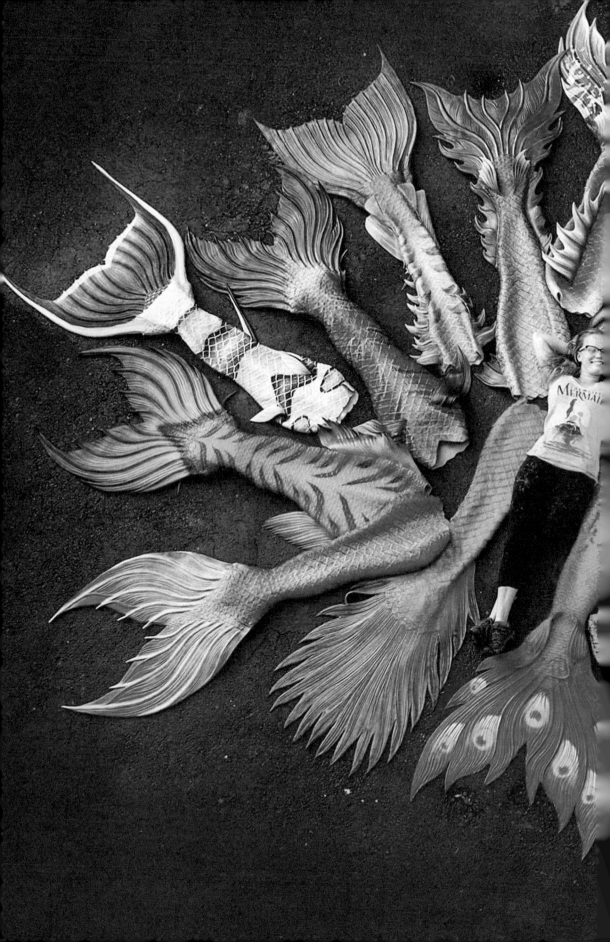

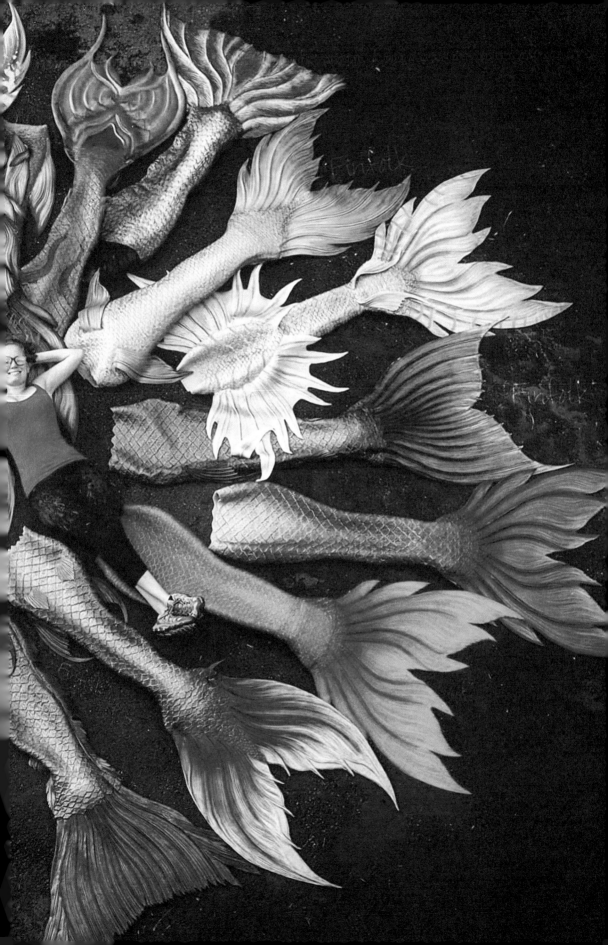

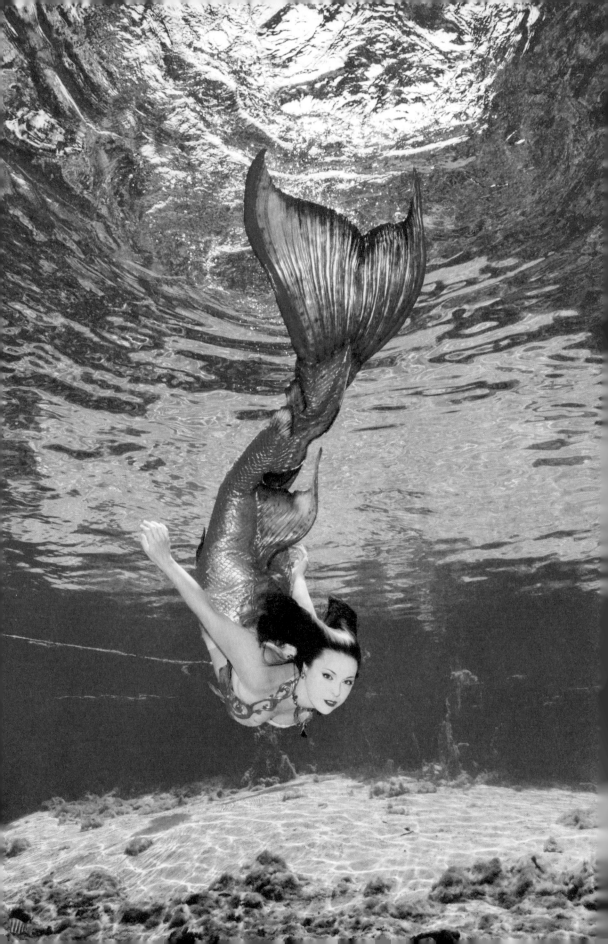

MERBELLA ❧ As a child, Raven Sutter taped images of mermaids she had torn from magazines to the wall above her bed. She longed for a tail like the ones she saw on those pages, and at age eight made her first one out of plain gray spandex and flippers. Though the tail was crude and practically transparent when wet, she "wore it countless times and took it everywhere." As she got older, she made "several terrible fabric tails" and neoprene ones, but longed to fashion those ultraglamorous creations she saw in movies. Over time she learned to do small casting and molding projects, and eventually made a functional, fully molded latex tail that she performed test after test on before she felt confident enough to make the jump to luxurious silicone. With her husband, she founded her own fashion house, Merbella, in 2012. Why mermaids? "They're symbols of beauty and mystery," she says. "But the appeal of tails stems around the fact that you can actually swim in them." Merbella is now one of the most exclusive tail couturiers around.

Sutter herself is a mermaid performer, appearing since 2011 in Merbella's traveling turn-of-the-century-style circus tank extravaganza, The Live Mermaid Exhibit & Show. In fact, Merbella created the mermaid costume for the 2017 movie *The Little Mermaid* and was the underwater stunt trainer for both the lead actress and the stunt double.

Professional mermaid and Merbella fan Kathy Shyne says that Sutter's ornate tails remind her of ancient magical fish, complete with lace-like tattering along the edges of the fins. To custom-make each tail, Sutter finds out exactly how a client intends to use it and designs around that purpose, looking up fish native to where she lives, as well as flora and fauna that align with her favorite colors. "Sometimes I'll design inspired by hair or eye color," Sutter says, "or anything else that stands out to me. I just like to include little hints of her into the design in every way I can to make each tail truly bespoke."

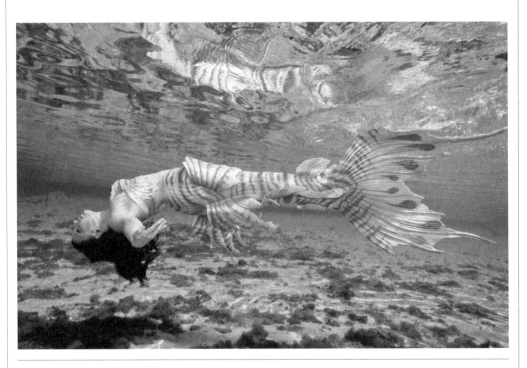

OPPOSITE: Merbella designer Raven Sutter swims at Weeki Wachee Springs in one of her early tails in this photograph by Andrew Brusso. + *ABOVE:* Sutter in one of her popular green lionfish tails, also captured by Brusso.

MERMAID ACCESSORIES

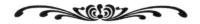

FROM DAY ONE, THE MERMAID HAS ALWAYS BEEN about accessories, somehow managing to keep a comb and a mirror on hand while perching upon rocks and luring human men to their ruin. She's been pictured with said objects since the early Middle Ages, though no one knows why beyond general purposes of glamour.

Robert Graves's theory was that the mermaid's comb was originally a plectrum (a thin tool used to strum or pluck an instrument) used by sirens to play their lyres and that it morphed into a comb over time. The mirror might have been a natural accompaniment—or it might have evolved from the traditional association between sea god- desses and the moon. Plenty of other killjoys have written of the mermaid's mirror and comb as sym- bols of her vanity and lasciviousness, too.

Not only did the mermaid's comb keep her locks long and lustrous, it sometimes served as a device for humans to call to her. "The Old Man of Cury," from Robert Hunt's *Popular Romances of the West of England* (1903), tells the story of an old man who, during a walk in the sand in "one of the coves near the Lizard Point," comes upon a lone mermaid stranded on a rock during low tide. While combing her hair, she explains her plight to the man, imploring him to help her get back to sea. As she speaks, she passes "her fingers through those beautiful locks, and [shakes] out a num- ber of small crabs, and much broken sea-weed,"

as mermaids do. She promises him that she will grant him three wishes if he'll help her, but says he must meet her on another day to collect them. Then, "taking her comb from her hair, she gave it to the old man, telling him he had but to comb the water and call her at any time, and she would come to him." He does so, and his wishes are granted. The story ends by noting that the comb is owned today by the old man's descendants, but that "some people are unbelieving enough to say the comb is only a part of a shark's jaw." Citing an age-old truth, the narrator notes that "sceptical people are never lovable people."

One of the most iconic mermaid accessories comes from Irish folklore: the *cohuleen druith*, a bright red magical hood or cap covered in feath- ers that was worn by mermaids (or merrows, or *moruadh*, or *moruach*, as they were called) and was necessary to their life underwater. In *Fairy and Folk Tales of the Irish Peasantry* (1888), Yeats writes that the merrow has "when in their own shape, a red cap . . . usually covered with feathers. If this is stolen, they cannot again go down under

OPPOSITE: Model Jessica Dru poses in an elaborate mermaid headdress from Miss G Designs, an oyster shell mantle from Fortunate Nora, and a Creature of Habit dress featuring dyed lace and ombré silk chiffon sewn to a nude mesh slip. Photographer Bella Kotak calls the shot a "combination of all our creative skills and love for wild, windswept folklore."

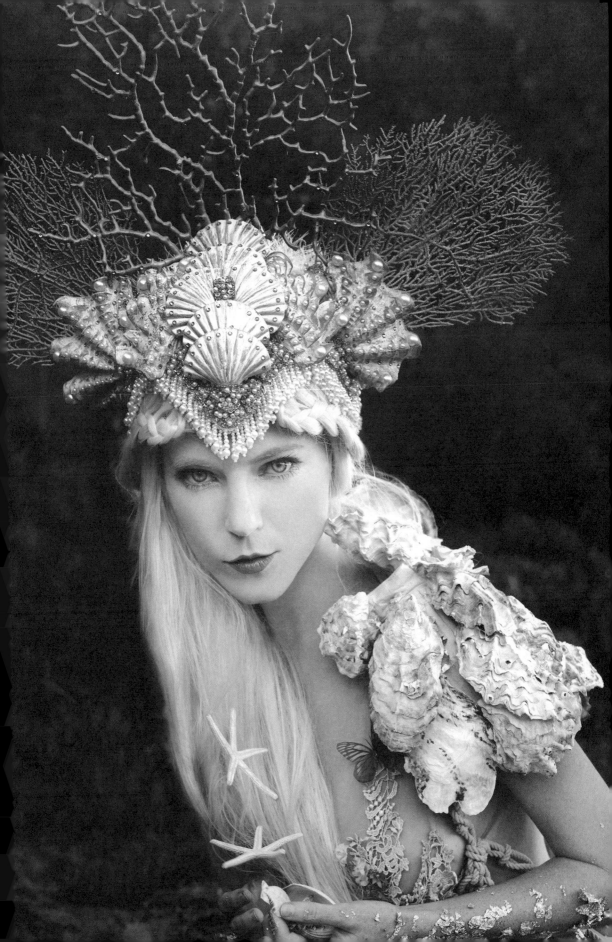

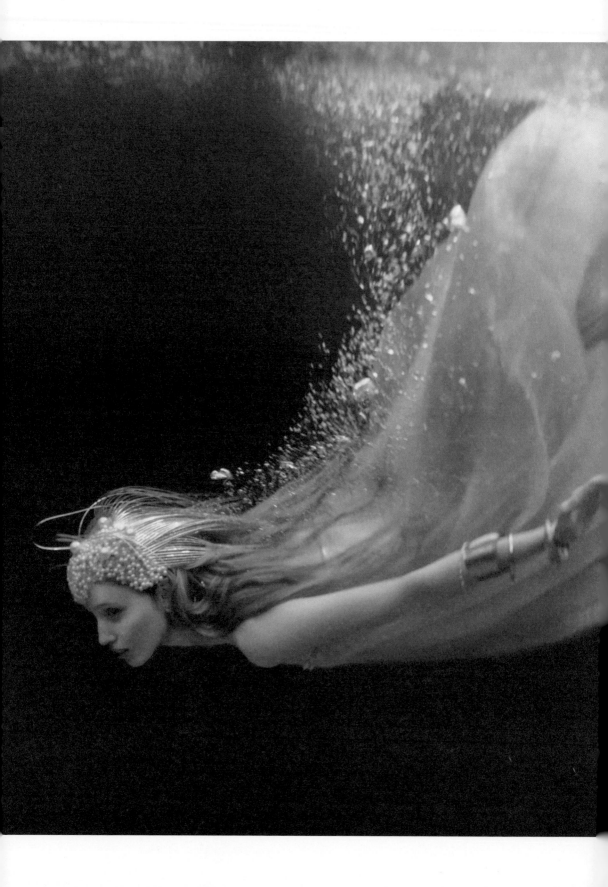

the waves." He goes on to say of their bold use of color: "Red is the color of magic in every country, and has been so from the very earliest times. The caps of fairies and magicians are well-nigh always red." If the mermaid comes upon her stolen *cohuleen druith*, she is irresistibly drawn back to the sea, even if she happens to have married a human man and had children with him. In one tale, "The Sea Fairies," from Patrick Kennedy's *Legendary Fictions of the Irish Celts* (1891), a mermaid is so annoyed by how her human husband treats the sea cows that emerge to graze in his meadows and be near their sea-born relative that she "poked out her *cohuleen druith* and quitted him." The man was "sorry when it was too late," and, sadly, their children had "rough scaly skin and a delicate membrane between fingers and toes."

The shell mermaid crown has become a phenomenon more recently, though it has cropped up in older mermaid art (in one of Arthur Rackham's illustrations for *A Midsummer Night's Dream*, the mermaid is wearing a fetching shell band: see page 8). In 2016 Melbourne artist Chelsea Shiels's ornate and bejeweled mermaid crowns went viral, and now social media is full of handmade treasures, from a delicate band of shells to a flashy gem-laden crown with dangling pearls and fancy shells jutting upward. You can easily piece together your own to be that much closer to mermaid royalty (see "Make a Mermaid Crown" on page 60). In mermaid adornment, no sea bling is off-limits: While Hans Christian Andersen's little mermaid princess did not wear a shell crown, on her fifteenth birthday her royal grandmother adorned her head with a wreath of white lilies, of which "every flower leaf was half a pearl." The old lady then "ordered eight great oysters to attach themselves to the tail of the princess to show her high rank." High fashion, indeed!

LEFT: Photographer Ekaterina Belinskaya joined model Elena Mitinskaya, in a gown by costume designer Alisa Gagarina, underwater for this dreamy fashion shoot in a Moscow pool.

Make a Mermaid Crown

—Tricia Saroya

HE RIGHT HEADPIECE CAN MAKE THE MERMAID. HERE IS a stately easy-to-make crown that will make any mermaid look more royal.

TOOLS AND MATERIALS

- Simple plastic adult-size headband, substantial enough to attach shells with glue to it. Double-headband style recommended.

- 3 spiral-shaped shells, one roughly 2 inches tall and the other two about 1½ inches tall

- A wide variety of small shells, including 2 small clamshells

- 2 tiny sand dollars

- 3 strands of costume or thrift store pearls

- Pearl-wired garland, available at a crafts store or online

- Sparkly vintage earring

- An array of sparkly items: crystals, pieces of jewelry, Christmas decorations, etc.

- Hot glue gun and glue sticks

- Heavy-duty diagonal wire cutter

ABOVE: Actress Sonalii Castillo models a mermaid crown in this image by Steve Parke.

DIRECTIONS

1. Hot-glue the 2-inch spiral shell to the center of the headband.

2. Work out from the center, hot-gluing shells as you go.

3. Continue adding shells, making sure that you leave a tiny bit of room between each shell so that as you put your headband on and it flexes, the shells have room to move.

4. Take apart a few strands of the pearls; add the individual pearls to the shells.

5. Take a piece of pearl-wired garland and cut it into two small pieces. Hot-glue it to the center of the crown.

6. Take a vintage earring and cut off the clip part using the wire cutter. Glue the earring to the top of the center shell.

7. Hot-glue lots of sparkly pieces for added bling.

8. Take loose pearls from thrift store necklaces, and glue them into the empty spaces. Don't hesitate to keep gluing several layers. Just make sure you leave room so that the headband can flex as you put it on your head.

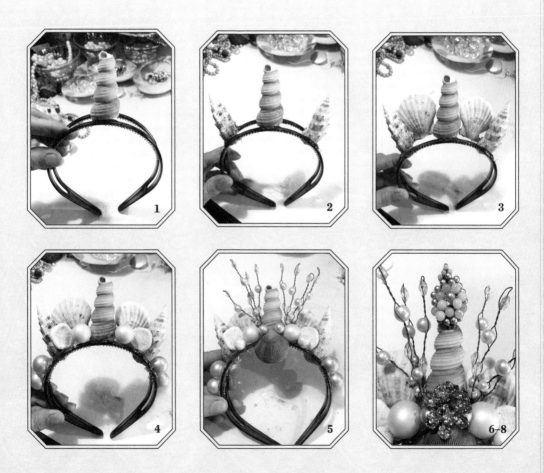

Make a Mermaid Mirror

— KARIMA CAMMELL

SEASHELLS AND GLASS MAY BE ABUNDANTLY AVAILABLE, but when combined creatively, they are anything but basic; after all, no two seashells are alike. Transform these simple supplies into these mirrors inspired by John McRae, a teacher at Castle in the Air in Berkeley, California. Try using different materials such as stones, glass beads, glitter, or colored sand to fill in empty spaces. This technique can be used to create shellwork picture frames, too, perfect for housing photos of you in full mermaid attire.

MATERIALS

* **Palm-size round mirror**
* **Scallop shell large enough to hold the mirror**
* **Tiny seashells in various sizes, shapes, and colors**
* **White glue**
* **Talcum powder**
* **Old teacup or glass jar and teaspoon**
* **Small plastic produce bag and scissors for making a piping tool**
* **Food coloring** (optional)

DIRECTIONS

1. Plan your mirror's design by arranging the smaller seashells in decorative patterns around the mirror on a tabletop.

2. Make a paste by using the spoon to mix one part white glue to two parts talcum powder in the teacup or jar. The paste is ready when it holds its shape and is no longer runny. If it gets too thick, add glue; if it's too runny, add talcum. Tint the paste, if desired, by stirring in a few drops of food coloring.

3. Fill the plastic bag with the paste, tie it closed, and cut a tiny snip from one corner to make a piping tool.

4. Using the spoon and piping tool, fill the scallop shell with the paste and smooth it flat.

5. Press the mirror into the shell until the mirror's rim is below the surface of the paste. Use a damp cloth to clean any paste that gets onto the face of the mirror.

6. Decorate around the mirror by pressing the shells into the paste.

7. Fill in the rest of the scallop shell with the smaller shells according to your design. Use the piping tool to add spots of paste to hold the shells in place. Allow the mirror to dry overnight before handling.

OPPOSITE: Ann Blyth in a classic mermaid pose in a still from the 1948 film *Mr. Peabody and the Mermaid.*

They would pelt me with starry
 spangles and shells,
Laughing and clapping their
 hands between,
All night, merrily, merrily,
But I would throw to them back
 in mine
Turkis and agate and almondine...

—ALFRED, LORD TENNYSON
 "The Merman," 1830

Make a Sea Mist Necklace

—JoEllen Elam Conway

JUST AS MERMAIDS GATHER PEARLY SEA MIST TO FORM necklaces for their adornment, you can create one of your own. Choose pearls, beads, and sequin paillettes in your favorite colors. Here, we used pastel greens, blues, and clear-colored pearls in various sizes.

TOOLS AND MATERIALS

- **Needle-nose pliers**
- **Wire cutters**
- **Jewelry wire** (26-gauge), **12½ feet long**
- **1 lobster-clasp closure**
- **Imitation pearls, 23 small** (4 millimeters), **21 medium** (6 millimeters), **3 large** (11 millimeters)
- **Beads, up to two dozen or more in various sizes and colors, as desired**
- **6 to 10 large sequin paillettes** (1½ inches) **with holes, in the color of your choice**

DIRECTIONS

1. Cut five separate lengths of wire 20 to 30 inches long, varying lengths, leaving 4 inches on each end of each wire free.

2. Thread the pearls one at a time through the wire, then loop the wire back through the pearls, tying them into place. Add paillettes as desired, making sure the placement is random.

3. Gather the wires together on one side and divide them up into three sections, then braid the ends together into a 2-inch braid. Because you have only five wires, one strand of the braid will only be a single wire and the other two will comprise two wires each.

4. Thread the lobster-clasp closure through the loose wires and slide it down to the top of the braid. Fold over the loose wires and wrap around the braid.

5. Gather wires on the other end of the necklace and repeat the same 2-inch braid on the other side. Fold the braid to form a loop, then wrap the loose wires around to the bottom.

6. To create the effect of silvery swirls of whirling waves, wrap a few sections of the wire around the pliers to form swirls randomly throughout the necklace wires.

2

3A

3B

5B

3C

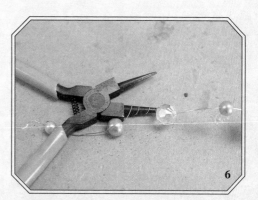

6

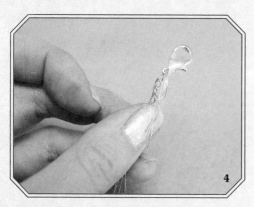

4

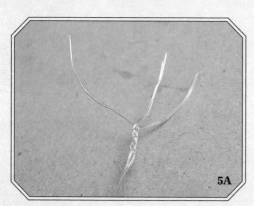

5A

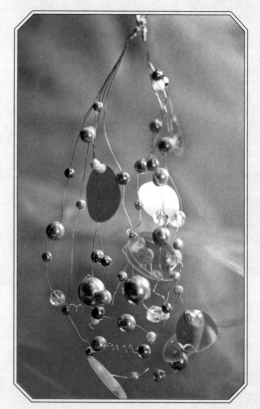

MERMAID BEAUTY
at EVERY AGE

I**T'S CLEAR, DEAR READER, THAT WE'RE SO DAZZLED** by mermaids that we tend to represent them in art as lithe young creatures with long locks and dewy adolescent and usually pale skin; in other words, we often default to traditional Western beauty standards when depicting them. But the mermaid comes in every size and shape and color, as we well know, especially landlocked ones who might spend their days driving cars and shopping at supermarket chains but in fact are filled with a deep yearning for the sea.

The truth is that mermaids do not age the way regular humans do, no matter where they reside on land or in water. An example comes from Florida's longtime mermaid attraction Weeki Wachee Springs, founded in 1947 and featuring an underwater theater built into the limestone of the spring. While the main performing mermaids at Weeki have usually been women in their late teens, a team of alumnae mermaids ranging in age from their fifties to their early seventies came together for the park's fiftieth anniversary in 1997. The show was so popular that it became a regular feature, and today, in addition to seeing daily shows starring the current crop of mermaids, visitors can see monthly shows starring some of the very same women who came together for the fiftieth anniversary. "We still awe people with our underwater talents," says the oldest working mermaid, Vicki Smith, who recently celebrated the sixtieth anniversary of her first mermaid show.

Part of their secret? The weightlessness of being underwater, where time slips away completely. Each of the former mermaids talks about that quality of being weightless and feeling in the spring exactly as she did when she was a teenager back in the day, working as a mermaid. "My favorite memory," Smith says, "is not cutting the ribbon for the new million-dollar theater with the governor of Florida in 1960, nor is it swimming for Elvis Presley the year after. My favorite memory is from when I was seventeen and I was sitting on the platform getting ready to dive into the spring. The pink azaleas were in full bloom. I remember feeling the warmth of the sun on my face, then diving into that fluid aquamarine

OPPOSITE: Model Jessica Dru (see page 57) arranged this surprise "Queen of the Sea" shoot with photographer Cassie Fuertez for her mother's sixty-second birthday to shine a light on her beauty.

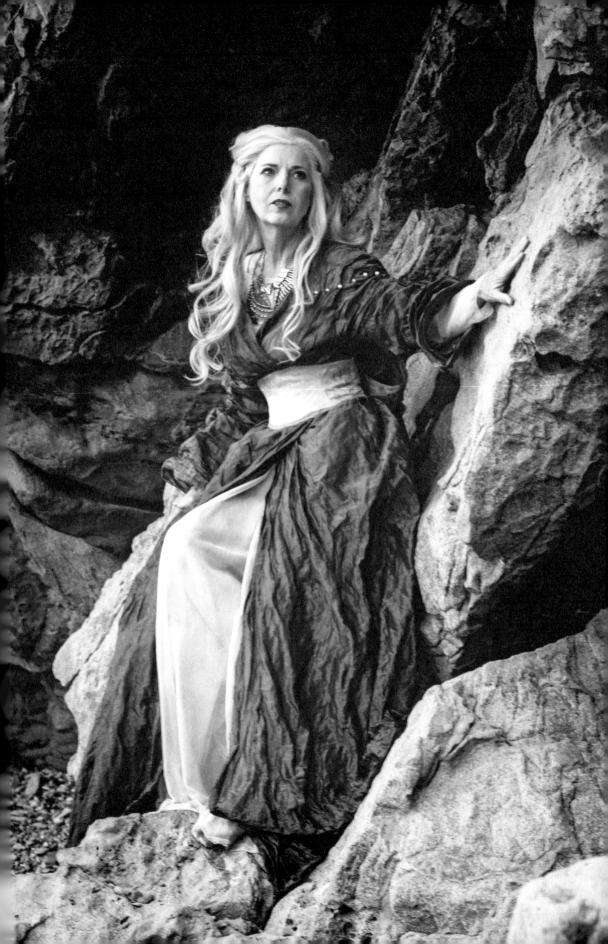

world that looks like liquid diamonds. When I'm at the spring now, I'm seventeen again, about to step into that crystal water for the first time."

Since 2010, these fabulous mermaids have run the two-day Sirens of the Deep Mermaid Camp for adult women. Every summer, women from all over come to the park, put on a tail, and learn to swim on the famed Weeki underwater theater stage while their friends and family take photographs of them through the glass.

There, the former mermaids have become stars in their own right. As Smith said, "This lady approached me as I came out of the back dock. She told me she wanted a picture of me. I explained that there would be a beautiful young mermaid posing for pictures after the next show. Then she said, 'No, I want a picture of you. I cannot believe you women are still doing this after all these years. I am fifty-two years old and you have shown me that I have a lot of good years left.' And that's what got me going. I told her, 'Don't stop moving! No matter how deep the water, no matter how strong the tide, just keep swimming!' The other girls were coming out, so she got a picture with several of us and left. I didn't get a chance to tell her how the ancient water of Weeki is the magic that feeds our mermaid souls."

Above: Vicki Smith performing at Weeki Wachee Springs at age seventeen. + *Opposite:* Sixty years later, at seventy-seven, Smith performing in the same waters, captured here by Andrew Brusso.

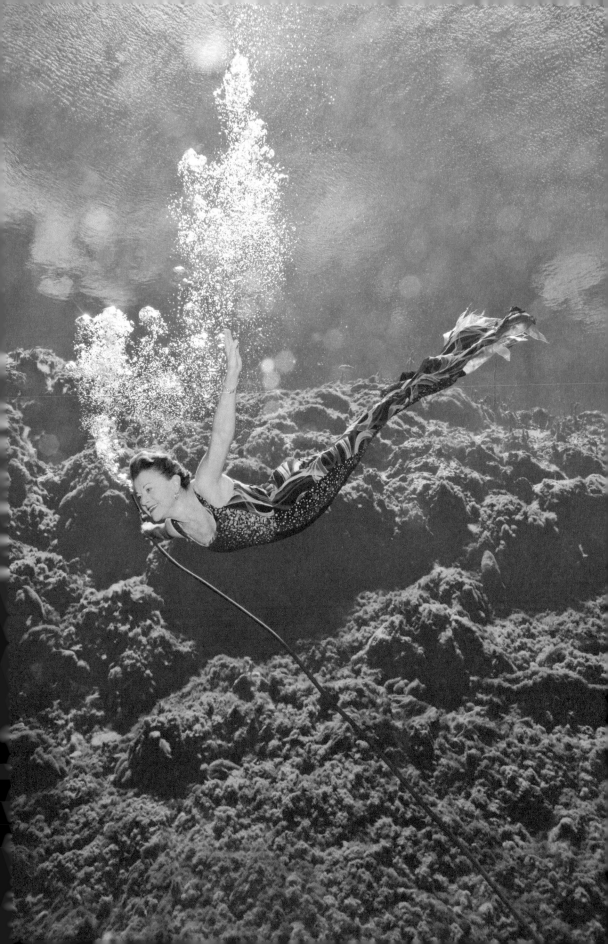

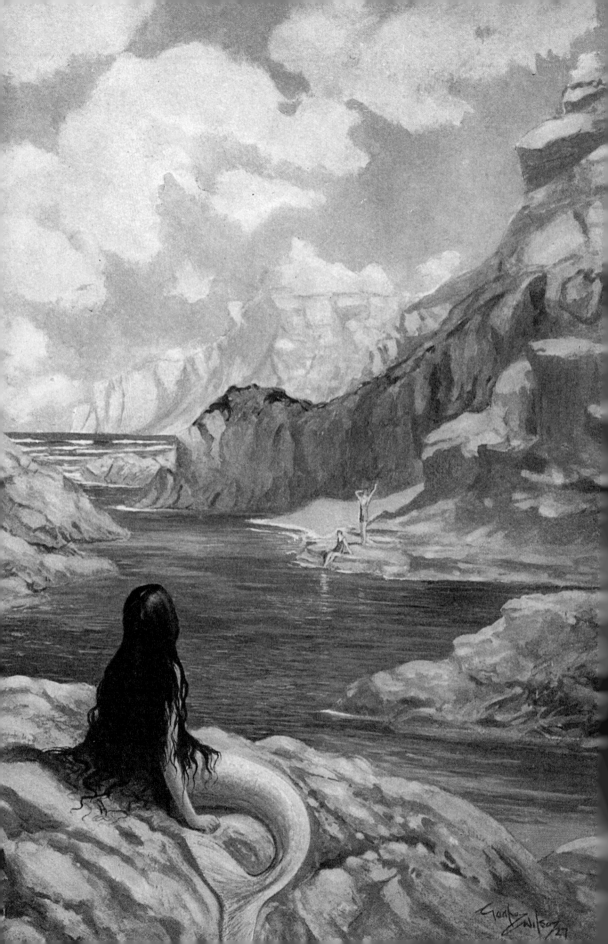

BATHE LIKE *a* MERMAID

— RONA BERG

ERMAIDS, WHO SPEND LONG SALTY DAYS entangled in the flowing ribbons of kelp that float beneath the sea, reap beauty benefits that mere mortals can only dream about. Their skin is luminous, with an incandescent glow. Their hair is thick and shiny with an alluring potency and power. And since seaweed—and seawater—are known to firm the skin, their bodies are taut and smooth.

Isaac Asimov once said that seawater is the soup of life, and it's true. All life came from the sea, and the bracing ocean brine can be a powerful restorative. The ocean's healing waters and many of its flora are renowned for their curative powers. The ancient Greeks loved to bathe in a bouillabaisse of salts and lovely scented oils by the sea. Europeans have long flocked to the ocean for centuries to take the waters and wrap themselves in sea plants and vegetables to regulate the thyroid gland; to help heal skin conditions like eczema, psoriasis, dermatitis, and acne; and to ease respiratory conditions. These various therapeutic treatments fall under two main categories: algotherapy (the therapeutic use of seaweed and algae) and thalassotherapy (the medical use of seawater).

Seawater and sea salts are loaded with enzymes and minerals and can contain up to eighty-five natural trace elements that help replace electrolytes and trace minerals that we may have sweated out. Rich in vitamins A, C, and K as well as essential fatty acids, seaweed helps us absorb minerals back into the skin, which is why seaweed baths are so beneficial. Seaweed has antioxidant properties, too, protecting the skin from free-radical damage, wrinkles, and aging.

There are more than three thousand types of seaweed, and each type is said to have a different effect. For example, laminaria, or green algae, rich in iodine, stimulates the oxygen content in the body's cells; fucus, or brown algae, has a detoxifying effect on the body; white algae is rich in calcium, and magnesium, which acts as an anti-inflammatory, relieves water retention, and stimulates circulation. Massaging the hips and thighs with seaweed soap may help break down cellulite and improve circulation. All seaweed naturally cleanses and purifies the skin, helping to improve its suppleness and elasticity—like the snap in a mermaid's tail.

To follow are some mermaid-inspired ideas for making your own baths more luxurious.

OPPOSITE: Intruders! Illustration by Godfrey Wilson for the *Tatler*, August 15, 1928.

Mermaid Soaks

WHEN WE'RE IMMERSED IN WARM SALTY WATER AND delicious oceanic smells, all burdens lift. In that solitude, we feel weightless, at one with the sea. Here are two wonderful renewing bath options that will make you feel as if all of your cares have washed down the drain.

A LUSCIOUS SEAWEED SOAK

1. Prepare your own soothing seaweed soak with long, luxurious, dehydrated strips of kelp from beauty brands that specialize in sourcing from the sea.

2. Unwrap the strips, place them in a warm bath, and watch them slowly reconstitute. Meanwhile, get into the flow by turning on your favorite music or listening to a spa soundtrack of water lapping on the shore. Light an aromatherapy candle.

3. By the time you step into the bath, you will find yourself surrounded by softly undulating waves of seaweed. After a few minutes, they'll release a silky gel into the water, making you feel like a mermaid in a watery dreamworld.

THE DIVINE GODDESS BATH

1. Head to the tub, sea sponge in hand, for a relaxing mineral bath soak. This soak will make your skin as preternaturally soft as the loveliest mermaid's.

2. Run a warm bath, sprinkling in aromatic bath salts—or sea salt—and drizzling in your favorite bath oils. If you're in the mood to make it look really pretty, toss in organic dried herbs (rosemary soothes sore muscles; sage is grounding) and flower petals (lavender and chamomile are relaxing; rose promotes feelings of love).

3. Light an aromatherapy candle, slowly sink into the tub, and let the stress of the day float away.

NORI: A Dehydrated Kelp Substitute

If you can't find dehydrated kelp, buy a package of nori (the black seaweed squares used to roll sushi) at the supermarket. Cut three or four sheets into quarters, place them in a small pot, fill the pot with water, and let it boil for five to ten minutes. Let the liquid cool, then pour it into your warm bath.

Homemade Bath Salts

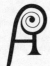

A FEW SCALLOP SHELLS OF THESE DELICIOUS SALTS ARE perfect for a soothing bath. The salts also double as a body scrub: Standing in a full tub, gently exfoliate your dampened skin. Then sit down, relax, and watch the salts melt away.

MATERIALS

+ **1 cup dry nonfat milk**
+ **1 cup baking soda**
+ **½ cup sea salt**
+ **A few drops of a favorite essential oil**
+ **Medium-size glass or ceramic bowl**
+ **Airtight glass jar, sea blue or brown**
+ **Small scallop shell, as a scoop**

DIRECTIONS

1. Mix the nonfat milk, baking soda, salt, and essential oil together in the bowl. Transfer to an airtight glass jar, preferably sea blue or brown, to protect the oils against oxidation.

2. A small scallop shell makes a perfect scoop, and you can store it inside the jar with the salts. This mixture keeps for up to one year if stored in a cool, dry place.

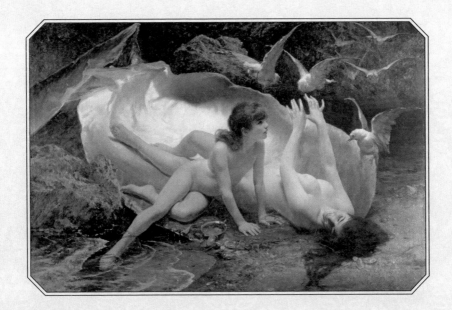

OPPOSITE: Sea Nymph, William Robert Symonds, 1893.
ABOVE: The Naiads, Gioacchino Pagliei, 1881.

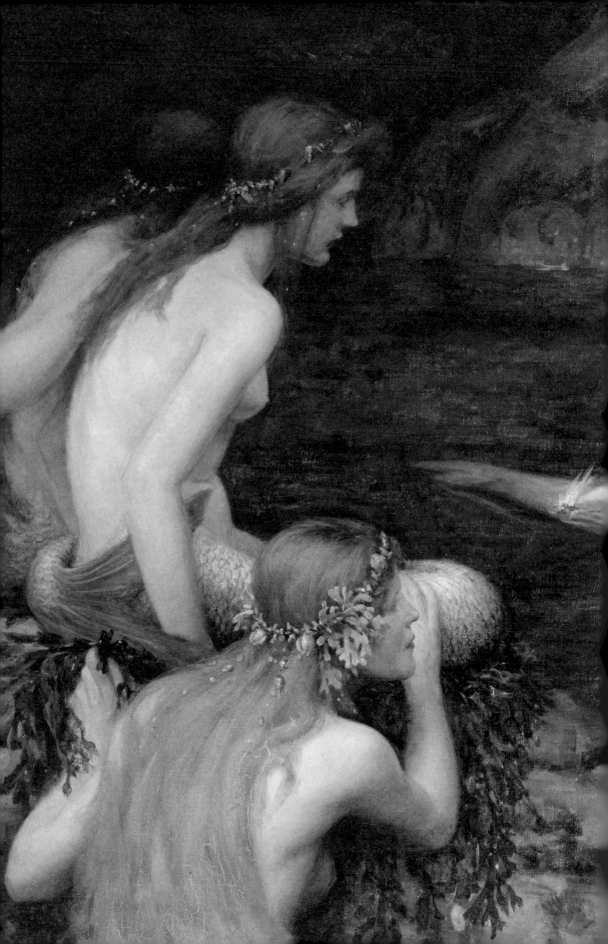

II. Arts & Culture

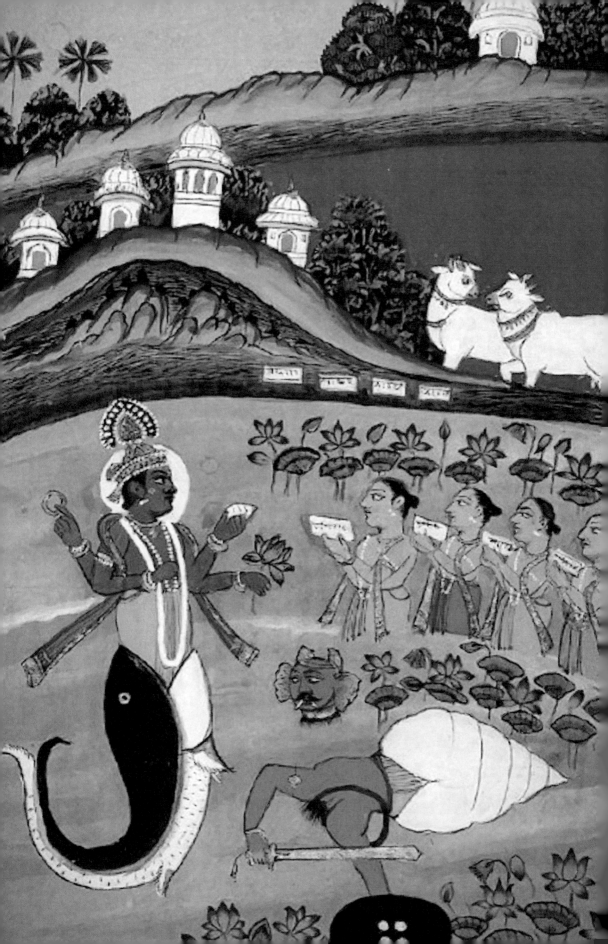

FISH-TAILED GODS *of the* ANCIENT WORLD

F ISH-TAILED GODS, CREATURES AT ONCE HUMAN and piscine in form, can be found in cultures worldwide, although pinpointing their first appearance can be as slippery as catching a mermaid in a net. The mermaid's earliest ancestor was most likely the Babylonian male sea god Ea, or Oannes (his Greek name), one of the triad of gods of Babylonian mythology. In stories dating back to 5,000 BC, Oannes was rumored to emerge each day from the sea, along with the sun, to educate humans in the ways of the world and then to disappear again each night in the same dramatic fashion.

Writing in the first century BC, Greek scholar Alexander Polyhistor explained how, among other things, Oannes "gave [men] an insight into letters and science, and every kind of art. He taught them to construct houses, to found temples, to compile laws, and explained to them the principles of geometric knowledge." Though he was mainly a fish, he had a human head and human feet poking out from below his fluke. Early representations of him basically depicted a man in a fish suit. In the eighth century BC, Oannes's form was modified when he appeared as a merman—half man and half fish—on an Assyrian sculpture.

Other fish-tailed gods emerged as successors to Oannes, such as Dagon of the Philistines, who seems to have first appeared in the late third and early second millennia BC. He is in the Old Testament; in the book of Samuel, he's found fallen on his face in front of the ark of the Lord. Dagon's head and palms have been removed, and there's "only a stump left to him," which some scholars have taken as reference to his fishlike lower half. In *Paradise Lost*, Milton refers to him as "Dagon his name, sea-monster, upward man / And downward fish." Another biblical connection to the mermen of old comes in the person of Noah, who has appeared in some art with a fish tail, along with his wife and sons, probably because of the third century BC writings of the priest Berossus on the Chaldeans (Chaldea was a Semitic nation absorbed into Babylonia), whose flood story was interpreted by some early Christians as a version of the Old Testament. In the 1883 tome *Sea Fables Explained*, naturalist

PAGES 74–75: *A Race with Mermaids and Tritons*, Collier Twentyman Smithers, 1895.
OPPOSITE: Vishnu in his first avatar (incarnation) as Matsya, artist unknown, India, c. 1800.

Henry Lee equates Oannes and Noah: "Oannes was one of the names under which [Noah] was worshipped in Chaldea, at Erech 'the place of the ark,' as the sacred and intelligent fish-god, the teacher of mankind, the god of science and knowledge." Famously, in 1483, a woodcut appears in the Nuremberg Bible showing Noah in the ark—and a mermaid, merman, and merdog swimming in the ocean beside it.

Scholars Gwen Benwell and Arthur Waugh, who discuss all these fish-tailed ancestors in detail in their book *Sea Enchantress*, point out that Oannes's wife and daughter likely had mermaid forms but "are vague figures, almost entirely swallowed up by their shadowy past." They instead identify the earliest mermaid as the Semitic moon goddess Atargatis, also known as Derceto by the Philistines. Diodorus of Sicily tells the dramatic story of how she came to have a fish tail: "Aphrodite, being offended with this goddess, inspired in her a violent passion for a certain handsome youth among her votaries; and Derceto gave herself to the Syrian and bore a daughter, but then, filled with shame of her sinful deed, she killed the youth and exposed the child in a rocky desert region, while as for herself, from shame and grief she threw herself into the lake and was changed as to the form of her body into a fish." Like Oannes, Derceto was mainly and initially represented as a human sporting a fish costume, but over the years and with the evolution of the surrounding lore, she eventually took the form of half woman, half fish—and remained that way. As it happens, her daughter, Semiramis, survived and became queen of Assyria, and stories of her enchanted the medieval world.

The Greek goddess Aphrodite, who was born from sea foam, is sometimes associated with Atargatis. According to author Beatrice Phillpotts, "Atargatis will be better known today in her later guise as Aphrodite, Greek goddess of love, subsequently the Romans' Venus. Born from the sea in a scallop shell, Aphrodite retained

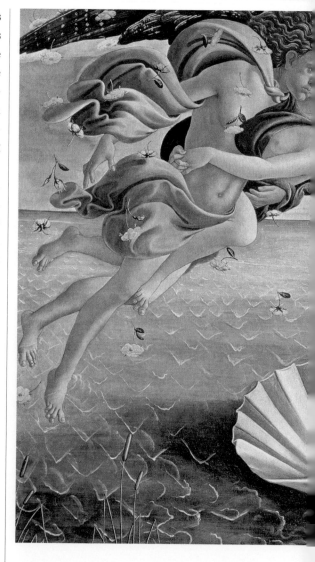

Atargatis's close connection with the sea, but lost her fishy attributes." Aphrodite also liked to while away the hours with mermen, the tritons.

The ancient Vedas of India also contain various aquatic gods and goddesses and nymphs. Written between the sixth and eighth centuries BC, the *Shatapatha Brahmana* is an early religious text of the Vedic tradition (the precursor to modern-day Hinduism), and contains one of the first-ever written accounts of a merbeing, an avatar of the Hindu god Vishnu named Matsya who was said to have the upper half of a human and lower body of a fish. It is Matsya, disguised as a tiny horned

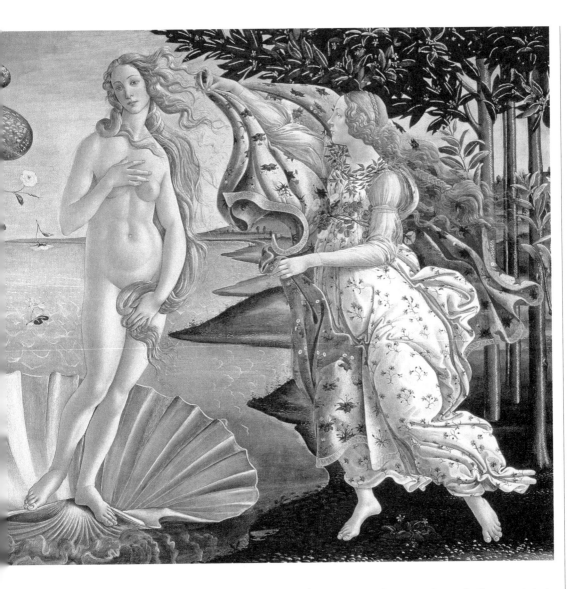

fish, who appears to the first human man, Manu, while he's washing in the river. The fish asks Manu to protect him. Manu takes the fish home, where the fish grows larger and larger until he finally asks Manu to take him to the sea. In return, the fish tells Manu the exact date of an impending flood and instructs him to build a ship in preparation for it. On the day of the great flood, Manu boards the ship and, per the fish's instructions, ties a rope from the ship to the fish's horn. The fish then swims the boat to the safety of the high Himalayas. After the waters subside, Manu descends the mountain to find that he's the sole survivor of the human race. He offers many prayers to the gods, and within a year, the gods send him a woman; together, Manu and the woman create a new race, the Aryans.

Looking to the ancient world and its pantheon of sea gods and goddesses, some of whom have tails, can be dazzling and overwhelming. It is no wonder that human women find such power in identifying with the mermaid—and her goddess ancestresses who once ruled the seas.

ABOVE: *The Birth of Venus*, Sandro Botticelli, c. 1485.

SIRENS *in* CLASSIC MYTHOLOGY

I N HOMER'S *THE ODYSSEY*, WRITTEN AROUND the eighth century BC, Greek war hero Odysseus encounters numerous obstacles and delays on his ten-year journey back home to Ithaca from the Trojan War. The most seductive and dangerous of all are the sirens, creatures who are half bird, half woman, and who lure all within earshot with their hypnotic voices, then literally sing them to death.

The witch goddess Circe warns Odysseus before he sets sail: "If any one unwarily draws in too close and hears the singing of the Sirens, his wife and children will never welcome him home again, for they sit in a green field and warble him to death with the sweetness of their song. There is a great heap of dead men's bones lying all around, with the flesh still rotting off them."

She goes on to advise him to stop his men's ears with wax to block out the sirens' song. But she says, "if you like you can listen yourself," in which case "you may get the men to bind you as you stand upright on a cross-piece half way up the mast, and they must lash the rope's ends to the mast itself, that you may have the pleasure of listening. If you beg and pray the men to unloose you, then they must bind you faster." This is indeed what comes to pass, in a famous scene, as Odysseus, overcome by longing upon hearing those enchanted voices, begs his men, in vain, to untie him, and ends up riding to safety.

Today the word "siren" is commonly associated with the mermaid and feminine wiles in general, but to the ancient Greeks the siren was a bird-woman, with early paintings depicting her in a form that is not exactly comely. According to Jane Harrison in *Prolegomena to the Study of Greek Religion* (1903), the siren was originally a ker, or ghost, who had links to the world of the dead and might have functioned as an emissary between this world and the next. It was Homer who gave the siren her gorgeous, otherworldly voice, which later became a key attribute of the mermaid and turned her into a noir-worthy femme fatale. Homer himself doesn't actually depict the sirens as having bird bodies or fish tails, but as Benwell and Waugh describe, the early Greek artists "had no doubts on the subject, and invariably portrayed the sirens as woman-faced birds, never as mermaids or sea nymphs, when they illustrated the episode of Odysseus with the sirens."

OPPOSITE: The Siren, John William Waterhouse, c. 1900.

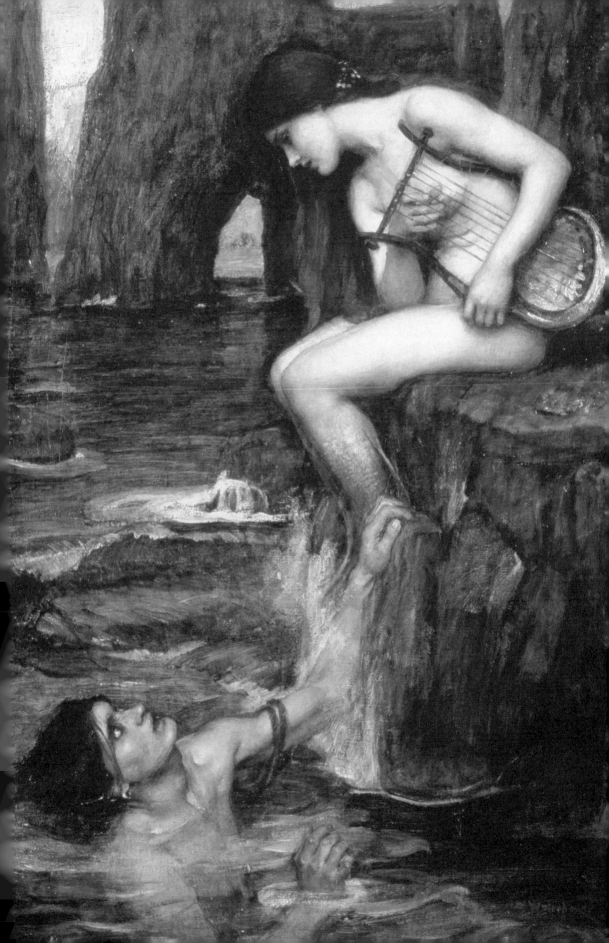

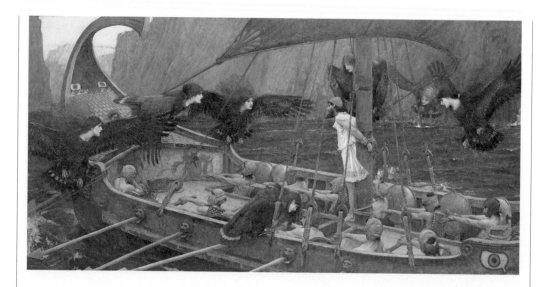

The shift from powerful and otherworldly bird-woman to mermaid was gradual; it began much later, around 300 BC, and was completed in the Middle Ages. It was only with the rise of Christianity that the avian attributes slowly became replaced by aquatic ones, according to Benwell and Waugh. During the time of transition, the siren occasionally appeared in art with both wings and webbed feet. Some Latin bestiaries, for example, show a "syren" with a fish tail as well as claws and feathers. Scholar Roberta Milliken goes so far as to say that "the mermaid is more of a parasitic figure. It essentially fed off and usurped the siren's history and made it its own." But instead of holding great knowledge and power like the sirens did, the mermaid figure became an "emblem of danger and lust," especially in the early church, where she represented the sin and temptation that godly men were tasked with resisting. Indeed, she appears in churches and cathedrals all through the Middle Ages as a cautionary (yet glamorous) figure.

While the siren evolved from half woman, half bird, to half woman, half fish, there were other Greek divinities who were more mermaid-like in their original forms. Nereus, a predecessor of the Greek sea god Poseidon and father of the sea nymphs called the nereids, sometimes appeared in art with a fish tail. Poseidon and the nereid Amphitrite were parents to the magnificently tressed merman Triton, whose name was later used more generally to describe the tritons, half men, half fish, who grew, according to the second-century geographer Pausanias, "hair like that of marsh frogs," and who had "tail[s] like a dolphin's instead of feet." In one tale, a fisherman named Glaucus empties his daily catch into the grass on a little island in the river. He is sorting through the fish when they suddenly revive and begin moving their fins as if they're underwater. Startled, he watches as they all scurry to the water, plunge in, and swim away. Wondering at the magical transformation he's just witnessed, he tastes a bit of the grass the fish were lying on—and is then overtaken by an irresistible longing and plunges into the sea, where he is transformed into a triton. It is not an unpleasant or unhunky transition. *Bulfinch's Mythology* (1855) describes it this way: "His hair was sea-green, and trailed behind him on the water; his shoulders grew broad, and what had been thighs and legs assumed the form of a fish's tail. The sea-gods complimented him on the change of his appearance, and he fancied himself rather a good-looking personage."

Opposite: Ulysses and the Sirens, John William Waterhouse, c. 1891. ✦ *Top: The Sirens*, Edward Coley Burne-Jones, c. 1875. ✦ *Bottom: Glaucus and Scylla*, Filippo Lauri, seventeenth century.

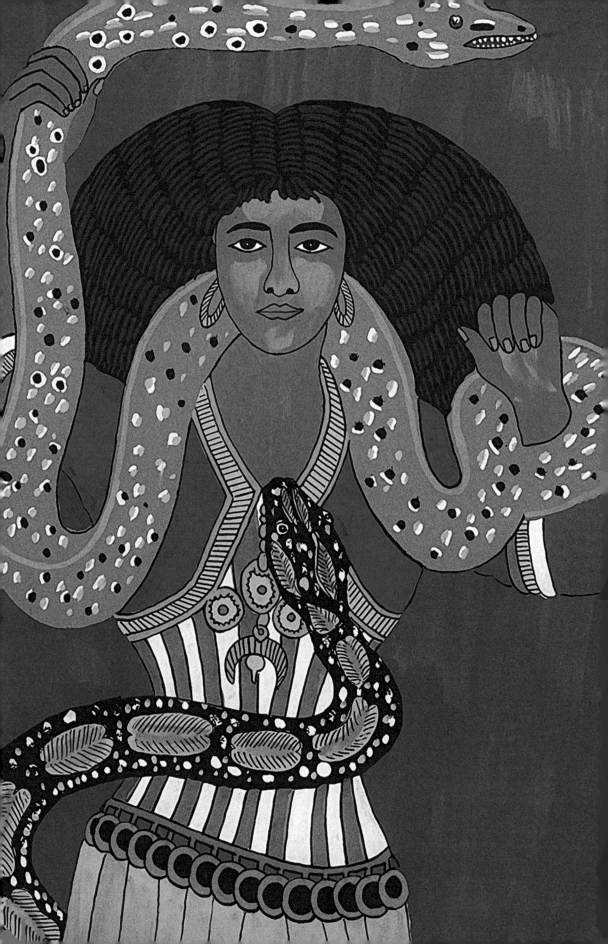

MAMI WATA

T HE WATER SPIRIT MAMI WATA, OR MOTHER Water, is a recognized mythical figure throughout much of Africa. A rich assortment of art surrounds her, and she's often portrayed as a mermaid, with the head and torso of a woman and the tail of a fish. She can also take the form of half woman, half snake.

Either way, she's ultraglamorous—and endlessly complicated. She can heal the sick and strike down the disobedient as she pleases. As African and African diaspora arts and cultures expert Henry Drewal puts it, she's "beautiful, jealous, generous, seductive, and potentially deadly." Not one to balk at bold fashion statements, she is often depicted in art draped in baubles of all colors, with a thick mane of ink-black locks, and donning a giant snake like a scarf, its head resting between her breasts.

According to Drewal, in Africa the earliest representations of indigenous water gods and goddesses appeared on rock paintings twenty-eight thousand years ago; these ancient figures represented all sorts of hybrid creatures cavorting in the water. None of them were mermaids as we know them. The earliest image we have of an African mermaid is from the late fifteenth century. Drewal believes that a visiting Portuguese client commissioned an unknown African artist to sculpt a saltcellar with a mermaid on it, supplying an image for the artist to use. The artist copied the image and immediately altered it to make it relevant to his culture, showing the mermaid swimming with crocodiles, symbols of water spirits where he lived. This, Drewal believes, is how the mermaid was first incorporated into an African pantheon of water spirits. In the nineteenth century, another European image came to West Africa—a chromolithograph by the German artist Felix Schlesinger advertising a popular traveling show; it depicted an exotic woman handling snakes. Drewal believes that this image was seen by African sailors and carried to West Africa, "and that it eventually joined the mermaid as one of the other key images for Mami Wata."

When, between the sixteenth and nineteenth centuries, millions of Africans were forced to leave their homeland and cross the Atlantic to live as slaves, they brought Mami Wata with them. Over time, as new cultures formed and flourished in these new lands, Mami Wata became known by other names, such as Lasirèn in Haiti or Maman de l'Eau in Trinidad and Tobago.

Opposite: Mami Wata, Zoumana Sane, 1987.

MORE MERMAIDS *from* AROUND *the* WORLD

W HILE IT'S IMPOSSIBLE TO CATALOGUE THE endless types of glitzy aquatic hybrids that exist in almost every culture, and it would be indelicate to try, what follows is a brief compendium of a few especially interesting mermaid-like creatures that have long entranced humans throughout the world.

BEN-VARREY ❧

Native to the Isle of Man, ben-varrey (the Manx word for "mermaid") are half human and half fish, with scales of gold and golden hair falling in glimmering waves. They're gifted with prophecy, kind to everyone, and bless those who help them with prosperity and occasionally even the location of hidden treasure.

In the tale "Teeval, Princess of the Ocean," recounted by Sophia Morrison in her 1911 collection of Manx folklore, *Manx Fairy Tales*, a handsome yet poor young man named Conchubar decides he wants to be a king. He consults a local druid, who bids him to go to the Isle of Man and ask the smith of the gods, Culain, to fashion him a sword and shield. With these, he would win the kingdom of Ulster and become king.

Conchubar sets sail to the Isle of Man and finds Culain, who agrees to make him his sword and shield. While Conchubar waits for his weapons, he wanders down the beach and sees a mermaid asleep on the beach: "Her hair was golden, like the gorse in bloom; her skin whiter than the foam of the sea, her lips red as the coral, and her cheeks rosy like the little clouds that were flying before the face of the rising sun. The fringe of her dress of many coloured seaweeds rose and fell with the ebb and flow of the waves. Pearls gleamed on her neck and arms." Knowing he'd lose her as soon as she woke, he binds her "fast with his girdle." The mermaid wakes and cries for him to set her free, telling him that she is Teeval, the princess of the ocean, and that she will gift him something precious if he does so. Conchubar removes the girdle, and Teeval tells him to have her image and name engraved on the shield Culain is making. When in battle, she says, Conchubar could look

ABOVE: Illustration by Florence Teare for Sophia Morrison's *Manx Fairy Tales*, 1911.
OPPOSITE: Water Sprites, Gustav Klimt, 1899.

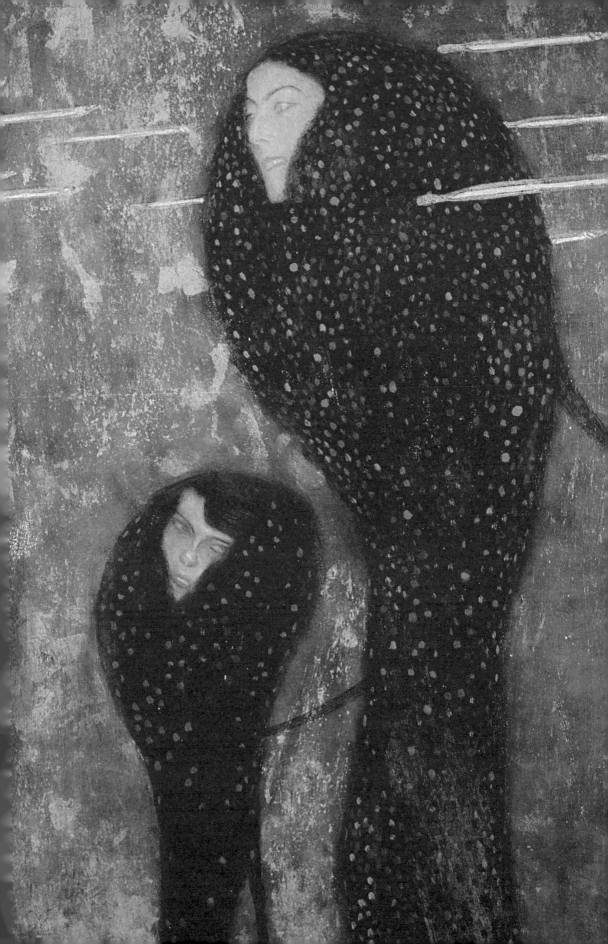

upon her face and call her name and his enemies' strength would go from them. With regret, Conchubar releases Teeval and returns to Culain's forge, where he collects his sword and shield. He is victorious in so many battles after that that he wins fame all over Ireland and becomes king of Ulster. Alas, he never sees Teeval again. But though he might have a broken heart, he fares much better—and more royally—than those who encounter mermaids in other woeful tales.

FINFOLK ❧ In his 1880 compendium *The Orcadian Sketch-Book: Being Traits of Old Orkney Life Written Partly in the Orkney Dialect,* folklorist Walter Traill Dennison elucidates the ways of the merfolk of the Orkney islands. The Finfolk (that is, the Finmen and Finwives) are dark, gloomy shape-shifters and sorcerers who enjoy abducting mortals for the purpose of marriage. Unfortunate mortals are spirited away to Hildaland, the magical island home of the Finfolk, where they become the spouse of their abductor. But you can't blame these misunderstood creatures: Finwives are doomed to become old and

repulsive unless they obtain a human husband, so their motivation is not insignificant.

The origins of the Finfolk lie in the tale of the mermaid queen. In a story included in *Scottish Antiquary* (1886), Walter Traill Dennison tells of a great queen of the land renowned for her beauty. One day, she chances upon a naked woman sitting on a rock by the sea, combing her long golden hair. As shocked by the woman's stunning beauty as she is by her nudity, the queen sends one of her handmaidens to fetch a gown to cover the creature. As she's being covered up, the creature says: "I am queen of the sea, and the Mermaid's my neem, / Nae shaw my fair body I denno tink sheem, / Nae claiths file me skin, nae dress will I wear, / Bit the braw taets o' me bonnie, bonnie hair."

The queen is wildly jealous of the mermaid's beauty and spreads the word far and wide that it's a "sin and a shame" to allow a woman's form to be seen naked on the seashores. The mermaid's beauty comes from sorcery, the queen claims, and her sweet singing voice—so sweet that no man who hears it can ever care for a human woman again—is the result of enchantment. The women

of the land, fearing that this impossibly magical creature will steal their men, take up the cry and give it no rest until it is deemed that, in order to lessen her appeal, the mermaid must have a tail. So, by magical means, all mermaids are given tails (though one might argue that this did little to lessen their hard-to-get allure). The men of the land, furious to be robbed of the opportunity of possessing such great beauty, insist that a caveat be added: if a man falls in love with a mermaid, she will be able to rid herself of the tail. And so the legend of the Finfolk was born.

KELPIES ❧

In Scotland, kelpies are shape-shifting water spirits who haunt rivers. They exist in horse form when they're in the water, but they can willfully shape-shift into winsome young men on land. Luckily, you can recognize kelpies by their reversed hooves or, when they're in human form, the water weeds in their hair. A kelpie may be captured to harness its physical strength, but beware: once the kelpie is released, it will almost certainly bestow a curse on its captor.

In a woeful tale recounted by George Douglas in *Scottish Fairy and Folk Tales* (1901), a laird from the family of the Grahams of Morphie captures a kelpie and forces the creature to build a castle for him. When the task is done, the kelpie, just before disappearing back into the water, issues a curse that "Morphie'll never thrive / as lang's as kelpy is alive!" The Graham family sinks into misfortune, and eventually the clan is no more.

Kelpies are also known for creating a sense of terror by their mere presence. In *Notes on the Folk-Lore of the North-East of Scotland* (1881), Walter Gregor tells this tale: "A hardy Highlander was returning home on one occasion from a sacrament. He was on horseback. He had charge of a number of horses that were at pasture on the side of a lonely loch. The loch lay in his way home, and he would pass it, and see whether it was all well with the animals. He came upon them all in a huddle, and, to his astonishment, he saw in the midst of them what he thought was a grey horse that did not belong to the herd. He looked, and, in the twinkling of an eye, he saw an old man with long grey hair and a long grey beard. The horse he was riding on immediately started off, and for miles, over rocks and rough road, galloped at full speed till home was reached."

MORGENS ❧

Morgens (also referred to as morgans, Mari Morgans, or merry-maids) are mermaids whose name means "born of the sea." They live in sumptuous underwater crystal and gold castles with elaborate, lush sea gardens. When they surface, they sit on rocks near the shore, combing their long, luscious locks in a seductive manner with the hope of luring a human forth. Should a human enter the water, the morgens may—or may not, depending on their mood—pull him down to their castle and to his death. If a morgen is angry (or just in a bad mood), she has the power to send a great flood to destroy an entire village and destroy crops.

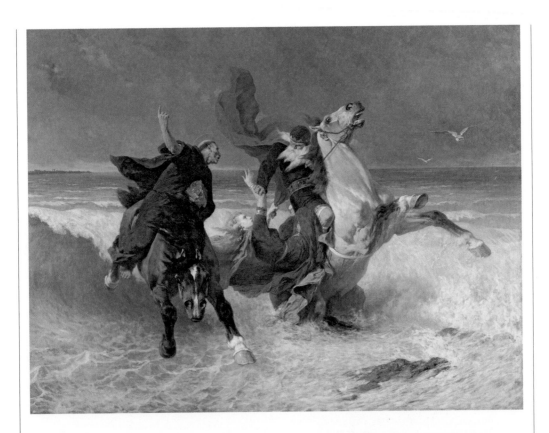

In *The Fairy-Faith in Celtic Countries* (1911), W. Y. Evans-Wentz recounts their dramatic origin story:

Following the old people and the Breton legends, the *Morgan* (*Mari Morgan* in Breton) was Dahut, the daughter of King Gradlon, who was ruler of the city of Is. Legend records that when Dahut had entered at night the bedchamber of her father and had cut from around his neck the cord which held the key of the sea-dike flood-gates, and had given this key to the Black Prince, under whose evil love she had fallen, and who, according to belief, was no other than the Devil, St. Guenolé soon afterwards began to cry aloud, 'Great King, arise! The flood-gates are open, and the sea is no longer restrained!' Suddenly the old King Gradlon arose, and, leaping on his horse, was fleeing from the city with St. Guenolé, when he encountered his own daughter amid the waves. She piteously begged aid of her father, and he took her up behind him on the horse; but St. Guenolé, seeing that the waters were gaining on them, said to the king, 'Throw into the sea the demon you have behind you, and we shall be saved!' Thereupon Gradlon flung his daughter into the abyss, and he and St. Guenolé were saved. Since that time, the fishermen declare that they have seen, in times of rough sea and clear moonlight, Dahut, daughter of King Gradlon, sitting on the rocks combing her fair hair and singing, in the place where her father flung her. And to-day there is recognized under the Breton name *Marie Morgan*, the daughter who sings amid the sea.

Above: *The Flight of Gradlon Mawr*, Evariste Vital Luminais, c. 1884.

NINGYO ❧ The ningyo of Japanese folklore are perhaps the least comely of all mermaid peoples. A ningyo, translated as "human fish" or "mermaid," is a creature with a monkey's mouth with small, sharp teeth, shining gold scales, and a lovely voice like a songbird. A ningyo can prophesy the future and cries tears of pearls. The lore is that those who consume the flesh of a ningyo attain unnaturally long life, but catching one can bring about great storms, so most fishermen would throw them back into the sea. Japanese lore also says that if a ningyo washes up on shore, it is an omen of war to come.

One of the earliest written stories of ningyo in Japan is in *Otogizoshi*, a fifteenth-century illustrated book of tales. The protagonist, a raccoon, meets a nun who tells him the story of a fisherman who catches a ningyo and brings it home to feast on with friends. One friend notices that the fish has a human face and alerts the others, and they all refuse to eat. Unfortunately, the fisherman's fifteen-year-old daughter wanders in and, without noticing the fish's face, helps herself. As a result, she does, indeed, attain an unnaturally long life, living until age eight hundred. She also stops growing and, to her father's dismay, becomes a nun. The fisherman, having learned a hard lesson, petitions the prince to build a shrine for the ningyo. There, the ningyo's preserved remains rest for all to see and to inspire reflection upon the sanctity of life.

RUSALKI ❧ Rusalki are gorgeous water spirits that are sometimes helpful, but more often vengeful, toward humans. In Russia and Ukraine, when a young woman dies a violent death near a lake or river, it is believed that she might return to haunt the body of water as a rusalka. If the young

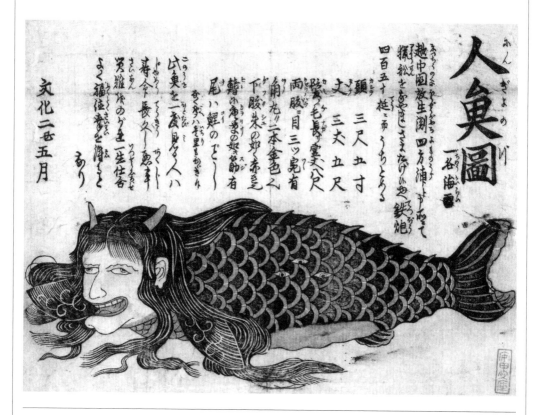

ABOVE: A painting of a "mermaid" reportedly captured in Toyama Bay, Japan, in 1805. The accompanying text records that the creature was 10.6 meters (just under 35 feet) long.

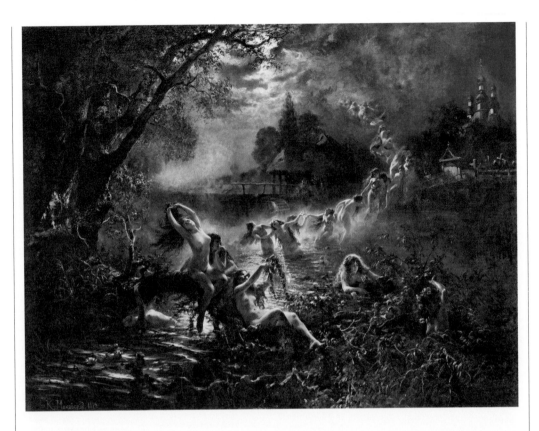

woman's death is avenged, she will return to a peaceful slumber in the body of water; if not, she may become malevolent, luring young men with her great beauty and soft voice, then tangling them in her long hair and drowning them.

Rusalki change appearances with the seasons. In the spring and summer they appear as ivory-skinned nymphs with luxurious green or red hair and are dressed in garlands of flowers and leaves. In the autumn and winter, they resemble corpses, with pallid skin, red-rimmed eyes, and puffy features. During those bitter months, they wear only pond weeds.

In these countries, the first week in June is believed to be especially dangerous. As the winter months wane and the weather warms, the rusalki leave their watery abodes to swing on branches of birch or willow trees in the dark of the night. Young men are especially vulnerable to their alluring voices calling to them; when the young men arrive, the rusalki tangle them in their hair and drown them to satiate their need for vengeance. Women hang offerings of incense or wormwood on tree branches near rivers and lakes to appease the rusalki, and swimming is strictly forbidden lest a vengeful rusalka drown her unwitting victim.

One of the most famous rusalka stories is the Antonín Dvořák opera *Rusalka*, a version of the Undine story (see page 103). In it, a water nymph named Rusalka falls in love with a human prince and longs to become human to be with him. Her father, a water sprite, is horrified and tells her that to accomplish that, she will have to seek help from the witch Jezibaba. Jezibaba agrees to provide a magic potion that Rusalka may drink and become human. However, she warns the nymph that not only will she lose her power

ABOVE: Rusalki, **Konstantin Makovsky, 1879.**

of speech but that also, if the man she loves does not return her love, she will be damned forever and the man she loves will die. Rusalka proceeds; the prince sees her and is enchanted by her beauty; they fall in love. From the lake come the cries of the other water sprites and rusalki, mourning their loss. Unfortunately, the prince is fickle, as princes sometimes are, and his love doesn't last. He rejects Rusalka, then later repents. Rusalka explains that her kiss will now kill him, but he asks her to kiss him anyway. She does, and he dies in an appropriately romantic yet ghastly fashion.

SIYOKOY AND SIRENA 🐟 The siyokoy

are Filipino mermen who have the gnarled and twisted upper body of a badly deformed human male and the lower scaled body of a fish. They're nasty creatures who capture fishermen, drown them, and eat them. Their female counterparts, the sirena, however, are much more pleasant in their deadliness. With long wavy hair, the upper body of a human female, and the lower body of a fish, they are protectors of the sea and lure fishermen and sailors to their death with their great beauty and lilting singing.

ABOVE: This *Pilipino Komiks* cover (1953) features the sirena Dyesebel.

In 1952–1953, *Pilipino Komiks* first featured the tale of the sirena Dyesebel, created by Mars Ravelo, in five of its issues; a film version, *Dyesebel*, released in 1953, too. The story is this: Dyesebel is born to two human parents. Her mother, while pregnant, spent hours staring at pictures of mermaids, causing Dyesebel to be born with a fish's tail instead of two legs. Appalled by his daughter's deformity, Dyesebel's father takes her out in a terrible storm with the intention of abandoning her, but his efforts are thwarted by the bad weather. Dyesebel and her father return to their home by the ocean, where she spends her days looking longingly out to sea, wondering where she herself fits into the human world with her fish's tail.

One day, as Dyesebel gazes out to the ocean, she espies a mermaid. Ultimately, the two become great friends, and the mermaid convinces Diangga, the sea witch, to give Dyesebel the ability to breathe underwater so that she can be with her new friends.

Later, Dyesebel sees a human man on the shore and immediately falls madly in love with him, then woos him with words of love that she sings to him. They have a torrid affair until a former lover of the man discovers his involvement with Dyesebel. The woman captures Dyesebel and sells her to a circus freak show. Some months later, the man rescues Dyesebel and takes her back to the sea.

Her friends are thrilled to see her, and she tells them of her great love for the human man. In turn, they go to Diangga, who agrees to turn Dyesebel's fish tail into human legs so that she can live out her days with the man she loves. Dyesebel returns to land, and she and the man live happily ever after.

SUVANNAMACCHA ❧ The tale of the mermaid Suvannamaccha (Sanskrit for "golden fish") is primarily a Thai story but one that is told in other areas of Southeast Asia. Suvannamaccha's image is seen throughout Thailand as a symbol of good luck.

In the sixth-century *Ramayana*, an epic Hindu chronology of more than twenty-four thousand verses, Suvannamaccha, with her long black hair and elaborate headdress of gold and jewels, is depicted as the loveliest of mermaids. She enters the story when a demon kidnaps a woman named Sita and holds her captive on the island of Lanka. Sita's husband, Lord Rama (an avatar of the god Vishnu), orders a man named Hanuman to build a causeway from their homeland, Thailand, to Lanka for Rama's army to cross over and rescue his wife. Hanuman is told he has only seven days to build the causeway or he will forfeit his life, so he and his workers begin. They throw enormous boulders into the sea to build the foundation for the causeway, but every boulder disappears by the next day.

When Hanuman steps into the waters to investigate, he finds a bevy of mermaids taking the rocks and moving them. He spots one mermaid supervising the rest in their endeavors and immediately falls in love with her; together, they travel to the bottom of the sea. When he asks her why the mermaids are stealing the rocks, she identifies herself as Suvannamaccha, a daughter of the demon who abducted Sita. Hanuman tells Suvannamaccha of his orders to build the causeway for Sita's rescue. Because the mermaid loves Hanuman so much, she promises not to prevent him from building the causeway any longer and to return the stolen rocks.

Hanuman stays under the sea with his mermaid love, but eventually returns to the surface to complete his work. When he does, Lord Rama grants him more time to complete the causeway, and together they wage a battle against the demon in Lanka. The battle rages for ten days and nights; in the end, Lord Rama and Hanuman are victorious and Sita is rescued. Though Rama and Sita go on to be happy for many, many years, poor Hanuman is needed by Rama's side and never sees Suvannamaccha again.

OPPOSITE: **Hanuman and Suvannamaccha in a mural painting from Wat Phra Kaew, Bangkok.**

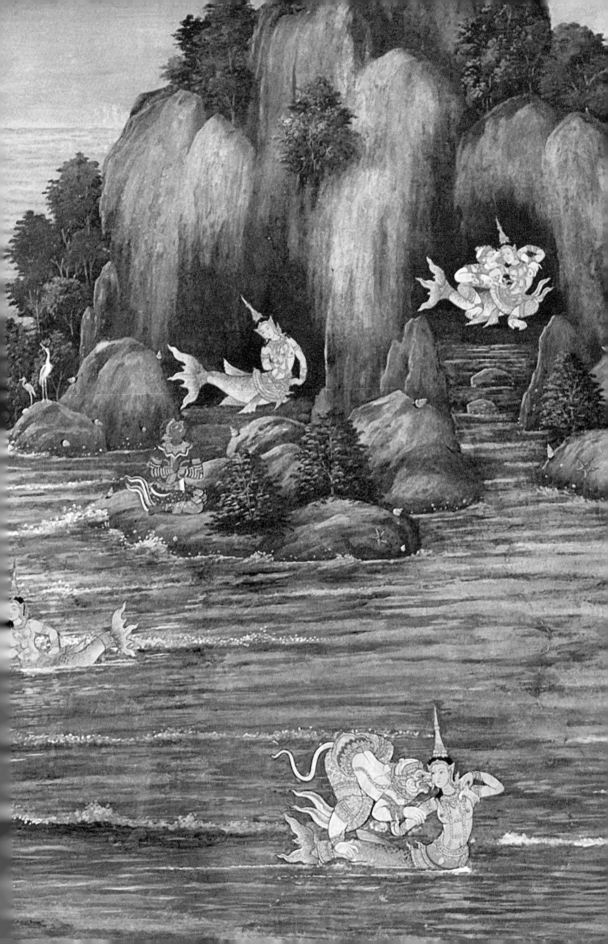

Make Your Own Sailors' Valentine

— SUSAN BLACK

THE STORY BEHIND SAILORS' VALENTINES IS A SWOONY one. In the nineteenth century, it was commonly said that lovelorn sailors far from home would craft exquisite shell mosaics in octagonal wooden boxes topped with glass for their sweethearts back home, using the shells they collected in distant lands (mostly the West Indies). Often featuring hearts and sweet messages, these works of art became known as "sailors' valentines." Today, they are rare collectibles and can sell for thousands of dollars.

Historians now believe that sailors purchased the boxes as souvenirs from native craftsmen in ports of call, mainly in the town of Bridgetown, Barbados, rather than making them themselves. It is, after all, difficult to do detailed work on a rocking ship, not to mention having glue dry in a wet, humid environment. Luckily, it's the thought that counts. The art has had a resurgence in the last several years, as more and more artists rediscover this traditional form.

You can make your own sailors' valentine with this project adapted from a kit by Susan Black of Nantucket Sailors' Valentines, who's been making these kits for more than a decade. You can enclose the shells in the shadow box so that they're displayed under glass, if you wish, then hang the valentine or display it on a shelf, mantel, or coffee table—or give it as a token of love.

You can purchase the shadow box and shells listed here at numerous shell shops and suppliers online, or visit www.nantucketsailorsvalentines.com for the full kit or the shadow box itself.

Makes one 9-by-9-inch valentine

MATERIALS

- 44 black umbonium seashells
- 125 small or 75 large pearly umbonium seashells
- 9 heart cockle seashells
- 35 purple clam seashells
- 132 reticulated nassa seashells
- 93 rose cup seashells
- ⅛ teaspoon poppy seeds
- One 6-millimeter pink cultured pearl

- Octagonal front-loading shadow box, 8 inches in diameter inside, 9 inches outside
- Purple (or background color of choice) card stock
- Tacky glue
- Glue dots for extra support when gluing down pattern
- Toothpick
- White paper

PEARLY UMBONIUM
CULTURED PEARL
STEP #9

ROSE CUPS
STEP #7

BLACK UMBONIUMS STEP #1

PEARLY UMBONIUMS STEP #2

PEARLY SNAILS STEP #5

RETICULATED NASSAS
STEP #6

Nantucket Sailor's Valentine Kit© 2005

*Template: Enlarge
200 percent per
the instructions on
page 98, step 1.*

PURPLE CLAMS
STEP #4 HEART COCKLES STEP #3

*The finished
valentine.*

1

4

2

3

DIRECTIONS

Scan the pattern, on page 97, then enlarge it 200 percent so that it measures 8 inches across the interior diameter.

Print the pattern onto the card stock, then glue it to the bottom of the front-loading box, using glue dots for extra support.

1. Glue black umboniums to the provided pattern. Lay all the shells in the same direction, cupped into each other, as shown in the detail photo.

2. Glue pearly umboniums to the pattern. Lay all the shells in the same direction, cupped into each other as shown in the detail photo. Set aside the extra umboniums for steps 5 and 9.

3. Glue heart cockles to the pattern. Lay the outer cockles up to the sides of the box with the flatter side facedown. Lay the center cockle just up to the black umbonium in the center, also with the flatter side facing down.

4. Glue purple clams to the pattern. The clams will be leaning against the sides of the box. Arrange the clams on their sides, slightly overlapping each other, tucked next to each heart cockle, as shown in the detail photo.

5. Glue pearly umboniums to the pattern. Lay all the shells cupped into each other in the same direction, as shown in the detail photo.

5

6

6. Glue reticulated nassas to the pattern. Tilt
 the shells upward. Each row will be leaning
 against the row in front of it, as shown in the
 detail photo.

7. Glue rose cups to the pattern. Start by
 building the outside row, then lay each
 row, working toward the center of the heart.
 Tuck the last row under the edges of the
 heart cockle, as shown in the detail photo.
 The rose cups may fall back. Continue to
 push them up until the glue is set.

7

8. To create the rose cup flowers, put a dot of
 glue for each flower on white paper. Arrange
 six rose cups as shown in the first detail
 photo; make eight flowers and use glue
 dots as needed to provide more stability
 during gluing. If rose cups fall slightly, tilt
 each shell up until the glue sets. Dab glue
 at the center of each flower; sprinkle poppy
 seeds onto the dab. Remove any seeds that
 land outside the center. Once the glue is
 dry, cut each flower around the glued area
 at the base, making sure no paper is showing
 beyond the petals.

8

9. Glue the flowers to the center of each pearly
 umbonium row, adding glue to each flower's
 paper base to attach. Glue a pearly umbo-
 nium on top of the black umbonium, just
 above the center heart cockle, and glue the
 cultured pearl, holes hidden, to the heart
 cockle as shown.

9

MÉLUSINE, UNDINE, *and*
THE LITTLE MERMAID

THE MERMAID'S STARRY AND ETHEREAL BEAUTY, glamour, and unattainability have long captured our imaginations, with stories about her an inherent part of oral traditions worldwide. Throughout time, she's appeared in literary blockbusters including *The Odyssey*, *The Divine Comedy*, *A Midsummer Night's Dream*, *The Arabian Nights*, and *The Faerie Queene*. In the three classic works here, each of which has influenced legions of writers and been told and retold numerous times, the mermaid takes center stage—and proves, once and for all, that literary mermaids should steer well away from human men, no matter how handsome or royal, as no good can come of it.

MÉLUSINE ❦ The story of the mermaid Mélusine existed in the French oral folk tradition throughout the Middle Ages. But it was Frenchman Jean d'Arras who collected its variants and put the story onto paper in 1393. His tale *Chronique de Mélusine*, also known as *Mélusine; or, The Noble History of Lusignan*, is now considered a definitive fourteenth-century romance: d'Arras wrote *Mélusine* for Jean de Berry, the brother of King Charles V of France, in part to show the magnificent lineage of the waning Lusignan dynasty.

The story goes that Elinas, the king of Albany (Scotland), is out hunting one day when he comes upon a spring in the wood. As he approaches, he sees a stunning woman who tells him her name is Pressina. They ultimately marry, although Pressina imposes one condition upon her betrothed: that he should never visit when she is either birthing or bathing their children. Not long after, Pressina gives birth to triplets, three daughters whom she names Melior, Palatina, and Mélusine. Elinas is overjoyed and, without thinking, bursts into the chamber where Pressina is bathing them. Pressina cries out that he has broken his word and curses him, claiming that her descendants will avenge her. Then she disappears with her three daughters to Avalon.

On the girls' fifteenth birthday, their mother tells them why they have been brought up there. Mélusine wants revenge, and she and her sisters travel to Albany, where they capture King Elinas, locking him away with his riches in the Brandelois Mountains. When Pressina learns what her daughters have done, she flies into a rage and punishes them for their lack of respect to their father. In some versions of the tale, the curse she inflicts on Mélusine is that she will become

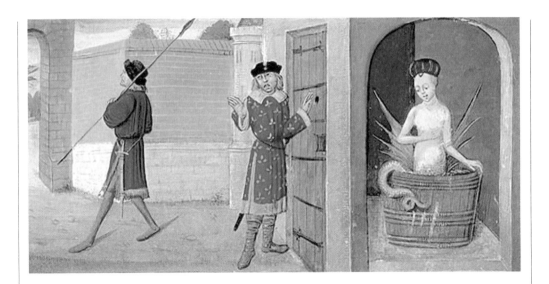

a serpent from the waist down every Saturday; in others, she becomes a mermaid.

Shortly thereafter, Mélusine leaves Avalon and begins roaming through the world, eventually arriving in the forest of Colombiers in Poitou, France. The fey folk tell her that they have been waiting for her to arrive and rule that land. Count Raymond is in the forest, too, and comes upon Mélusine standing by a fountain known as the Fountain of Thirst. The two fall in love and decide to marry, under one condition: Mélusine insists that he leave her be on Saturdays and never try to find out where she is or what she is doing.

Using the wealth she took from her father, she builds a castle next to the Fountain of Thirst. Mélusine and Raymond have ten children, all boys, all of whom became renowned for their exploits during the Crusades.

One day, Raymond can no longer contain his curiosity about his wife's Saturday activities and follows her to the cave she goes to every week. He enters while she is bathing and sees that from the waist down, she is a serpent with scales of gray and blue.

When Mélusine sees him, she cries and stretches out her arms, which transform into wings, and she begins to disappear into the air, saying, "Thou, and those who for more than a hundred years shall succeed thee, shall know that whenever I am seen to hover over the fair castle of Lusignan, then will it be certain that in that very year the castle will get a new lord; and though people may not perceive me in the air, yet they will see me by the Fountain of Thirst; and thus shall it be so long as the castle stand in honor and flourishing—especially on the Friday before the lord of the castle shall die."

Before and during the writing of *Mélusine*, Jean de Berry had reason to assert his claim to Lusignan; the text itself even confirms that, after passing from hand to hand, the fortress founded by Mélusine had only recently "by right and by the sword" come into Berry's possession. In their introduction to *Mélusine; or, The Noble History of Lusignan* (2012), Donald Maddox and Sara Sturm-Maddox explain how this reflected "a long-standing trend in medieval Europe, where a strong interest in genealogy among feudal families in the twelfth and thirteenth centuries led to a proliferation of semihistorical genealogies alloyed with fictive forebears"; lineages were often traced back to an illustrious (and in this case

ABOVE: Mélusine's secret discovered, from *Le Roman de Mélusine* by Jean d'Arras, c. 1450–1500.

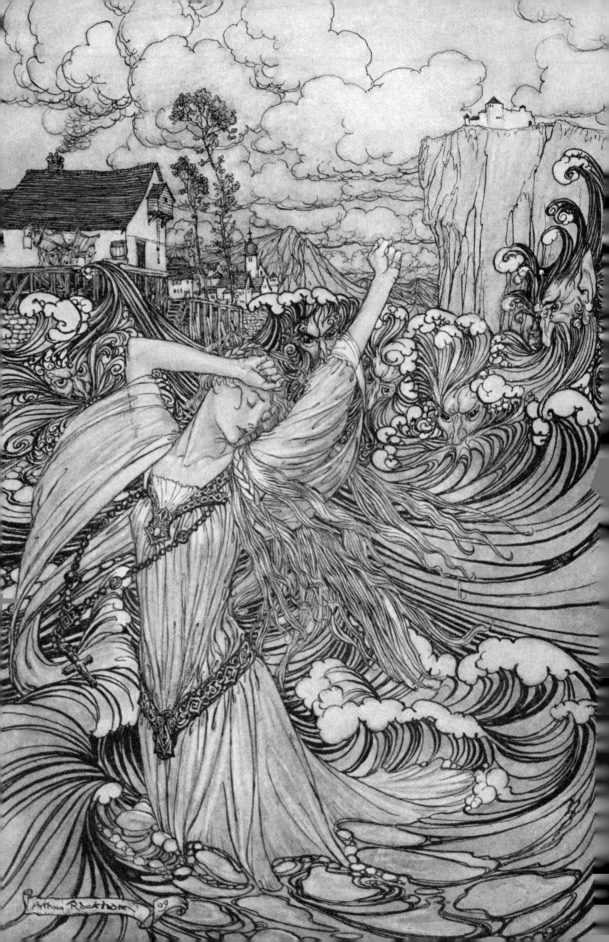

glamorously supernatural) ancestor. And according to popular belief in the region, any legitimate claimant to Lusignan had to be a descendant of Mélusine. The work proved so popular and convincing that, according to Thomas Keightley in *The Fairy Mythology* (1828), "several noble houses were ambitious of showing a descent from [Mélusine]."

Jean d'Arras finished *Mélusine* in 1393, and after the invention of the printing press, which allowed widespread printing of the book (and countless others, of course), its popularity soared throughout Europe. By the end of the sixteenth century there were twenty-two different editions in print throughout the continent.

Undine ❧ Fourteenth-century German alchemist and astrologer Paracelsus not only invented laudanum, an opiate commonly used in the Renaissance as a cough suppressant and pain killer, but also claimed to have first identified an undine. A mischievous magical water spirit with the upper body of a human and the lower body of a serpent, an undine had no soul but could gain one from marriage to a mortal man. In *The Secret Teachings of All Ages* (1928), Manly P. Hall specified: "There are many groups of undines. Some inhabit waterfalls, where they can be seen in the spray; others are indigenous to swiftly moving rivers; some have their habitat in dripping, oozing fens or marshes; while other groups dwell in clear mountain lakes. According to the philosophers of antiquity, every fountain had its nymph; every ocean wave its oceanid. The water spirits were known under such names as oreades, nereides, limoniades, naiades, water sprites, sea maids, mermaids, and potamides."

By the nineteenth century, Undine was also the name of a specific water nymph in the popular novella *Undine* (1811) by German folklore writer Friedrich de la Motte Fouqué. The tale

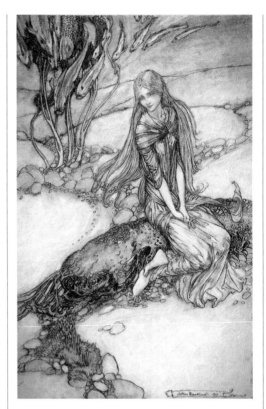

was influenced by the story of Mélusine and also involved a hybrid yet irresistible female marrying a human man.

The story is this: The daughter of a poor fisherman and his wife, "attracted by something very beautiful in the water," falls into a lake and is thought to have drowned. That same evening a lovely young girl appears at the couple's door; as the fisherman later relays, "a beautiful little girl three or four years old, richly dressed, stood on the threshold smiling at us. We were quite dumb with astonishment, and I knew not at first whether it were a vision or a reality. But I saw the water dripping from her golden hair and rich garments, and I perceived that the pretty child had been lying in the water, and needed help." The husband and wife bring the wild girl, named Undine, into their house and raise her as their own.

Opposite: Soon she was lost to sight in the Danube, from the 1909 edition of Friedrich de la Motte Fouqué's *Undine*, illustrated by Arthur Rackham. ✦ *Above: He could see Undine beneath the crystal vault*, also by Rackham for the 1909 edition.

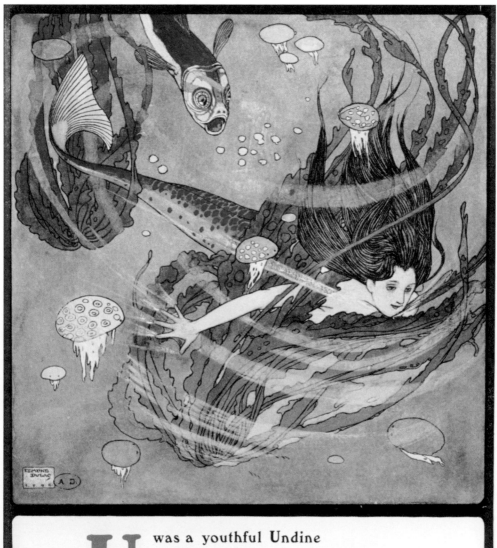

U was a youthful Undine
In the kingdom of ultramarine.
Often week after week
She would play hide and seek,
In the weeds with an ugly sardine.

Some years later, a handsome knight, Sir Huldbrand of Ringstetten, seeks refuge in the poor family's cottage during a quest to prove his love for the maiden Bertalda, the foster daughter of the duke and duchess. But after meeting Undine, he is smitten with her. The two fall in love and marry. Only after does she confess that she is a water spirit—and that through the marriage she's gained a soul. She explains, "My father, a powerful water-prince in the Mediterranean Sea, desired that his only daughter should become possessed of a soul,

even though she must then endure many of the sufferings of those thus endowed. Such as we are, however, can only obtain a soul by the closest union of affection with one of your human race. I am now possessed of a soul, and my soul thanks you, my inexpressibly beloved one . . ." Huldbrand, more enamored than ever, vows to never forsake her.

Huldbrand takes his new wife back to his castle—and civilization. During the journey, Undine's shape-shifting uncle Kühleborn appears to the couple as an old man and harasses them: "His countenance assumed a frightful expression, and he grinned fiercely at Undine, who screamed aloud and called upon her husband for assistance. As quick as lightning, the knight sprang to the other side of the horse, and aimed his sharp sword at Kühleborn's head. But the sword cut through a waterfall, which was rushing down near them from a lofty crag; and with a splash, which almost sounded like a burst of laughter, it poured over them and wet them through to the skin." Huldbrand and Undine then return to the kingdom, where Bertalda is grief-stricken that her beloved now has a beautiful bride, but "reconciled herself to circumstances, and lived on the most friendly terms with Undine, who was looked upon throughout the city as a princess whom Huldbrand had rescued in the forest from some evil enchantment."

In fact, Bertalda and Undine feel an uncommon attachment to each other. When Undine, Huldebrand, and Bertalda are out walking, Kühleborn appears again to Undine. He pulls her aside and reveals to her that Bertalda is, in truth, the birth daughter of the poor old fisherman and his wife who raised Undine herself.

Meanwhile, Kühleborn and his kin are eager to get Undine back. Undine tries to resist their efforts and makes her husband promise to never lay a curse on her when they're on the water, for if he does, she may be lost to him forever. When Huldbrand, Undine, and Bertalda take a trip down the Danube River, Huldbrand is alarmed by a storm and curses Undine. Fouqué writes: "Undine vanished over the side of the vessel. Whether she plunged into the stream, or flowed away with it, they knew not; her disappearance was like both and neither. Soon, however, she was completely lost sight of in the Danube; only a few little waves kept whispering, as if sobbing, round the boat, and they almost seemed to be saying: 'Oh woe, woe! oh remain true! oh woe!'" Under the water, Kühleborn reminds her that she is "subject to the laws of our element, and if [Huldbrand] marries again and is unfaithful to you, you are in duty bound to take away his life."

A few months after the tragic disappearance of Undine, Huldbrand and Bertalda fall in love and marry. On the night of the nuptials, a female specter with a ghostly veil rises from one of the castle fountains, passes Bertalda, who is frozen with terror upon the sight of Undine's ghost, and enters the marriage chamber. Sir Huldbrand greets the specter and accepts the kiss she offers him and then dies. At the knight's funeral, the specter is in attendance again and will not leave, despite Bertalda's pleas. Only after the funeral party kneels to pray and rises does the specter vanish, leaving behind a silvery spring encircling the grave mound of the knight. To this day, the villagers say the spring is Undine, holding her knight in her arms.

The story of Undine has inspired numerous other artists, including E. T. A. Hoffmann and Tchaikovsky, who composed operas; Debussy, a prelude for piano; Hans Werner Henze, music for the ballet choreographed by Sir Frederick Ashton; and Hans Christian Andersen, the story "The Little Mermaid."

Opposite: *Undine,* an illustration by Edmund Dulac for the letter "U" from his alphabet book *Lyrics Pathetic & Humorous from A to Z,* 1909.

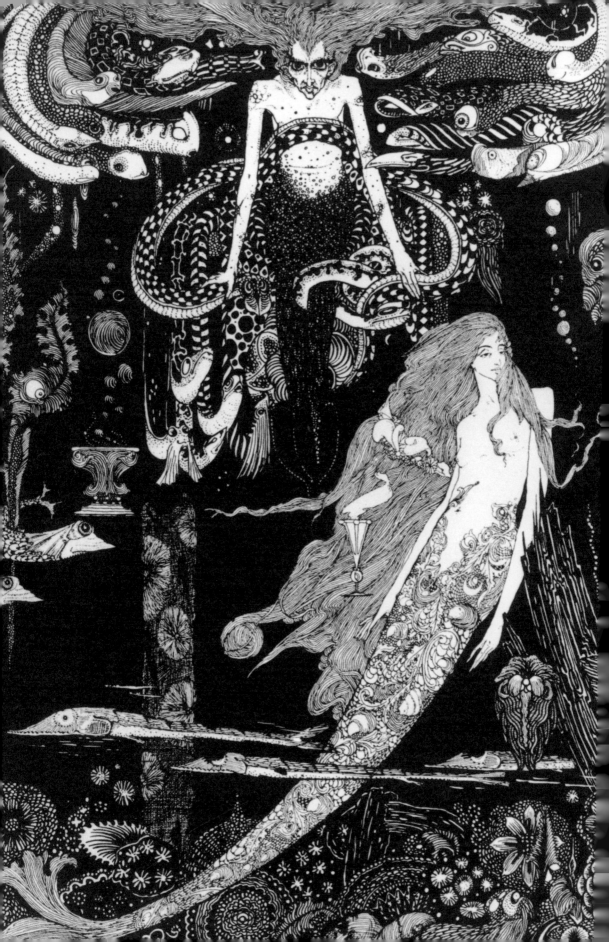

THE LITTLE MERMAID ❧

Flame-haired, silky-voiced Ariel, star of Walt Disney's animated feature *The Little Mermaid*, is the most famous of all modern mermaids. When the Disney film came out in 1989, millions of girls fell in love with the mischievous, strong-willed nymph and swooned over her love story with the dashing human prince. But the original "Little Mermaid" on which the film was based was written in a fit of heartbreak by nineteenth-century wordsmith Hans Christian Andersen—and was a much more woeful tale.

Andersen wrote "The Little Mermaid" in 1836, when his friend Edvard Collin was getting married. Hans had an unrequited love for his well-heeled friend, as he did quite often for people, both female (more publicly) and male (more privately). Collin wouldn't even agree to address his friend by the familiar "*du*" in Danish, causing Andersen endless suffering and leading him to imagine, in a draft of a letter never sent, that their friendship would reach this perfect "*du*" state after death. Andersen, it seems, most likely never had an adult relationship, or sex of any kind, but was rife with overwhelming passions and unreturned romantic affections. He was often in a state of heartbreak, and it was in such a state that he retreated to his hometown of Odense, Denmark, as Collins was getting married to a woman. There he wrote the sad story of a mermaid who longs for a human soul and who tries and fails to find love with a human prince.

In the tale and on her first visit to the surface of the ocean, the young mermaid saves a prince from drowning and falls deeply in love with him. She visits the sea witch for assistance, and the witch gives her a potion that will turn her tail to legs. In exchange, the witch takes the mermaid's voice by cutting out her tongue, warning the mermaid that every step she takes with her human

legs will cause "great pain, as if a sword were passing through you. But all who see you will say that you are the prettiest little human being they ever saw. You will still have the same floating gracefulness of movement, and no dancer will ever tread so lightly; but at every step you take it will feel as if you were treading upon sharp knives." There is another problem: if the mermaid does not marry, the witch warns, she will turn to sea foam and die. The mermaid agrees to this terrible deal, then travels to the prince's castle.

Though the prince feels great affection for the mute and lovely girl, he does not fall in love with her. She suffers for the lack of reciprocation, but is happy to be with him all the same. Then one day it's announced that he will marry a princess; he travels to the princess's kingdom with the mermaid by his side, revealing to her that he can only love the woman who saved him. When he sees the princess in person, he believes she is the one who saved him from drowning and folds his blushing bride-to-be in his arms. "'Oh, I am too happy,' says he to the little mermaid; 'my fondest hopes are all

Opposite: "I know what you want" said the sea witch, illustration by Harry Clarke for "The Little Mermaid" from *Fairy Tales by Hans Christian Andersen*, 1916. ✦ *Above: At the mere sight of the bright liquid they drew back in terror*, illustration by Edmund Dulac for *Stories from Hans Andersen*, 1911.

warm blood falls upon your feet they will grow together again, and form into a fish's tail, and you will be once more a mermaid, and return to us to live out your three hundred years before you die and change into the salt sea foam. Haste, then; he or you must die before sunrise. Our old grandmother moans so for you, that her white hair is falling off from sorrow, as ours fell under the witch's scissors. Kill the prince and come back; hasten: do you not see the first red streaks in the sky? In a few minutes the sun will rise, and you must die.' And then they sighed deeply and mournfully, and sank down beneath the waves."

The little mermaid takes the knife and goes to the sleeping prince and his bride, but cannot muster the strength to kill him. She then flings herself overboard and waits for death. Instead, she feels a strange lightness, and all around her "floated hundreds of transparent beautiful beings." The little mermaid "perceived that she had a body like theirs, and that she continued to rise higher and higher out of the foam." She learns that she has become a daughter of the air, who, as one of the beings explains to her, "do not possess an immortal soul, [and] can, by their good deeds, procure one for themselves. We fly to warm countries, and cool the sultry air that destroys mankind with the pestilence. We carry the perfume of the flowers to spread health and restoration." They continue: "You, poor little mermaid, have tried with your whole heart to do as we are doing; you have suffered and endured and raised yourself to the spirit-world by your good deeds; and now, by striving for three hundred years in the same way, you may obtain an immortal soul." Though she has failed to gain the love of the prince, the little mermaid will finally, she is told, have the chance to gain the immortal soul she's always wanted.

fulfilled. You will rejoice at my happiness; for your devotion to me is great and sincere.'"

The little mermaid's heart is broken, but she faithfully attends the wedding that very same day at the princess's kingdom. "The little mermaid, dressed in silk and gold, held up the bride's train; but her ears heard nothing of the festive music, and her eyes saw not the holy ceremony; she thought of the night of death which was coming to her, and of all she had lost in the world." That same evening, the joyful wedding party retreats to the ship to return to the prince's homeland.

Early the next morning, the little mermaid's sisters, their hair shorn, rise from the depths of the ocean and appear to her:

"'We have given our hair to the witch,' said they, 'to obtain help for you, that you may not die to-night. She has given us a knife: here it is, see it is very sharp. Before the sun rises you must plunge it into the heart of the prince; when the

Above: Where the ocean is deepest stands the sea-king's palace, illustration by Arthur Rackham from *Fairy Tales by Hans Christian Andersen,* 1932. + Opposite: The *Little Mermaid* statue is the most popular and iconic tourist attraction in Denmark.

Copenhagen's Little Mermaid

UNVEILED IN 1913, COPENHAGEN'S FAMOUS *Little Mermaid* statue was a gift to the city from brewer Carl Jacobsen. Jacobsen—fascinated by a performance of the ballet *The Little Mermaid* at Copenhagen's Royal Theatre—commissioned the piece from sculptor Edvard Eriksen. Copies of the *Little Mermaid* statue are also located in Salt Lake City, Utah; Solvang, California; Kimballton, Iowa; Piatra Neamt, Romania; and Weihai, China.

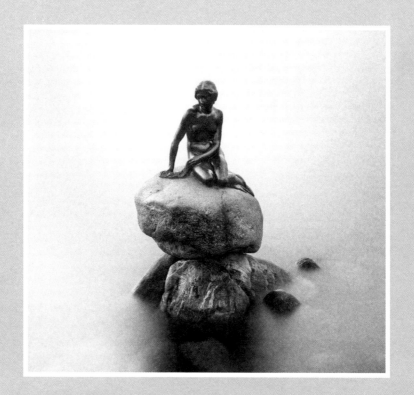

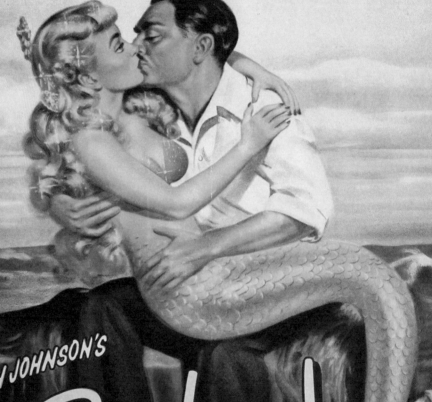

UNIVERSAL-INTERNATIONAL presents

WILLIAM POWELL ⋆ ANN BLYTH

in NUNNALLY JOHNSON'S

"Mr. Peabody and the Mermaid"

with IRENE HERVEY · ANDREA KING · CLINTON SUNDBERG

Screenplay by NUNNALLY JOHNSON · From the novel "Peabody's Mermaid" by Guy and Constance Jones

Directed by IRVING PICHEL · Associate Producer, Gene Fowler, Jr.

MERMAIDS *in the* MOVIES

S LONG AS HUMANS HAVE BEEN ABLE TO MAKE films, they've tried to capture footage of the elusive half fish, half lady and tend to present these ladies of the sea as up-to-no-good temptresses or lovelorn innocents. Here are some of the most popular attempts to bring ocean magic to the big screen.

"THE MERMAID," 1904 ❧ The mermaid (page 112) made her screen debut in this three-minute Georges Méliès film showcasing trick photography. In it, a magician goes through a series of tricks—pulling rabbits from a hat and conjuring fish to fill an aquarium—until a mermaid magically appears in his tank. The mermaid then turns into a human while the magician becomes Neptune, king of the sea.

NEPTUNE'S DAUGHTER, 1914 ❧ Starring professional swimmer (and mermaid) Annette Kellerman (see page 126) and directed by Herbert Brenon, this film is now lost. In it, Kellerman plays Annette, the mermaid daughter of Neptune. When her sister dies after being caught in an earthly king's net, Annette goes to land to avenge her—but falls in love with the king, played by William E. Shay, instead. Kellerman appeared in a number of mermaid-themed films in the 1910s and 1920s, most of them lost.

MIRANDA, 1948 ❧ This British comedy, adapted from a stage play by Peter Blackmore and directed by Ken Annakin, is about a vacationing man (Griffith Jones) who snags a mermaid (Glynis Johns) on his fishing line, this time in Cornwall.

The mermaid makes the man her prisoner—and only agrees to free him if he'll take her to London. He disguises the mermaid as a wheelchair-bound invalid and brings her home for one month to his wife, who reluctantly agrees to the arrangement but quickly becomes jealous. Glynis Johns reprised her role of Miranda in 1954's *Mad About Men.*

MR. PEABODY and the MERMAID, 1948 ❧ Based on a 1945 novel by Guy and Constance Jones and directed by Irving Pichel, this film focuses on a middle-aged man (William Powell) and the young mermaid (Ann Blyth) whom he reels in on his fishing line while vacationing in the Caribbean with his wife (Irene Hervey). He hides the mermaid in his bathtub (his wife confuses her for a big fish) and the resort's fish pond. All the while his wife suspects him of cheating with a vacationing singer (Andrea King) instead. Once all is sorted, Peabody and his wife happily head home.

MILLION DOLLAR MERMAID, 1952 ❧ This smash 1952 musical directed by Mervyn LeRoy stars Esther Williams and tells the story of performer Annette Kellerman, who'd been largely forgotten in Hollywood until Williams

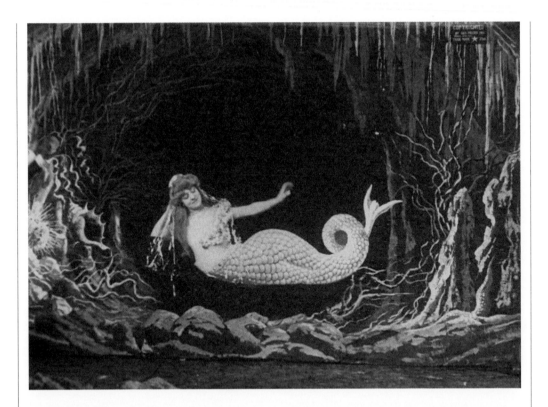

proposed making a film based on her life. Despite lackluster reviews (the *New York Times* described the film as "a luxuriance of razzle-dazzle that includes Hippodrome acts, water ballets, bathing suit shows, diving performances, low comedy, anachronisms and clichés"), the film went on to be one of MGM's top moneymakers that year.

MERMAIDS of TIBURON, 1962 ✖

This cult favorite by underwater photographer John Lamb focuses on a marine biologist (George Rowe) trying to recover a stash of pearls that are being protected by stunning mermaids, one of them being the (real-life) pinup model Diane Webber, as a pearl-seeking gangster (Timothy Carey) attempts to get his hands on the treasure, too. A second version of the film was cut to feature numerous topless scenes and was distributed under the subtle title *Aqua Sex*. When she played the mermaid in the 1965 film *Beach Blanket Bingo*, Marta Kristen wore the same tail made for Diane Webber for *Mermaids of Tiburon*.

SPLASH, 1984 ✖

A young boy is saved by a mermaid. Years later that same man again needs rescuing when he charters a boat after a drunken night. Having snagged his wallet, the mermaid, (Daryl Hannah) washes up to shore in New York City to find Allen (Tom Hanks) again. At first she's able to disguise her tail and the couple fall madly in love, but when her real identity is revealed by scientists who capture her to test her in their lab, Allen is horrified—and forced to make a decision. For more, see page 42.

THE LITTLE MERMAID, 1989 ✖

A sunny adaptation of the Hans Christian Andersen story, this megahit heralded a new age for the Walt Disney Company but took a great deal of liberty with the melancholy original tale, even ending with Ariel, in human form, happily marrying Prince Eric and sailing off into the sunset. In 2017, a live-action version of the tale was released on Netflix starring Gina Gershon, Poppy Drayton, and William Moseley.

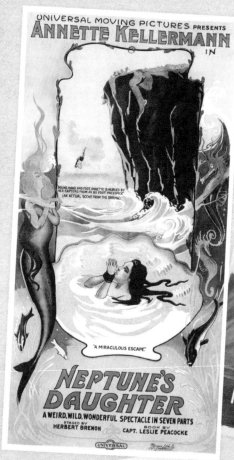

UNIVERSAL MOVING PICTURES PRESENTS
ANNETTE KELLERMANN IN

BOUND HAND AND FOOT ANNETTE IS HURLED BY
HER CAPTORS FROM AN 80 FOOT PRECIPICE
(AN ACTUAL SCENE FROM THE DRAMA)

"A MIRACULOUS ESCAPE."

NEPTUNE'S
DAUGHTER
A WEIRD, WILD, WONDERFUL SPECTACLE IN SEVEN PARTS
STAGED BY HERBERT BRENON BOOK BY CAPT. LESLIE PEACOCKE
UNIVERSAL

THAT WONDERFULLY FUNNY MOTION PICTURE...
Miranda
GLYNIS JOHNS · GOOGIE WITHERS
GRIFFITH JONES · JOHN McCALLUM
David Tomlinson · Yvonne Owen
Sonia Holm · Margaret Rutherford

A J. ARTHUR RANK Presentation
An EAGLE LION FILMS Release

Miranda HAS Everything !

THE MOST FANTASTIC UNDERSEA ADVENTURE EVER FILMED!

THE
MERMAIDS
OF TIBURON

in AQUASCOPE and EASTMAN COLOR

STARRING Diane WEBBER · George ROWE
TIMOTHY CAREY · JOSE GONZALES-GONZALES
THE MOST BEAUTIFUL MERMAIDS IN THE WORLD
Written, Produced and Directed by JOHN LAMB
A FILMGROUP PRESENTATION

M·G·M's Miracle color TECHNICOLOR Musical !
Million Dollar Mermaid

INSPIRED BY THE TRUE STORY OF BATHING BEAUTIES!

STARRING
Esther Williams
Victor Mature
Walter Pidgeon
David Brian

DONNA CORCORAN Screen Play by EVERETT FREEMAN Directed by MERVYN LeROY Produced by ARTHUR HORNBLOW, Jr. A METRO-GOLDWYN-MAYER PICTURE

Make a Shell Treasure Chest

—Tricia Saroya

ANY LARGER SHELL THAT IS IN TWO PARTS CAN BE USED to create a lovely little treasure box to hide all manner of mermaid secrets. The one used here is a spiny oyster shell. Don't worry if the two parts don't line up exactly. Undersea treasures are not always perfect, and close (and sparkly) is good enough. Remember, this is your creative project; decorate it to your heart's content!

OTHER TOOLS AND MATERIALS

- **Costume or thrift store pearls in various diameters**
- **Glitter**
- **Cotton**
- **A 2- to 3-inch piece of pretty ribbon**
- **Hot glue gun and glue sticks**
- **Vintage rhinestone jewelry** (optional)
- **Tiny shells** (optional)

1. Determine which half of the shell will be on top. The bottom piece won't be very visible, so pick the prettier half.

2. Cut a short length of ribbon and hot-glue one end to the back edge of one of the shells. This will act as your hinge. Now glue the other end of the ribbon in the same place on the other shell, leaving about ¼ inch of ribbon between the shells for ease of opening.

3. Hide the edge of the ribbon by gluing a small amount of cotton to it and adding in small pearls and baubles. Sprinkle glitter for a sparkly effect.

4. For legs, on the bottom shell, glue pearls in three or four places depending on whether you want a tripod configuration or a four-leg style. Start with three or four matching larger pearls, glue in place, and make sure the shell is balanced when you set it down. If not, gently pull off the pearls and reset. Once you get the placement correct, glue clusters of smaller pearls around them.

5. For the top part of the shell, glue more pearls or tiny shells and any touches of bling you might want to add. Sprinkle touches of glitter, or spray the entire shell with glitter once finished.

6. Add a little cluster of pearls at the front lip of the shell to give the effect of a clasp. Make sure the decorations don't interfere with the opening and closing of the shell.

7. The pattern and style are completely up to you.

VICTORIAN MERMAIDS

URING THE VICTORIAN ERA, WITH THE ADVENT of urbanization and industrialization, the world was in need of a little romance. Creative souls turned increasingly to an enchanted world, to fantasy, and to mythical characters—from fairies to mermaids—as sources of inspiration for their work. Writers like Matthew Arnold, Oscar Wilde, and Alfred, Lord Tennyson wrote about mermaids, while painters like Edward Burne-Jones, John William Waterhouse, and Arnold Böcklin populated their canvases with them. What follows is a small yet glittering sampling of excerpts.

She sinks into her spell: and when full soon
 Her lips move and she soars into her song,
 What creatures of the midmost main shall throng
In furrowed surf-clouds to the summoning rune:
 Till he, the fated mariner, hears her cry,
 And up her rock, bare-breasted, comes to die?

—DANTE GABRIEL ROSSETTI, "A Sea-Spell," *Ballads and Sonnets*, 1881

OPPOSITE: *A Sea Spell*, Dante Gabriel Rossetti, 1877.

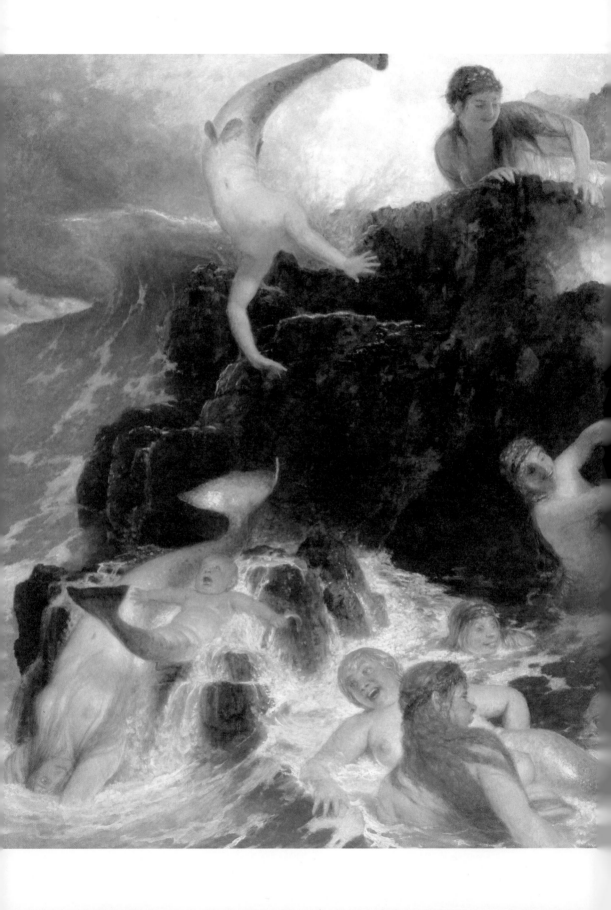

Once she sate with you and me,

On a red gold throne in the heart
of the sea,

And the youngest sate on her knee.

She comb'd its bright hair, and she
tended it well,

When down swung the sound of a
far-off bell.

She sigh'd, she look'd up through
the clear green sea;

She said: "I must go, to my kinsfolk
pray

In the little grey church on the
shore to-day.

'T will be Easter-time in the world—
ah me!

And I lose my poor soul, Merman!
here with thee."

—MATTHEW ARNOLD
"The Forsaken Merman," *The Strayed
Reveller, and Other Poems,* 1849

LEFT: *Play of the Nereides,* Arnold Böcklin, 1886.

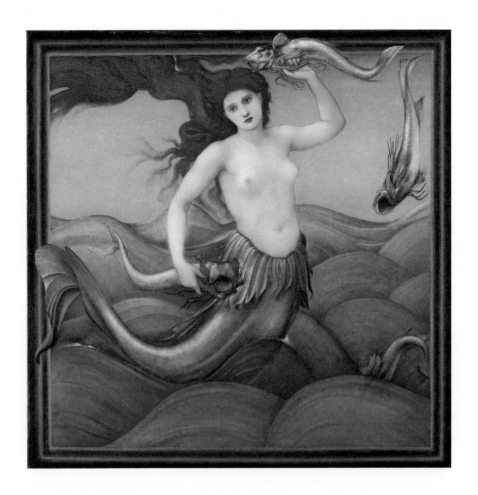

Her hair was as a wet fleece of gold, and each separate hair as a thread of line gold in a cup of glass. Her body was as white ivory, and her tail was of silver and pearl. Silver and pearl was her tail, and the green weeds of the sea coiled round it; and like sea-shells were her ears, and her lips were like sea-coral. The cold waves dashed over her cold breasts, and the salt glistened upon her eyelids.

—OSCAR WILDE, "The Fisherman and His Soul"
A House of Pomegranates, 1891

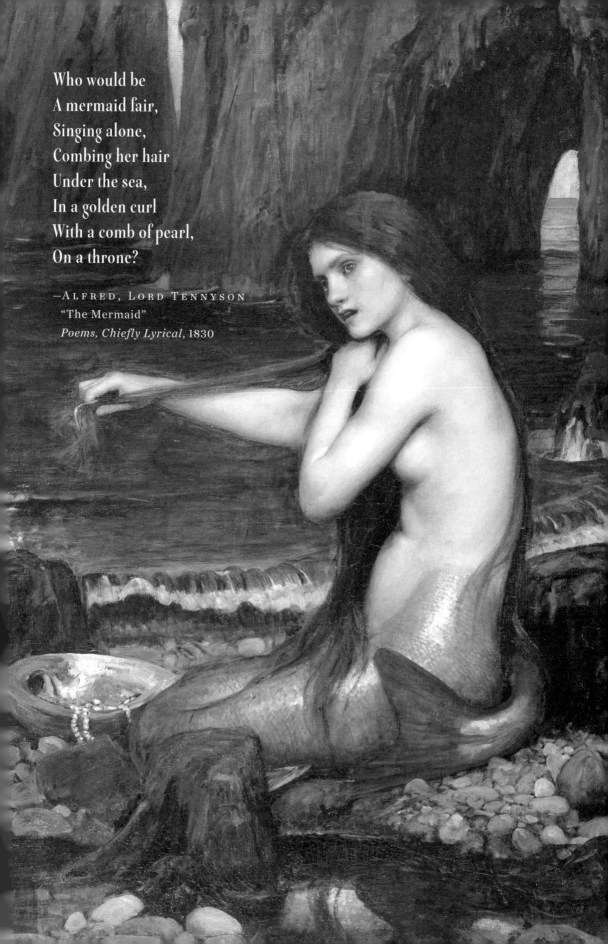

Who would be
A mermaid fair,
Singing alone,
Combing her hair
Under the sea,
In a golden curl
With a comb of pearl,
On a throne?

—ALFRED, LORD TENNYSON
"The Mermaid"
Poems, Chiefly Lyrical, 1830

HOAXES:
The FEEJEE MERMAID

— TIMOTHY SCHAFFERT

THE MODERN-DAY GOTH MERMAID IN ART AND fashion—with her dark tresses, kohl eyes, and perhaps some steampunky blowfish spines—is most often a celebration of the haunting sexuality of the mythical creature. But look back to the Victorian age, and the very inspiration for gothic style, and you'll find a mermaid spectacle that was an unsexy mix of taxidermy, black market corpses, and broken-down wharf-side museums.

The audience for mermaid corpses—popular sideshow attractions in the nineteenth century—was likely a mix of believers and disbelievers. The believers took the taxidermy to be proof of the mermaid's existence (after all, this was a time when many legitimate beasts, such as the dodo and the duck-billed platypus, were dismissed as having never existed at all), while the disbelievers delighted in the showman's tawdry efforts to defraud.

Even by 1878, Charles Dickens Jr.'s weekly publication, *All the Year Round*, referenced the tradition of the mermaid hoax with a weary disdain. In an article about the history of cabinets of curiosity (which were often larger than a cabinet, being a roomful of darkly whimsical detritus), the article's author wrote of the ubiquitous mermaid "made of a monkey's skin fastened as dexterously as none but a Chinaman could fasten it to some fish's tail ... believed in by a much more educated folk than those who frequent Barnum's museum ..."

The business of stitching together the various remains of fish, mammals, amphibians—whatever might produce a verily god-awful Frankenstein's monster-of-the-sea—seems to have been initiated by the Japanese. In some Victorian publications, "Japanese mermaid" is a generic term for any mummified mermaid-shaped cadaver. And the gifts of the Japanese mermaid maker were rumored to be so impressive that "Japanese mermaid" came to be a metaphor for any exquisite and convincing piece of artifice.

"Yet utterly absurd as they are," Reverend J. G. Wood writes of mermaid mummies in his book *Trespassers: Showing How the Inhabitants of Earth, Air, and Water Are Enabled to Trespass on Domains Not Their Own* (1875), "there are many persons who firmly believe in them. I once had a narrow escape from a personal assault at the hands of an owner of a Japanese mermaid. I saw it in his shop—a fishmonger's; stepped in to look at it, and made some remarks upon the ingenuity

with which wire had been made to imitate ribs and other bones. I thought that I was paying a compliment, but very soon found that the sooner I was out of the shop the better it would be. I have even seen one of these objects in which the artist had been audacious enough to fasten a great pair of bat-like wings to the shoulders."

Such audacity seemed to be a necessary characteristic for the mermaid maker of the Victorian age. While some fabricators relied on papiermâché to an unconvincing degree, the master of his craft would do business with grave robbers and tomb raiders if it meant a more accurate approximation. A mermaid manufacturer confessed in 1866 in *Tid-Bits*, a weekly magazine published in New York, that he'd once used the skeleton of an Indian child (his legs stunted by disease) stolen from a Georgia grave, skin from the shrunken head of a South American, large fish teeth, a fish tail, seaweed, and barnacles to create what he called a "masterpiece" of mermaid hokum. He doctored

an affidavit that indicated that a sailor had killed the mermaid with a knife in Hong Kong. He said: "After this I made a number of mermaids; where they are now I don't know. But they have rather gone out of fashion."

These mummies clearly owed their success—if, indeed, they met with success—to both the romantic notion of beautiful sea nymphs and a morbid curiosity regarding the depths of entertainment. P. T. Barnum's notorious Feejee Mermaid, the most famous of all mermaid

mummies, enjoyed the best of both celebrities, as Barnum proved a master of fantasy *and* disappointment. He drew folks to the mermaid exhibit by promoting the grisly pasteup as a specimen of beauty and as a perverse piece of humbug. Many spectators regarded sideshow entertainments as a kind of vaudeville, and Barnum's bait and switch enticed with a sordid comic horror.

Similarly, the newspaper writers of the time delighted in exposing and admonishing the various opportunistic mermaid-mummy exhibitors while also giddily describing the mummies' every frayed edge. *The Gentleman's Magazine*, a London publication, spilled much ink debating the authenticity of a mermaid display in 1822. One author saw more danger than just fraud, suggesting that "young children are frequently kidnapped for the purpose of making them a 'Koo-Shoo.' Their limbs, trunk, and head are moulded into a variety of strange and unnatural forms, and their eyes are not infrequently put out!"

While the mermaid mummy has not enjoyed a revival, the defunct tabloid *Weekly World News* spent many years exploiting mermaids through the 1980s, 1990s, and 2000s. One piece from August 20, 1985, proves a perfect marriage of the narcoleptic allure of dead mermaids and their mythical beauty: the mummified remains of a three-thousand-year-old mermaid were reportedly discovered in Russia, wearing a crown of seashells, pearls, and diamonds, and "most likely considered a queen or a goddess."

ABOVE: An illustration of a supposed "mermaid" (likely a dried monkey's head and body sewn to a fish's tail) exhibited in nineteenth-century London, from the 1875 book *The Monsters of the Deep, and Curiosities of Ocean Life: A Book of Anecdotes, Traditions, and Legends* by Armand Landrin and W. H. D. Adams.

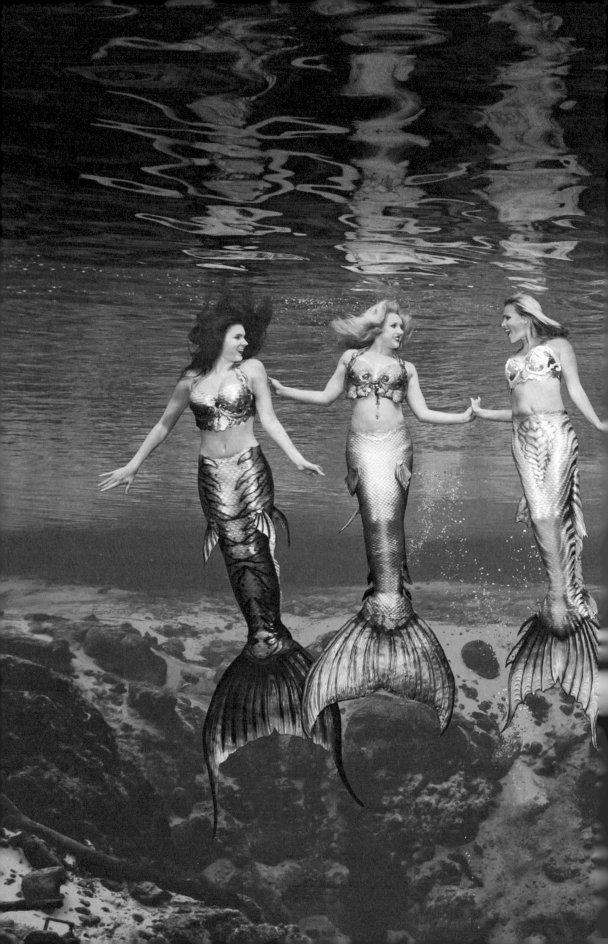

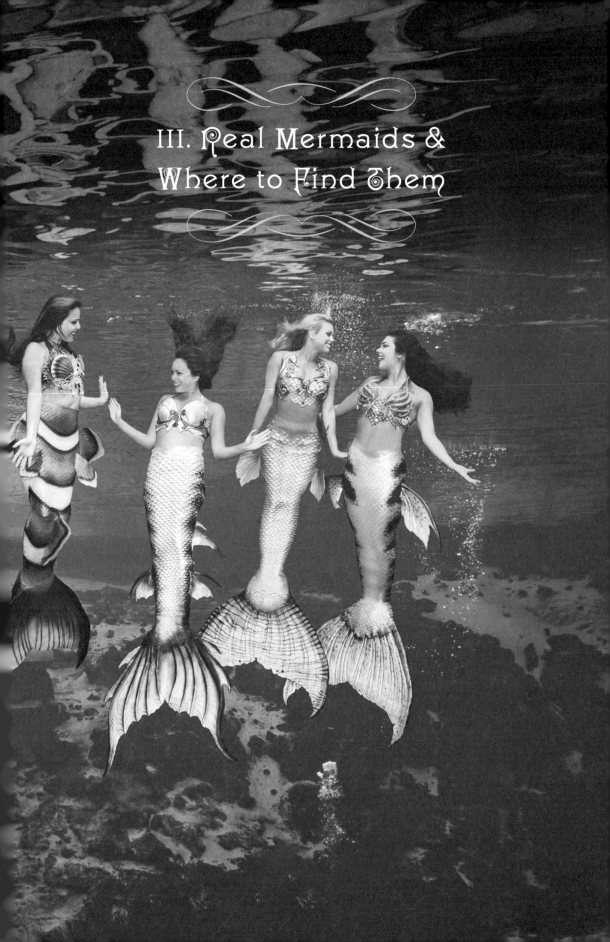

III. Real Mermaids & Where to Find Them

The FIRST MERMAID: ANNETTE KELLERMAN

Though [I'm] a professional mermaid for the movies, I still wait to see my first real one sitting on a damp grey rock combing her long green hair.

—ANNETTE KELLERMAN
How to Swim, 1918

In 1902, when Annette Kellerman was fifteen, as the story goes, she visited a tropical fish display at the Melbourne exhibition hall with her younger sister Mipps, who joked that Kellerman, an accomplished swimmer, should get inside the glass tank—which measured six feet deep, ten feet wide, and twenty feet long—and swim with the fish. Kellerman claimed later she climbed up the side and dove into the tank without hesitation as her sister collected money from astonished— and delighted—onlookers. Her stunt was such a crowd-pleaser that she was invited to perform there regularly. At one point, she was putting on two shows a day where she swam alongside the eels, seals, and fish, delighting the crowds with her grace underwater and ability to hold her breath for long stretches.

According to her biographers Emily Gibson and Barbara Firth (who suggest it's much more likely that the aquarium owner invited Kellerman to perform rather than the more sensational dare-you-to-dive story), Kellerman quickly realized that she could put on a real show by combining ballet with swimming for more graceful movements— and, having learned to hold her breath, that she could create a mermaid character to entertain the masses. She gave her first bona fide mermaid performance at the amusement park Princes Court, over Melbourne's Yarra River, sitting high on a platform in a silver-and-green mermaid tail before hurtling at great speed down a slide into the pool below. When she didn't emerge right away, the crowd grew more and more nervous— and at least one man was prepared to dive in to

PAGES 124–125: Weeki Wachee mermaids pose with Merbella's Raven Sutter (center), all wearing Merbella tails for the 2016 Weeki Wachee calendar, photographed by Andrew Brusso. *OPPOSITE:* A still from *A Daughter of the Gods*, 1916.

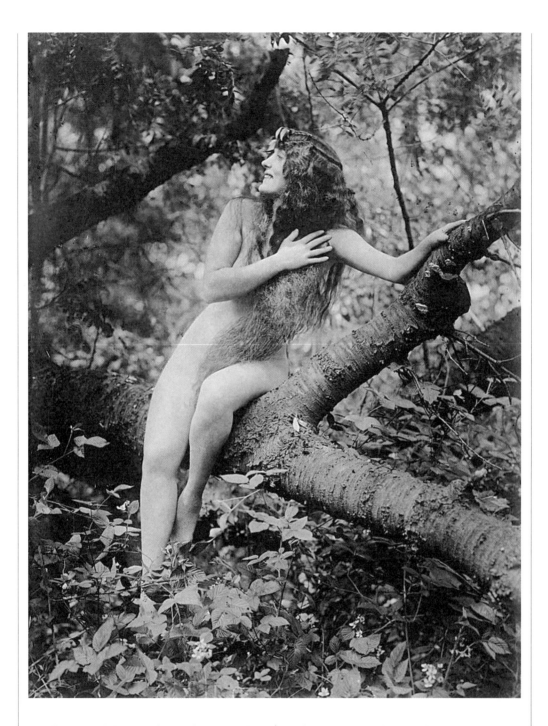

save her—until she resurfaced after more than two minutes to wild applause.

And so she became the world's first professional mermaid.

Annette Kellerman learned to swim as a small child in Sydney for a mermaidy reason: her legs were bowed, she couldn't stand upright, and, after being diagnosed with rickets, she'd had to wear heavy, painful iron braces on her legs from the time she was two to seven years old. To escape the pain, she would lose herself in the fairy-tale books she loved.

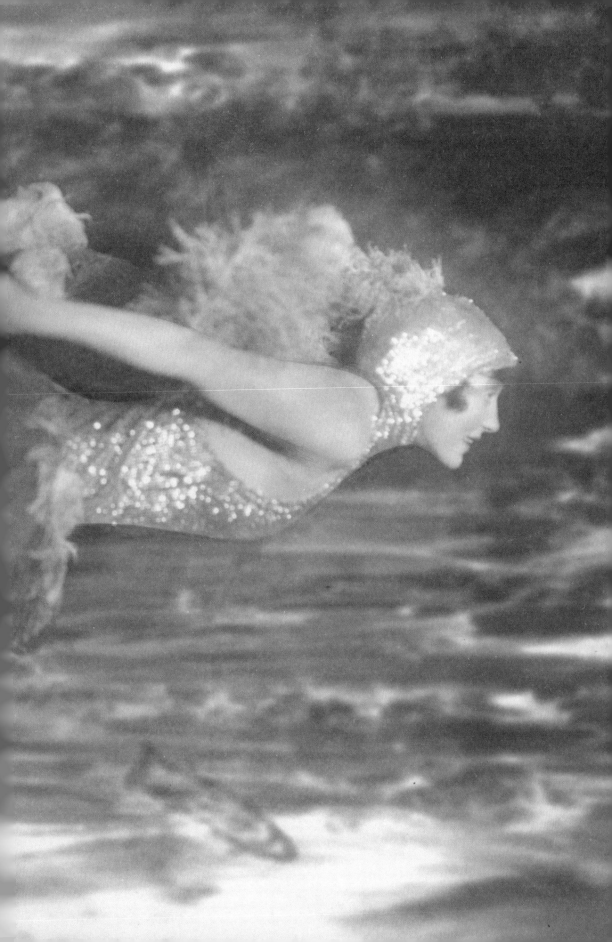

When her braces finally came off, the seven-year-old Kellerman was still too weak to walk properly, and the family's doctor prescribed swimming as a cure. Her transformation was miraculous: in the water, she was strong and ferocious, even magical. "Only a cripple can understand the intense joy I experienced," she wrote later. "After I learned, I'd go swimming anywhere, anytime." She trained at the same pool as Snowy Baker, one of the best divers in the country and future coach to Johnny Weissmuller, whom he'd teach to dive and swing through the trees as Tarzan. Kellerman quickly mastered diving as well. Having worked hard for her strong body, she became fearless.

By age fourteen she was beating everyone at her pool in races; the following year she started swimming competitively and establishing new world records. As the Kellerman family fell on hard times, they moved to Melbourne, where her father unsuccessfully tried to find work. The family increasingly relied on Annette and her talent as a way to earn money. She began training in the Yarra River and first swam a mile, then two and a half miles, and then five and then ten—officially the longest distance ever swum by a woman.

In 1904, when she was seventeen, her father took her to England in a bid to make some money for the family; while recreational swimming was commonplace in Australia, it was still more of a novelty in England. As a publicity stunt, she completed a seventeen-mile swim down the Thames River. It worked; the *London Daily Mirror* christened her the "Australian Mermaid" on its front page and offered her a contract to swim up and down the coast as they photographed her for eight weeks. She swam an average of forty-five miles a week. These coastal swims drew record-breaking crowds, were documented daily, and made her hugely famous. No one had seen anything like it. She might indeed have been a mermaid from the bottom of the sea.

Her newfound fame brought multiple offers, including to perform in London's exclusive Bath Club for the Duke and Duchess of Connaught. She went on to become the toast of Paris for a season, before returning to England to try to swim the English Channel, a feat she attempted three times without success. She continued to give swimming and diving performances all over London, including at the Hippodrome, famed for its variety shows that usually culminated in an aquatic performance. There, for a season, she performed aquatic tricks in a glass tank, mesmerizing audiences—until she was invited to America.

In 1907, she toured the United States, performing in glass tanks as the "Australian Mermaid," beginning at Chicago's White City Amusement Park in a specially built fourteen-foot-long tank, where she performed up to ten times a day. It was there that her father appointed her a new manager, Jimmie Sullivan, in part so he could return to Australia; Kellerman and Sullivan eventually fell in love, married, and moved to Boston. By then, she was the highest-paid female vaudeville star of the day, performing to packed houses. She had top billing for her show at Wonderland, in Revere Beach, Massachusetts, where the sign "ANNETTE KELLERMAN, The Australian Mermaid" could be seen from anywhere in the park.

Two other events contributed to her growing fame. In 1907 she was arrested on Revere Beach, where she appeared in her man's bathing suit with bare legs; a kindly judge dismissed the case after she explained how impractical women's swim costumes were, but mandated that she wear a robe until she stepped into the water. And in the summer of 1908 Harvard professor Dr. Dudley A. Sargent proclaimed that Kellerman was the "Perfect Woman," with measurements similar to

PAGES 128–129: An archival photo of Kellerman swimming underwater, c. 1925.
OPPOSITE: The poster for Annette Kellerman's 1918 film *Queen of the Sea*; the film is now considered lost.

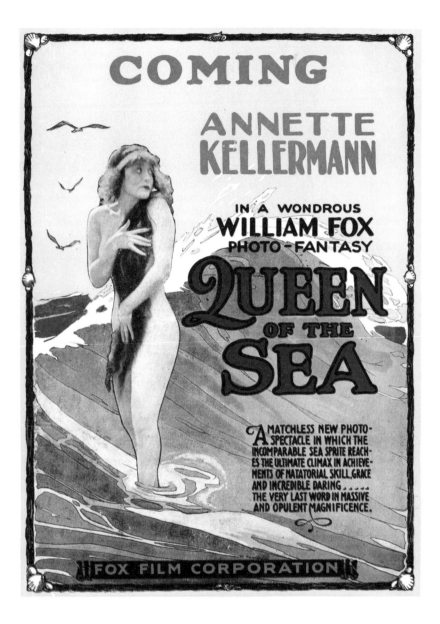

COMING
ANNETTE KELLERMANN
IN A WONDROUS WILLIAM FOX PHOTO-FANTASY
QUEEN OF THE SEA
A MATCHLESS NEW PHOTO-SPECTACLE IN WHICH THE INCOMPARABLE SEA SPRITE REACHES THE ULTIMATE CLIMAX IN ACHIEVEMENTS OF NATATORIAL SKILL, GRACE AND INCREDIBLE DARING THE VERY LAST WORD IN MASSIVE AND OPULENT MAGNIFICENCE.
FOX FILM CORPORATION

those of the Venus de Milo. Both events garnered a great deal of press and led Kellerman to the top theaters in New York, where starting in late 1908 she headed extravagant vaudeville programs that included dance, animal performances, comedy, and operetta. "There's a new Venus in town," declared the *New York Star* shortly after her debut.

After two years Kellerman left New York. Though she continued to perform in London and throughout the United States, more competition was emerging, and Kellerman was frustrated generally, wanting the world to know that she was more than a "pretty fish." After a contract dispute over money, Kellerman decided to turn her sights to film. She'd long had an idea to tell an underwater fairy tale with mermaids, but initially, when she and Jimmie pitched the idea to Hollywood, they had little success. One ungenerous executive, for example, said that women looked like drowned rats after coming out of the water.

Then one evening when she was out with friends, Kellerman met screenwriter Captain

Leslie T. Peacocke, who loved her idea of a movie set in Neptune's garden; he went home and wrote a draft for her that night. The film, *Neptune's Daughter*, became Kellerman's first feature in 1914, though it was not without mishaps: one scene was shot in a sixteen-foot-square glass tank filled with five thousand gallons of water. The glass was too thin and the tank broke midscene, sending Kellerman and her costar and director, Herbert Brenon—and a pile of fish and turtles and rocks—hurtling across the room in a rush of water and broken glass, leaving the costars bloodied in a pile of wreckage. Luckily, they survived, but spent many weeks in the hospital. The movie, which cost $35,000 to make, went back into production with a sturdier tank. It was a smash hit and earned more than $1 million at the box office. People loved the underwater fairy tale; nothing like it had ever been done.

In 1916, Kellerman starred in *A Daughter of the Gods*, the first movie to cost $1 million to make and the first film in which a woman appeared fully naked. It was Kellerman's idea to set the picture in two locations—Arabia and the Kingdom of the Mermaids—and it featured two hundred mermaids whom Kellerman herself trained, teaching them in Jamaica to swim with their legs tied together. As always, she performed all her own stunts, including diving into a pool of live crocodiles (when Sullivan caught wind of this he had a fight with the director). In another scene, she appears nude (though covered by her long hair) under a waterfall. The film was more than three hours long; no copies remain, and it's now considered lost. Kellerman went on to make more films, including *Queen of the Sea* (1918) and *Venus of the South Seas* (1924). The latter was her only film to survive intact.

She also performed, in 1916, a massive Mermaid Spectacular at the Hippodrome in New York, where she replaced ballerina Anna Pavlova as the star act. For this show, she replicated the diving scene from *A Daughter of the Gods*: as *Variety* reported, "while the music played and the singers sang and the fish and flying fairies did twists and turns in the grotto and the mermaids swam about in adjoining tanks, Kellerman did her dives into the centre water receptacle." Just as she had in the film, she performed with more than two hundred mermaids and sea nymphs as well as a giant chorus.

Kellerman stopped performing full-time in 1925. She went on to design clothing, write books, work with charities, and own a health store in Los Angeles in her later years. She also made a handful of short films demonstrating diving techniques and water ballet and continued to swim daily into her eighties.

Around 1950, MGM was looking for a vehicle for its biggest star, former champion swimmer Esther Williams. When Williams received *The One Piece Bathing Suit*, a script about Kellerman, she was fascinated. She watched Kellerman's earlier films, then persuaded the studio to buy the rights to Kellerman's autobiography, *My Story*.

In 1952, the film *Million Dollar Mermaid* brought Kellerman's extraordinary story to the big screen. Kellerman's reaction was mixed; she was most disappointed not to be playing herself, though she was sixty-five at the time. According to her biographers, Gibson and Firth, she told reporters of the time that she was "willing to concede that Esther had it from the neck up, but from the neck down I concede nothing." Though Kellerman ultimately wasn't a fan of the film, it was impressive: choreographer Busby Berkeley used more than one hundred swimmers and a host of effects to re-create Kellerman's show at the Hippodrome spectacularly. In the finale, hundreds of lit sparklers emerge from the water to form a backdrop to the ensemble.

OPPOSITE: **Esther Williams in a Busby Berkeley–choreographed scene from the 1952 film *Million Dollar Mermaid*.**

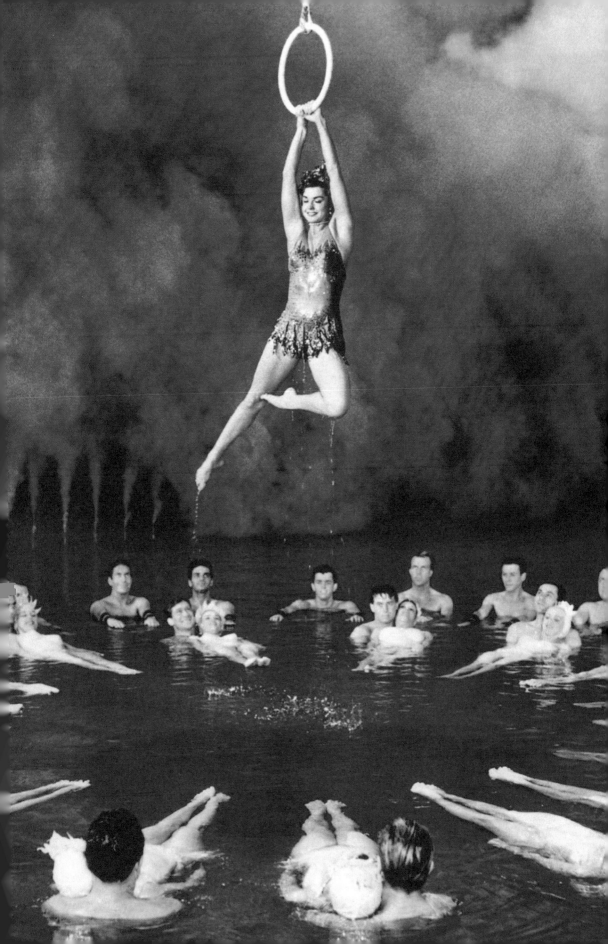

WEEKI WACHEE SPRINGS

EWT PERRY WAS A FORMER NAVY FROGMAN AND expert swimmer who'd worked at Silver Springs in Ocala, Florida, during the 1920s and 1930s, the era when the park's crystal clear spring became a hot spot for Hollywood filmmaking.

Numerous Tarzan movies were filmed here, and Perry and his sister also starred in several short films shot at the spring, including one about a mermaid school, "Neptune's Scholars," for which Perry actually provided instruction to the other actors. In 1941 Perry started working at Wakulla Springs, home to some of the largest and deepest freshwater springs in the world, in Crawfordville. He persuaded MGM to make two Tarzan films, *Tarzan's Secret Treasure* (1941) and *Tarzan's New York Adventure* (1942), there. (The infamous *Creature from the Black Lagoon* [1954] was made

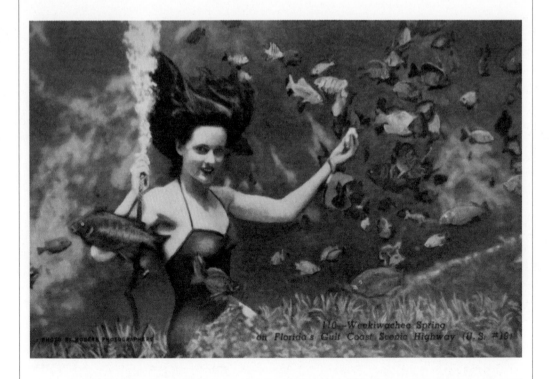

Above: A mermaid performing at Weeki Wachee, from a hand–colored souvenir viewbook, c.1949.
Opposite: Mermaid Bonita Colson riding Bubbles the Seahorse, c.1960.

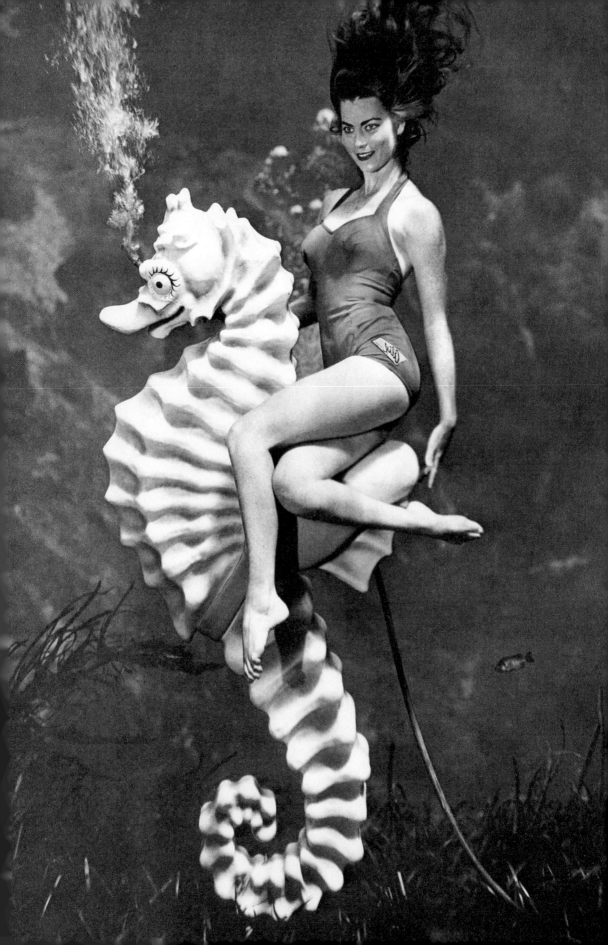

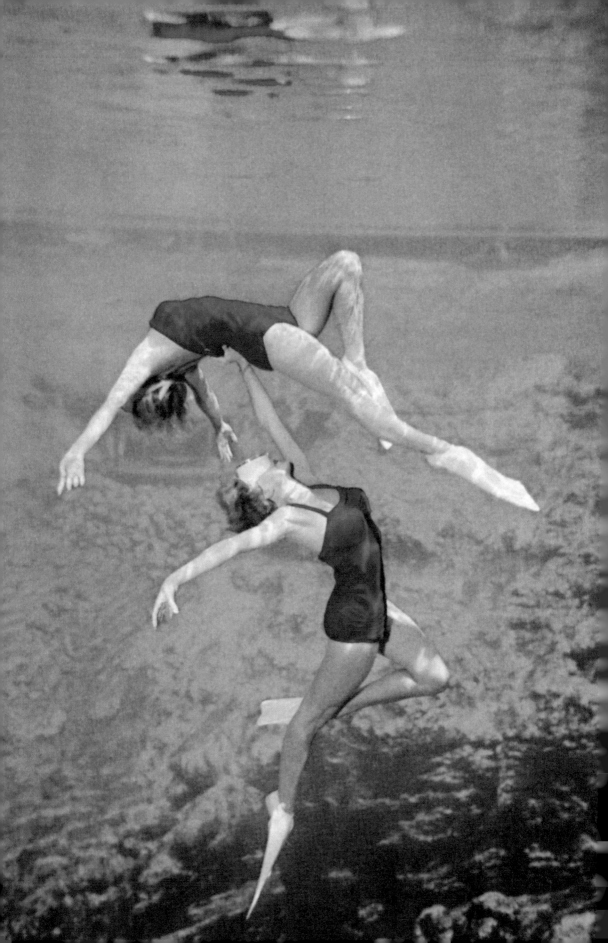

there, too, although Perry was no longer working at the park then.)

To make underwater filming easier, Perry had a few innovative ideas. He designed what he called a "hole on the water," a contraption that allowed a cameraman to stand in and film through a partially submerged glass compartment; a free-flowing air hose that supplied oxygen from an air compressor and that was hidden in the scenery, allowing performers to breathe below the surface; and an underwater air lock, which was basically an air-filled chamber that could fit four people at a time in a bubble of air, out of sight from the audience.

Perry had long dreamed of opening his own underwater theater. In 1946, he had a vision for an enterprise with the clear, sparkling waters of Weeki Wachee Springs, just short of Tampa, for its setting. He wanted to create a shimmering roadside attraction where beautiful mermaids would literally woo travelers off of Route 19, also known as the Gulf Coast Highway, and entertain

them by performing feats underwater. In the mid-1940s, road trips were newly popular, and the Gulf Coast Highway, a two-lane road, funneled traffic to Florida's booming west coast. After obtaining the proper permissions, Perry cleaned up the site in short order and built an underwater theater into the limestone of the spring, including the air locks and air hoses he'd developed for underwater performing. He then hired the Aquabelles, a local troupe of a dozen or so synchronized swimmers, to be his first mermaids, and opened Weeki Wachee Springs in 1947.

To enter the original theater, guests would push through a turnstile, descend a flight of stairs, and enter what resembled an underground train six feet below the surface of the water. From there, visitors could look through glass windows into the spring, where mermaids swam fetchingly and ate bananas and drank Grapette soda while posing underwater. They also created and performed the famous "adagio" pose that has been

Opposite: Two mermaids performing the classic "adagio" pose.
Above: Mermaids performing for a packed house in the late 1950s.

the trademark of Weeki ever since. The first mermaids didn't wear tails but regular bathing suits they supplied themselves, and when business was slow, they'd run up to the roadside, flag down passing motorists, run back, then jump into the water to perform.

Shortly after the attraction's opening, Universal-International studios called Perry for advice about where to film the mermaid movie they had in development; naturally, he suggested Weeki Wachee, and the now classic *Mr. Peabody and the Mermaid* (1948) went into production. Perry spent two weeks training star Ann Blyth in underwater swimming in the same way he trained all the Weeki mermaids, teaching her the basics of safe diving as well as breathing underwater with the air hose and holding her breath as she swam. He also taught her specialized skills, which she described in a piece she wrote for the magazine *Modern Screen* in 1948 as "how to do a Bronx cheer underwater, how to laugh underwater without strangling, [and] how to brush my hair underwater."

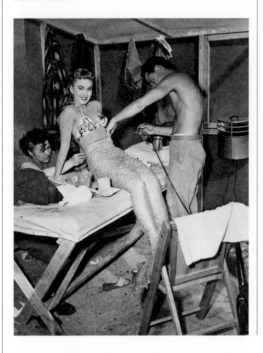

By the 1950s, Weeki Wachee had become a popular tourist stop and featured orchid gardens, jungle cruises, and a new beach in addition to the mermaid shows. Despite Weeki's successes, with its one-dollar admission fee it wasn't bringing in enough profit for stakeholders, and Perry left the business—going on to become a high school principal, open his own swim school, and develop a traveling underwater tank show. (In 1952, he also oversaw the development of mermaid attraction Aquarena Springs, in San Marco, Texas.) In 1959, ABC Paramount bought Weeki Wachee from its then owner and built a larger, million-dollar theater, submerged sixteen feet below the water's surface, that could seat four hundred people. ABC not only initiated choreographed, scripted shows, like *Alice in Waterland* and *Peter Pan*, with elaborate props and music; it also ushered in a whole new era of underwater performing.

By the time Elvis Presley paid a visit in 1961, Weeki Wachee was one of the most glamorous and beloved tourist attractions in the United States. Girls came from all over the world to land a coveted job as a Weeki Wachee mermaid. The thirty-five mermaids performed eight sold-out shows a day to adoring audiences and were idolized by their fans. In 1966, the City of Weeki Wachee was incorporated, and started appearing on maps and state road signs.

Sadly, business began to decline with the 1971 arrival of Interstate 75 and Disney World, which lured Florida tourists off of the Gulf Coast Highway and to the middle of the state, near Orlando. Nonetheless, Weeki Wachee survived long after tourists began to go elsewhere. The mermaids continued to put on elaborate shows despite the dwindling audiences. In an effort to attract more locals and tourists in the early 1980s, ABC opened the water park Buccaneer Bay at Weeki Wachee, which, for a time, drew in more

ABOVE: Makeup artists fitting actress Ann Blyth's tail during filming of *Mr. Peabody and the Mermaid*, 1948.

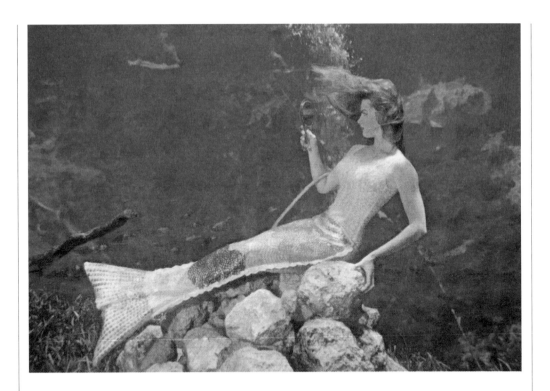

people than the mermaid shows. The water park was the last big investment in Weeki Wachee by the studio, though; within a few short years, it sold its stake in the site, marking the beginning of a long succession of new owners. These included Florida Leisure Attractions, which bought the park in 1984 and stopped putting on regular new shows, directing its marketing at Florida residents rather than outside tourists, and the Florida Leisure Acquisition Corporation, which took over in 1989 and made many more cuts; among other things, the mermaids had to start making their own costumes, tails, and props. For about twenty-five years, the attraction languished and struggled but continued to put on regular shows.

In 2003, the lease was transferred back to the City of Weeki Wachee, and in 2008 Weeki Wachee became a state park. Today the attraction is having a renaissance. Its summer camps for adult women, which launched in 2010, are sold out months ahead of time, and its mermaids (including some Weeki alumnae; see page 68) are making regular media appearances on television, in publications like the *New York Times* and *Vogue*, and in a stunning yearly calendar shot by photographer Andrew Brusso. The water is still as clear and sparkling and full of wonders as it was in the 1940s, and the mermaid shows go on. As the park's website says, "Fresh coats of paint adorn the walls of the Mermaid Villa, the gift shop is stocked with fanciful and functional mermaid souvenirs, and the mermaid theater is being restored to its former glory. Recently, carpeting on the walls was pulled back to reveal original ceramic tiles in Florida colors: teal, pink and aqua." But talk to anyone who's ever been associated with Weeki Wachee and it's readily apparent that the park's remarkably clear, magical springs cast a lifetime spell of enchantment upon anyone who has been lucky enough to swim in them—especially if they transformed into mermaids to do it.

Above: **Mermaid Bonita Colson checking her hair in a mirror, c. 1960.**

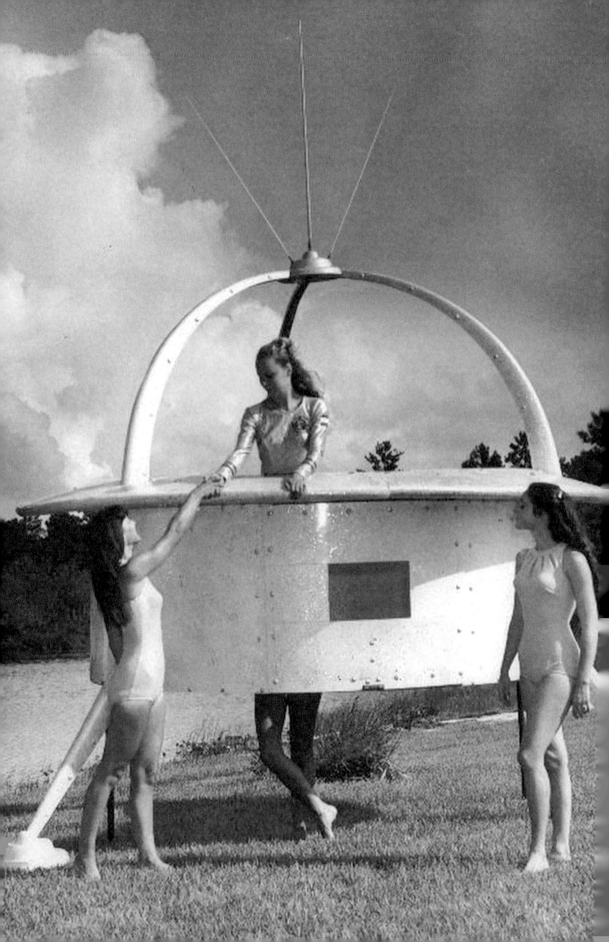

Mermaids on the Moon

THE WEEKI WACHEE SHOWS ALWAYS HAD THE SAME GIM-micks, so the stories were always loosely structured around them. There was a deep dive—where the mermaids disappeared into the "deep hole" in the spring and then floated up doing ballet moves to showcase their breath-holding abilities. The mermaids always fed the fish, ate and drank underwater, did buoyancy demonstrations, and walked on a tightrope.

Bonnie Georgiadis worked at Weeki Wachee for thirty-seven years, beginning in 1953 as a mermaid and, after helping out for years, taking over as choreographer and show producer in 1969, when she wrote and produced her first show, *Mermaids on the Moon*. Georgiadis had had the

idea in mind for a while, she says, "since I always thought the spring looked like the surface of the moon, with all the rocks and rough terrain." The weightlessness of being in the water was not unlike floating in outer space, either. The show featured music from *Barbarella* and other songs, including "Fly Me to the Moon."

It opened with two space girls pro-pelled by space-age-looking Aqueon swimming devices performing underwater ballet. They hear a noise and hide behind rocks. Anita Spaceship is arriving in her spaceship to investigate why the moon is no longer entering into its full phase. She walks down a cliff and plants her flag. The space girls reappear and escort Anita toward the theater just as a couple of evil "space goons" in rubber costumes come in from the side, scaring the space girls away. Anita pulls out a cloth and pretends to be a matador. The space goons pass through the cloth and then exit the scene. Later, a wizard appears from behind a large prop filled with gadgets and tells Anita that she has to go into the deep hole to break the spell on the moon. She does a deep dive and makes the moon full again. At the end of the show a great fiberglass full moon rises in the water as Anita and the space girls celebrate.

OPPOSITE: The spaceship for *Mermaids on the Moon*, 1969.
ABOVE: A bevy of mermaids pose for a souvenir postcard for the show.

BEAUTIFUL GIRLS THAT LIVE LIKE FISH:
The STORY *of* AQUARAMA

—ᴠɪɴᴛᴀɢᴇ Rᴏᴀᴅsɪᴅᴇ

I N 1963, IF YOU WERE HEADED OUT ON A ROAD trip for your summer vacation and wanted to take in a live mermaid show while you were at it, your choices were somewhat limited. You could head for Texas and enjoy a show, complete with a diving pig, at Aquarena Springs. Or perhaps you'd visit Florida and catch the show at Rainbow Springs, or, even more likely, you'd check out the queen of all mermaid shows at Weeki Wachee Springs. But in 1964 a new chapter of mermaid history was written with the grand opening of the Aquarama in Osage Beach, Missouri.

While at first thought the idea of a mermaid attraction in landlocked Missouri may seem strange, the Lake of the Ozarks area had many similarities to other major summer season destinations of the 1960s. The lake area offered excursion boats, miniature golf courses, amusement parks, hay rides, and in 1964, as the largest man-made lake in the United States, several water ski shows.

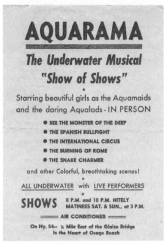

AQUARAMA

**The Underwater Musical
"Show of Shows"**

Starring beautiful girls as the Aquamaids
and the daring Aqualads - IN PERSON

● SEE THE MONSTER OF THE DEEP
● THE SPANISH BULLFIGHT
● THE INTERNATIONAL CIRCUS
● THE BURNING OF ROME
● THE SNAKE CHARMER

and other Colorful, breathtaking scenes!

ALL UNDERWATER with LIVE PERFORMERS

SHOWS 8 P.M. and 10 P.M. NITELY
MATINEES SAT. & SUN., at 3 P.M.

AIR CONDITIONED

On Hy. 54-- ¼ Mile East of the Glaize Bridge
In the Heart of Osage Beach

With many people coming to enjoy the water, Wally Johl thought a mermaid attraction seemed perfect for the area. Johl, along with his wife, Nola, and son, Marc, had settled at the lake in late 1959. The Johl family spent their first years there building swimming pools for many of the area's motels and resorts, running boat rentals, and operating a trampoline attraction called Tram-L-Town. It was during a

Aʙᴏᴠᴇ: The first flyer advertising the new mermaid shows at Aquarama in 1964. The theme was "Around the World," with each act set in a different exotic part of the world.

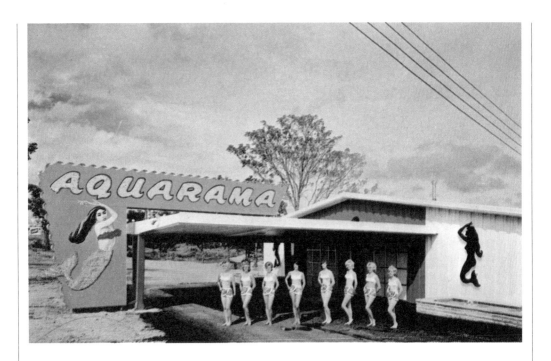

1962 visit to Florida's Weeki Wachee Springs that the Johl family decided to turn their dream of an underwater attraction into a reality. In the winter of 1963, construction of the Aquarama began.

They built a theater-style auditorium from which the audience had a panoramic view of the eighty-five-thousand-gallon tank through twelve large plate glass windows. Behind the glass, giant clam shells waited to reveal beautiful mermaids while a curtain of bubbles provided a unique show of its own.

Auditioning, hiring, and training mermaid performers had never been done at the Lake of the Ozarks, but the Johl family had planned well in advance. During their 1962 visit to Florida, the Johls had enlisted Barbara Hodgson, a Weeki Wachee performer with years of underwater experience, to come to Missouri to train the troupe of ten performers. After spending 1963 performing with the Aqua Spectacular, a traveling aquatic show based in Miami, Hodgson loaded up her Ford Falcon and headed for Osage Beach.

The original 1964 Aquarama cast was made up of eight Aquamaids and two Aqualads. While Weeki Wachee had their choice of experienced performers, the Aquarama crew, with the exception of Hodgson, were fifteen- and sixteen-year-old students at the local high school. Hodgson taught them underwater ballet along with basic maneuvers and components of routines she had learned at Weeki Wachee. An additional challenge the performers faced the first season was that the heated Aquarama tank was not completed in time for the performers to train in. In February 1964, with snow still on the ground, the Aquamaids and Aqualads found themselves learning to breathe with continually flowing air hoses in the unheated outdoor pool of a local motel. To this day many of the former performers still remember just how cold that pool was.

Costumes and mermaid tails were next on the list. It was decided that for some of the non-mermaid routines the Aquarama performers would wear Jantzen swimsuits embellished by hand with thousands of sequins and stones that

ABOVE: **The original cast of the show poses under the Aquarama sign, 1964.**

would show up well underwater. Other routines—like "The Bullfight in Spain" and the Hawaiian routine—called for costumes that would be designed and created especially for the Aquarama. The task of designing and creating these costumes fell on Nola and Marc Johl, and local seamstress extraordinaire Alma Bates.

Procuring mermaid tails in 1964 was much different from what it is today, when an Internet search for "mermaid tails for sale" yields more than one million search results. The lack of ready-to-wear mermaid tails at that time meant that the Aquarama tails needed to be hand created. The Johls chose shimmering gold and silver lamé for the tails and then uniquely decorated each one with cut glass stones and colored sequins. Each tail was lined with a plain fabric and included a matching top.

One of the main differences between the Aquarama tails and contemporary mermaid tails is the fabric used in their construction. Although invented in 1959, spandex had yet to become widely used for garments, and latex was still being used mainly for swim caps. The lack of these stretchable materials meant the Aquarama tails needed to be sized perfectly to fit each mermaid. This fit was accomplished by a combination of careful measurements along with a zipper that ran the entire length of the tails. Some of the mermaids coated the zippers of their tails with Vaseline to make them easier to use during underwater costume changes.

Aquarama opened on May 30, 1964. Offering two shows daily at 2:30 P.M. and 8:30 P.M., the Aquarama presented patrons with an Around the World Underwater theme that first season. A few of the settings for the acts included Hawaii, Tasmania, Paris, and Rome, and there was an American number performed to a John Philip Sousa march. The performances included pre-recorded music with live narration by Nola Johl, while the operation of the house and underwater lighting was handled by Wally Johl.

Between 1965 and 1967, the Aquarama expanded the range of routines and costumes. Some of the more unique bits included a James Bond–inspired *Thunderball* sketch that featured a battle to the death between a "good" Aqualad and an "evil" Aqualad, a go-go routine with performers in underwater cages shaking and shimmying away to Sandy Nelson's "Let There Be Drums," and an Alley Cat routine that had the girls wearing black-and-white one-piece suits complete with tails and accessorized with black tights and black gloves. The mermaid routines remained a staple of the Aquarama, with many of the former Aquamaids recalling these performances as their favorite acts. Blond Aquamaids recall another point of pride—their hair tinted green each summer from the chlorine used in Aquarama's tank.

In 1968, the Johl family made major changes to the Aquarama, renaming it the Cabaret Aquarama and replacing the auditorium-style seating with tables, chairs, and a dance floor. They also brought in a chef and full waitstaff to complete the transition to a supper club, with two underwater shows nightly at 7:00 P.M. and 9:30 P.M. Along with dinner, patrons could also enjoy a new signature cocktail, the Aquarama Sling, served by Aquarama's master mixologist.

At the end of the 1968 season, the Johls decided to move on. In five years they had realized a dream and entertained countless visitors to the Lake of the Ozarks, with a total of twenty-eight performers calling the eighty-five-thousand-gallon tank their summer home. The Aquarama continued under different management from 1969 to 1973, when it met the fate of countless other mom-and-pop roadside attractions. But the memories live on. Several of the former cast members recall their time at the Aquarama as some of the happiest times of their lives, and many remain close friends after hanging up their mermaid tails more than forty years ago. As one former Aquamaid said, "Nothing compares to being a mermaid. It's the best job in the world!"

The Aquarama Sling

THE AQUARAMA SLING WAS AQUARAMA'S SIGNATURE DRINK back in its 1960s heyday. The owners' son, Marc Johl, who also trained the swimmers and performed in the Aquarama show himself, found the recipe decades later in a pile of papers and passed it along to the company Vintage Roadside, which resurrected this light, fruity concoction for a Tiki Oasis event and has since shared it with their fans. Of the drink, Johl said, "This drink can be shaken over ice and strained or made 'frosty' by adding some ice and blending it. It was served in a hurricane glass, and garnished with a slice of fresh pineapple and a cherry spiked with a Chinese paper parasol."

Makes 1 cocktail

INGREDIENTS

+ 1½ ounces gin
+ ½ ounce Cherry Heering
+ Dash of Cointreau
+ Dash of Benedictine
+ 4 ounces passion fruit juice
+ ½ ounce Rose's lime juice
+ Grenadine to taste (and for color)
+ Dash of Angostura bitters
+ Slice of fresh pineapple for garnish
+ Cocktail cherry for garnish

DIRECTIONS

1. Combine all the ingredients (except the garnishes) in a blender.

2. Add ice and blend.

3. Serve in a hurricane glass and garnish with the pineapple slice and cherry.

MODERN MERMAIDS

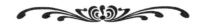

WHILE MERMAID ATTRACTIONS HAD THEIR heyday in decades past, there's been a resurgence of mermaid love in recent years, in no small part fueled by the Internet and its power to bring enthusiasts of all kinds together—including would-be sirens. Today, as in the past, mermaids are slipping into their tails and performing in glass tanks, they're traveling the world putting on shows, they're starring in movies, they're undulating in aquariums or winking at you from behind portholes, and they're swimming in the open ocean with humpback whales, manta rays, and sharks. They're even running camps, schools, and workshops so that aspiring mermaids can flex their fins, too. And at the annual gathering Mermania, in North Carolina, mermaids and mermen can drop the human pretenses altogether; hundreds gather to swim together in a huge pool, take workshops on topics like safety and tails and "merwrangling," and, in general, meet their own kind.

Today, mermaiding as a profession is so in vogue that there's even a *Fishy Business Handbook for Mermaids* by Halifax's Raina Mermaid, who has also written the instructive tomes *How to Be a Mermaid* and *My Life as a Mermaid*. The handbook leads aspiring mermaids through the very human tasks of defining core values, creating business plans, financing a mermaid business, buying tails, assembling teams, marketing the business, running shows, and even "how to move a mermaid safely" ("When carrying a mermaid, be sure to watch out for any items, wet floors, or people that may accidentally trip you"). The book is full of checklists for tail maintenance, risk management, safety, and items to bring to a convention (earplugs, goggles, nose plugs, neoprene socks) and any gigs a mermaid manages to snag. Some mermaids have built entire empires around their mermaidliness and serve as role models for aspiring half fish around the world.

HANNAH FRASER ❧ Hannah Fraser is arguably the one who made mermaiding a modern profession outside official mermaid attractions like Weeki Wachee Springs and the old-time aqua shows. Like Annette Kellerman,

OPPOSITE: Photographed by Brett Stanley, Hannah Fraser swims at the *Sapona* shipwreck, just south of the Bimini islands.

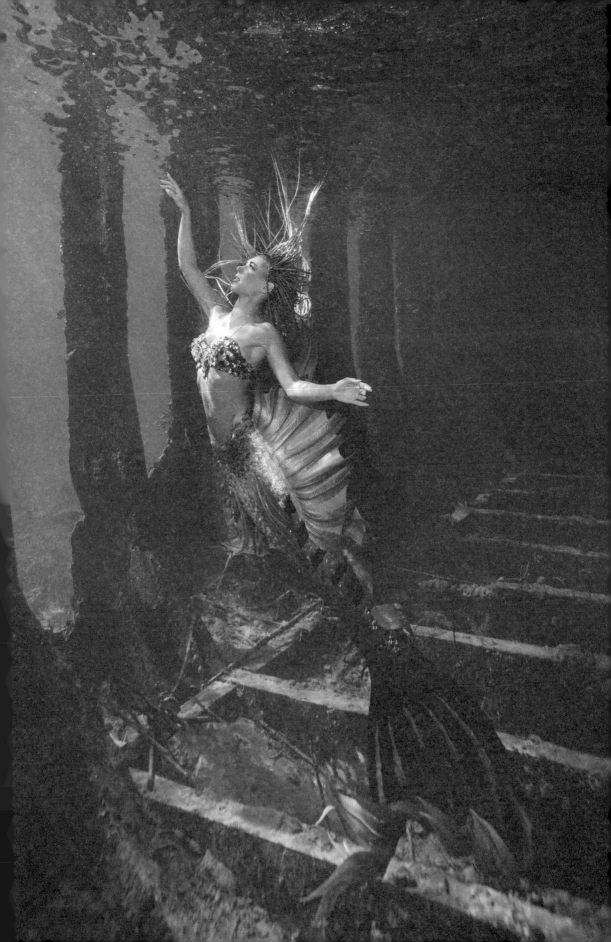

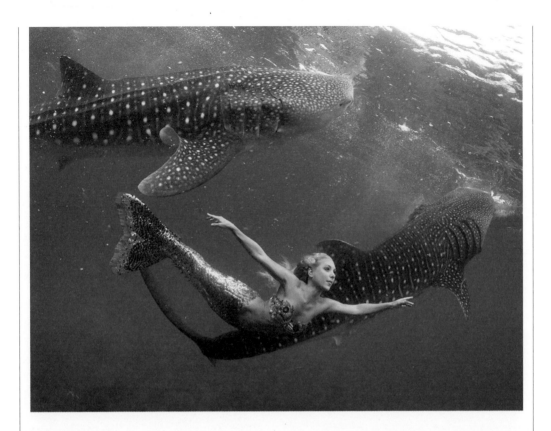

Fraser spent her formative years in Australia, though she lived far from the water. And like girls all over, she loved mermaids from the time she was a child, a love that was intensified when she watched *Splash* and realized that the fish-tailed creatures actually exist. Armed with this secret knowledge, she made her first tail when she was nine and wore it until it disintegrated.

Working as a model throughout her twenties, Fraser was hired at one point to do an underwater shoot and loved the result. "I looked at the photos and knew that was the energy I was trying to develop in myself," she says. "I thought I looked so much better underwater, I should be down there all the time!" The one thing missing? A tail. Through trial and error, she made her own from scratch using a wet suit sleeve along with flippers, a boomerang, some coat hangers, and duct tape to create the internal fluke. The tail

"functioned reasonably well considering the weird creation," she says. Soon after, she refined the fluke and spent days creating her own monofin by cutting flippers and bolting them onto polyethylene board, adding silicone to create the ridges in the flukes, and sanding it all down. Though she's continued to use a neoprene wet suit as a tail sleeve, she went from hand painting the tail to adding tiny sequin upon tiny sequin to the scales. "I've never bought a tail, only created them," she says. "I think it's an important part of the process of transformation for a mermaid—a rite of passage."

As a newly be-tailed mermaid, she appeared in a friend's eco-conservation river-cleanup documentary film and realized that she could combine her passion for mermaiding with her passion for the environment. When, in 2013, an environmentally unsound bridge was proposed

Above: Hannah, photographed by Kristian Schmidt, swims with whale sharks in Oslob, Philippines.

in her hometown of Byron Bay, Australia, she dressed in full mermaid form, then had friends carry her to the middle of a bridge to protest. She made front-page news when the police came and didn't know what to do with her. Around the same time, she was traveling the world to exotic locales with her now ex-husband, a pro surfer, so she started bringing a mermaid tail along with her. Whenever the surf was flat, she'd get into the tail and tempt the photographers to take shots of her. In this way she started developing a bona fide mermaid portfolio and publishing the images.

She also began swimming in her tail as often as possible, pushing herself to reach deeper depths and hold her breath for longer and longer periods, no doubt aided by a lifelong practice of breath work and yoga, thanks to her meditation-teacher mother, and exploration in different styles of movement, from hip-hop to ballroom to belly dance. In a bid to make her dreams come true, she issued a press release to Byron Bay's local newspaper stating that she was a professional mermaid and that she flew around the world to perform underwater. And the offers came pouring in.

Today, Fraser regularly does films (*Scales, A Mermaid's Tale, Beyond the Cage of Fear*, to name a few), television commercials (from Omega Watches and Lord & Taylor to the Bangkok Aquarium), photo shoots, parties and corporate events, and performances. An eco-activist, she collaborates with friends to create stunning footage in far-flung places of the world—swimming with humpback whales in Tonga, great white sharks in Mexico, dolphins in Hawaii, and whale sharks in the Philippines. She also educates audiences on ocean conservation. In 2007, she co-organized a "paddle-out" against Japanese dolphin slaughter, during which a group of activists attempted to shield dolphins being slaughtered in Taiji, Japan. This became one of the first actions to raise attention on dolphin killings in the country, and the event was later featured in the Oscar-winning documentary *The Cove*.

LINDEN WOLBERT ❧ Linden Wolbert grew up landlocked in Pennsylvania, participating in competitive swimming, watching nature specials, and dreaming about the sea. She always loved mermaids, she says, but was first and foremost a "nature geek," dazzled by the science of the ocean more than the fantasy of its more mythical inhabitants. After studying film and environmental science in college, she moved to Los Angeles in 2003 to pursue documentary filmmaking. She also became scuba certified. When she dived for the first time in the giant kelp forest near her home, she cried. It was "such a visceral, magical experience," she says, being immersed in the world she'd only seen on film. And when she discovered free diving (where a diver has no equipment and relies on their own breath underwater), she "went bonkers" and started spending all her free time training, racking up certifications, and learning everything she could. "When you free dive," she says, "you are a marine mammal, holding your breath just like a whale or a dolphin does."

It was when a friend invited her to help film a documentary about free diving in Grand Cayman that she first saw champion divers using monofins—mermaid-like swim fins that link the feet together and allow the wearer to move powerfully through the water—and became "obsessed." When she tried one out for herself, she "flew through the water." "On a single breath, I became a mermaid," she says. "When I finally lifted my head, the boat seemed miles away." That was the moment, she says, when she realized she could *be* a mermaid—professionally—and from then on she restructured her life to make it happen.

The first step was to make a tail. Through a friend, she began collaborating with special effects artist Allan Holt, learning about the world of special effects and silicone and crafting a tail that would be fast, durable, and gorgeous. After seven months, $20,000, and a lot of "blood, sweat, and tears," Tail 1.0 was born—a thirty-five-pound

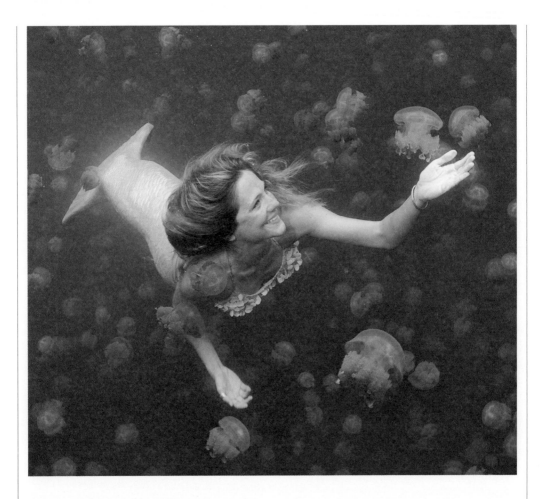

silicone appendage that Wolbert fits into "like a key into a keyhole." It also featured her now signature crescent-shaped fluke. When the tail was completed in 2006, word spread quickly, and people began hiring Wolbert to appear at their events in mermaid form—and she's worked as a mermaid full-time ever since. Her first event was at a rooftop pool party in San Diego, where she was carried in and out of the pool, swam in her tail, and posed for photos with guests. People couldn't believe what they were seeing, and that first performance and every appearance after generated wild enthusiasm. "People love seeing something unusual and exciting," she says.

She started making educational videos in 2009, launching her Mermaid Linden YouTube channel and gathering, since then, more than forty million views of her videos. In 2013 she started her "Mermaid Minute" series in which she educates children on all sorts of ocean inhabitants. A mermaid, she says, is the perfect teacher; she "can be an ambassador for ocean animals and communicate clearly with humans on land, too." She's also become a bona fide "entrepremermaid," not only running her own personal mermaid empire but also partnering with Body Glove in 2013 to produce a full line of Mermaid Linden underwater products.

ABOVE: Wendy Capili-Wilkie captured Linden swimming among the hundreds of thousands of pulsing golden jellyfish in Palau's famous Jellyfish Lake; over the course of millions of years of evolution, these creatures lost their need and ability to sting.

Launched in 2015, the line features children's and adult monofins, mix-and-match swimmable mermaid tails, and even towels and paddle vests.

Her main joy, though, is working with children, appearing at children's parties and using her mermaid persona to teach them about ocean life and conservation. She also regularly works with charities to grant children's wishes. Her most popular video, "Lauren's Wish: The True Heartwarming Story of Mermaid Magic," documents her visit in Scotland with eight-year-old Lauren, who suffers from short gut syndrome and dreams of mermaids. One October morning, a limo whisked Lauren and her family to the nearby Loch Lomond, where Mermaid Lindon emerged from the water to greet the little girl and gift her with a special necklace, then disappeared back in the water.

VIRGINIA HANKINS ❧ Today there are whole companies devoted to mermaid entertainment, offering alluring siren talent for high-end parties, music videos, and the like. Based in Hollywood, Virginia Hankins's Sheroes Entertainment is an underwater stunt team and live-action entertainment company, the go-to mermaid company for celebrity children's parties and events. Sheroes mermaids also perform at exclusive resorts and hotels, weddings, and wherever else mermaids are required.

ABOVE: **Mermaid Linden swims in the warm, crystal clear waters of the Atlantic in the Bahamas in this image by Agustin Muñoz.**

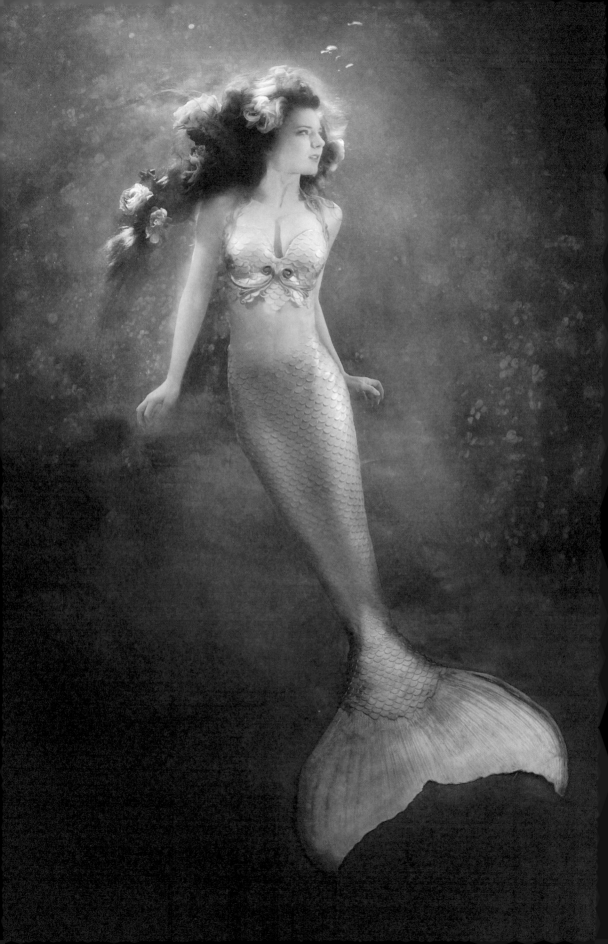

The company also runs the LA Mermaid School, with classes on mermaiding, underwater modeling, and professional development. In the one-day "Mermaiding 101," for ages six and up (the oldest student so far was sixty-eight), mermaid instructors lead the class in stretching and then untailed drills and skill practice before students don their tails and repeat the same exercises, learning to move through the water with their legs magically transformed. In "Mermaiding 201" students go on to work on advanced buoyancy control, hair and facial expression work underwater, floats and spins, breathing techniques, and simple group choreography basics.

As more and more mermaids emerge around the world and take to the water in their tails, they face all kinds of dangers, whether it's clinging children at a party or the risks of posing underwater without proper training. Hankins is a passionate proponent of safety and risk management, working closely with divers to develop new safety procedures according to Red Cross standards. Using techniques pulled from firefighter and sheriff's department training, Hankins personally trains all new mermaids on the Sheroes team. She teaches them how to handle unruly children, recognize when someone's in distress, work with safety divers, communicate with hand signals, ascend and descend underwater, regulate airflow and control buoyancy, and more. Hankins herself is PADI certified (PADI is the world's leading scuba diver training organization), and Sheroes is the only mermaid company sanctioned by the Red Cross. Despite the dangers, the sea is seductive: more than three hundred Southern California hopefuls recently applied for one open position on the pro mermaid team. About seventy-five finalists attended an in-person audition on land; eight were called back for an audition at a local pool. To be considered, would-be mermaids must have an existing American Red Cross lifeguard certification in addition to "talent, class, outgoing charisma, responsibility, cheerfulness, and patience with children," as the Sheroes website specifies.

Hankins grew up in Southern California with dreams of becoming a knight; she even had a full suit of armor crafted for herself before she became the first female knight at the Southern California Renaissance Pleasure Faire in 2012. She became a mermaid on a whim that same year, when photographer Brenda Stumpf invited her along on an underwater fashion shoot in Mexico and suggested she bring costumes or ideas for fun shoots during downtime to take advantage of the spectacular locale. Hankins immediately suggested mermaids—a refreshing change of pace from riding horses and being covered in metal. When they realized they couldn't find a tail rental in time, they built two of their own in a whirlwind two weeks, with the help of model Jessica Dru, who would also transform into a mermaid for the shoot. After consulting photographer and special effects friends, and using silicone, neoprene, and fabric, the team came up with tails that wouldn't be too swimmable but would look spectacular underwater in the photographs.

Having transformed from knight to siren, Hankins has traveled all over. She performed as a mermaid at Château de Fontainebleau, Napoleon's castle thirty miles southeast of Paris, during Paris Fashion Week, and also represented La Mer at its 2016 fiftieth anniversary bash in Los Angeles, where she starred in a short mermaid film that was shot in Canada and shown at the event (which she was able to attend with legs). A trip to Roatan, Honduras, revealed massive swells of plastic and landfills, inspiring Hankins to educate others about consumption and its effect on the ocean and its inhabitants. Advocating for ocean life is "part of the job," she says.

OPPOSITE: Virginia Hankins poses in her backyard pool for this Pre-Raphaelite–inspired photograph by her longtime collaborator Brenda Stumpf.

MERMAID
COCKTAIL LOUNGES

—Vintage Roadside

I N 1953 THE MARLIN BEACH HOTEL, THEN FORT Lauderdale's newest oceanfront resort, needed a hook—a way to stand out from the other resorts crowded along this stretch of world-famous beach. While the hotel offered numerous luxuries and services, they added a special cocktail lounge.

The Two Fathoms Down Lounge ❧ Located below sea level, this lounge was designed to resemble a ship's hull sitting on the ocean floor. The windows didn't provide a view into the murky depths of the Atlantic Ocean, however, but an unobstructed view into the hotel pool. Watching families of tourists swim around may have been briefly interesting, but it was not exactly entertainment.

Shortly after the lounge opened, though, Donna Jean Korosa, a Weeki Wachee performer, made an overnight drive to Fort Lauderdale to pitch the idea of a new type of underwater show to the hotel. Management was hesitant, but Donna had a few never-before-seen acts in mind such as "Millicent the Mermaid and Finbad the Sailor," the story of a wayward sailor discovering a mermaid washed ashore; an underwater ice-skating routine, which started with the performers popping out of the top hat of a ten-foot-tall underwater snowman; and an

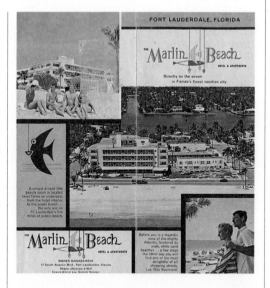

alluring Polynesian number complete with grass skirts. The underwater cocktail lounge show was born. The price of admission: six dollars. The Marlin Beach show was so popular that soon several other shows began popping up around the country.

Above: A 1953 brochure for the Marlin Beach Hotel, home of the first mermaid performances in an underwater cocktail lounge.

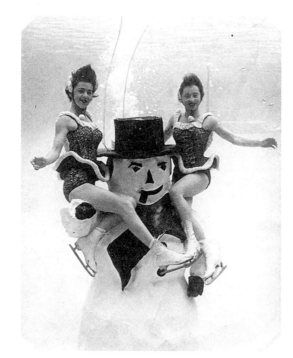

Top: A 1955 postcard from the renamed "Jules Verne Room" at the Marlin Beach Hotel. Donna Jean Korosa, the first cocktail lounge performer, appears on the right in a bright red bathing suit. ✦ Bottom: Every winter, the Marlin Beach Hotel featured an elaborate holiday show. Sharon Lee (left) and Donna Jean Korosa (right) would hide inside a snowman, dramatically burst out of it through the hat, and then "ice-skate" around the pool, which also had a fully decorated Christmas tree anchored to the bottom.

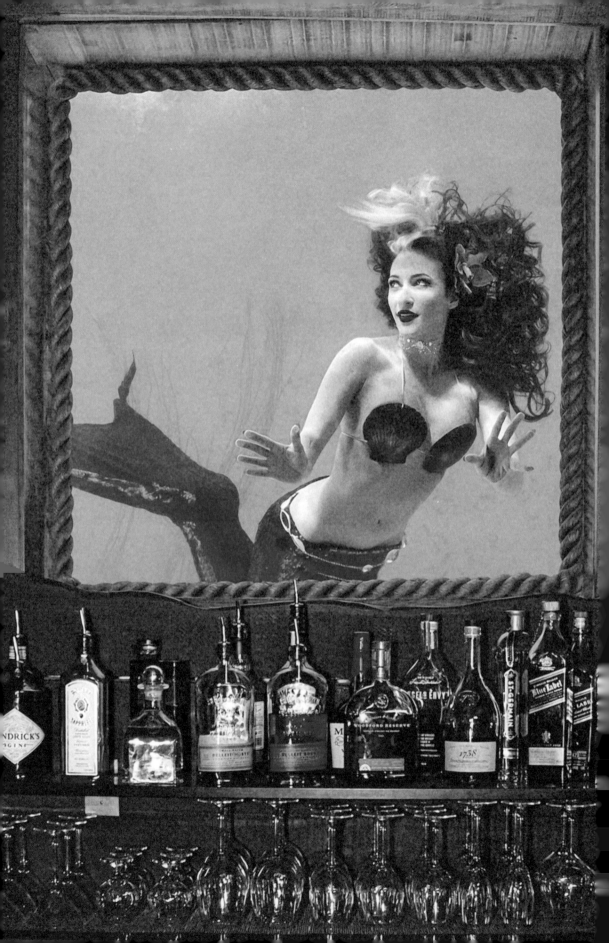

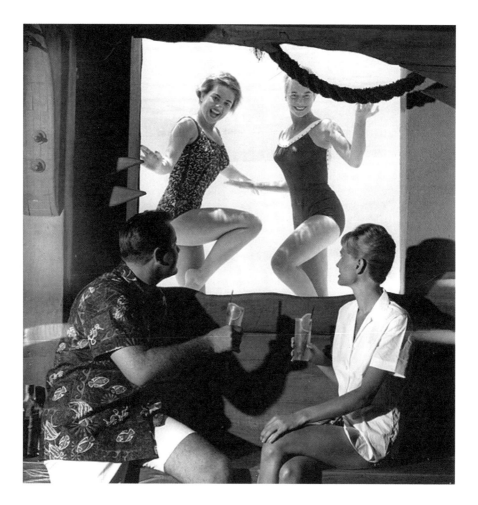

THE WRECK ❧ The Yankee Clipper hotel, also in Fort Lauderdale, opened its lounge, the Wreck, in 1956. In keeping with the hotel's nautical theme, the lounge had the decor of a Spanish galleon; it also featured underwater performances. The hotel was the "it" place to visit when it opened and attracted glittery patrons like Joe DiMaggio and Marilyn Monroe, who were frequent visitors and even carved their names into the bar itself.

Though the shows stopped in 1962, mermaid performer MeduSirena regenerated interest in the bar when she started the retro-aquatic shows up again in 2006, in an effort to renew interest in underwater entertainment—or, as she calls it, "retrotainment preservation." If you're looking to take a step back to the golden age of the porthole lounge, you can still catch performances by MeduSirena and her Aquaticats every Friday and Saturday at 6:30 P.M., when patrons pack into the small, historic bar to see these mermaids gliding gracefully past the bar windows, smiling and blowing kisses at the crowd as they perform aquatic dance and acrobatics in the pool outside. At 9:30, the pod returns for a more adult, burlesque-themed show.

OPPOSITE: MeduSirena performing at the Wreck Bar. When she designed the retro–inspired mermaid shows, she says she wanted the performers to "look as if they were wearing glamorous dresses that just happened to serve as fish tails." + *ABOVE:* A promotional photograph for the Wreck Bar, late 1960s. The two mermaids were "on loan" from the Two Fathoms Down Lounge at the Marlin Beach Hotel.

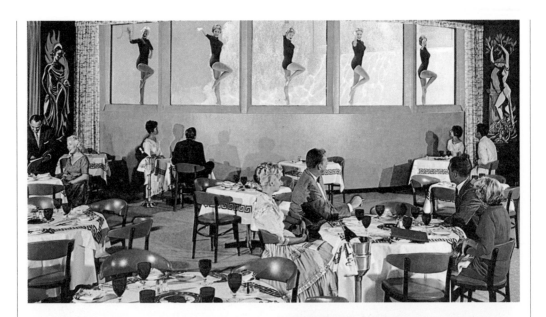

THE EVERGLADES ✵ In 1958, Miami's

Everglades Hotel underwent a massive renovation. The jewel in the crown: a new rooftop lounge complete with a porthole pool. The Everglades recruited none other than Donna Jean Korosa, the first cocktail lounge mermaid, to train a new group of performers at her mermaid school. One of these performers, Sharon Lee, had something special, and she and Korosa teamed up to form a dynamic underwater duo. Based on the amount of glowing local press given to the pair, it was clear that they, along with their shows, were not to be missed when visiting the area. Sadly, though, the Everglades Hotel never really took off as a business. There have been whispers of mob involvement and other sordid tales best left to fade into history.

SHAKER HOUSE HOTEL ✵ Since

summer is the off-season at most South Florida beaches, Donna Jean and Sharon did an underwater show at the Shaker House Hotel in Shaker Heights, Ohio, where drink specialties in the lounge included the Mermaid's Delight for the ladies and the King Neptune for the gentlemen.

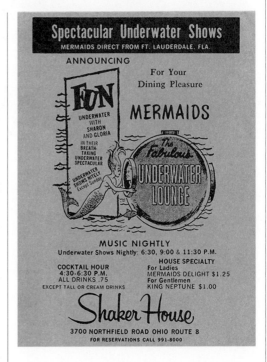

Donna Jean and Sharon's performances were a huge hit, and for four years the mermaids split their time between Florida and Ohio, before finally retiring to start families and lead non-mermaid lives.

TOP: A 1958 promotional postcard for the new rooftop lounge at Miami's Everglades Hotel.
BOTTOM: A late 1950s tabletop ad for Donna Jean Korosa and Sharon Lee's show at the Shaker House Hotel.

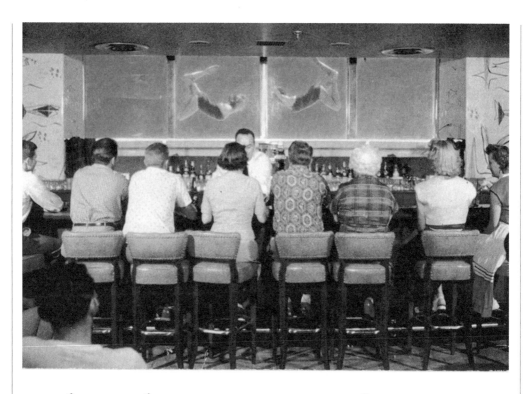

THE HACIENDA HOTEL MERMAID ROOM

If you found yourself traveling Highway 99, you could spend an evening at the Hacienda Hotel in Fresno. The hotel opened its Mermaid Room in 1956, which was described in the local newspaper as a place where "you could sit at the bar and sip and ogle a tall cool one all at the same time." The Hacienda had quite a list of A-list guests doing just that: Frank Sinatra, Jerry Lee Lewis, Redd Foxx, and Nat King Cole all took in a mermaid performance or two.

THE EL RANCHO MOTEL MERMAID ROOM

Several other lounges offered underwater shows to varying degrees of success. In Millbrae, California, the El Rancho Motel created an underwater lounge, the Mermaid Room. The lounge featured nightly underwater shows that were frequented by the likes of Bing Crosby as well as Richard Nixon, who stopped in several times during his 1956 vice presidential campaign.

THE SEA HORSE LOUNGE

The Sea Horse Lounge at the Southwind Motel in Rock Island, Illinois, tried to make its mark with underwater lingerie shows. It took the city only six weeks to put an end to those. The bikini shows that followed proved to be less popular.

DAVY JONES LOCKER

The Reef Hotel on Waikiki Beach had an underwater lounge called Davy Jones Locker, and the patrons at the bar were often entertained by "adult" activities carried out in the pool by swimmers who were unaware of the pool's windows. The bartender also kept a Polaroid camera handy to capture any swimwear malfunctions, which were often caused by use of the diving board located above one of the windows. These photographs were rumored to have filled several photo albums.

ABOVE: Patrons enjoy the underwater show at the Hacienda Hotel, mid-1950s.

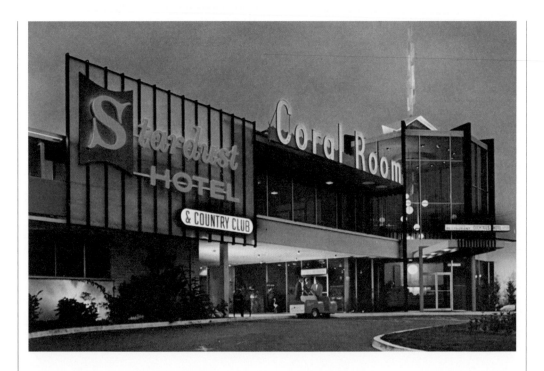

THE REEF LOUNGE ❧ The lounge with perhaps the wildest stories is the Reef Lounge, once located in the Stardust Hotel and Country Club in San Diego. The lounge became famous in the late 1960s, thanks to a midnight show that featured topless mermaids as well as underwater go-go dancers, who were mostly San Diego college students. The *Los Angeles Times* reported that one of the mermaids actually earned San Diego City College credit for her "life experience" swimming at the Reef. The tales from the 1970s include professional football players jumping in with the mermaids and even a *Star Wars*–themed show. The shows eventually began to wane in popularity, and the lounge closed around 1980.

These underwater shows, which began in the 1950s, enjoyed tremendous popularity throughout the next decade and a half before falling victim to changing times. However, thanks to the continuing love for all things mermaid, these pioneering performers and the places they performed are now being recognized for the contributions they made to the evolution of the underwater show and are inspiring a new generation of mermaid lounges, including those featured on the next few pages.

ABOVE: The Stardust Hotel (now the Handlery Hotel), San Diego, 1960s.

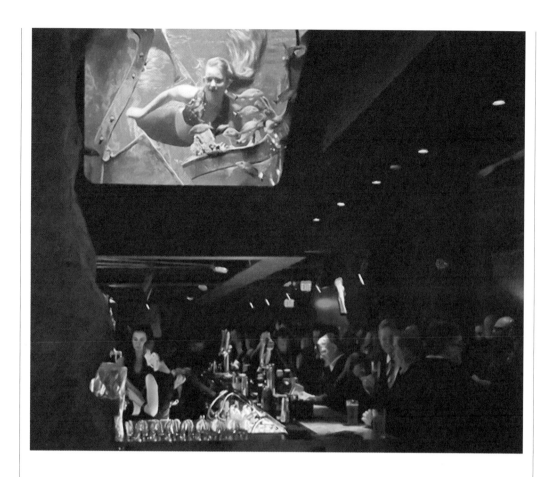

DIVE BAR ❦ Inspired by midcentury aquatic shows and the glitter and sparkle of Las Vegas, George and Lynda Karpaty opened Dive Bar in 2011 on one of Sacramento's main drags, installing a forty-foot-long, four-and-a-half-foot-deep, and four-and-a-half-foot-wide tank above the bar that can hold up to five merpeople at a time. These sirens perform for huge crowds during happy hours and evening shows, doing backflips, underwater contact juggling, and hand-stands; blowing bubble rings; twirling bottles; and generally interacting in a lovable mermaid fashion with the crowd below. To get the job, aspiring mers go through a rigorous audition process that begins with sit-down interviews, moves forward with two in-tank auditions, continues with a monthlong training process, and ends with an *American Idol*–type competition where the public votes for the winners.

The same year Dive Bar opened, Sacramento held its first annual Promenade of Mermaids; a take on the Coney Island Mermaid Parade, it snakes its way through Old Town. Within a few years, the promenade had expanded into an entire Mermaid Weekend, which also features beach cleanups, movie screenings, lectures, special Dive Bar shows, photo shoots, and more. In 2016 new owners came on board; plans are in the works to make Dive Bar not just "a bar with mermaids," as head mermaid Rachel Smith puts it, but "a mermaid bar." "It'll be mermaid as all get-out," she says.

ABOVE: Head mermaid Rachel Smith is suspended over the crowd at Sacramento's Dive Bar.

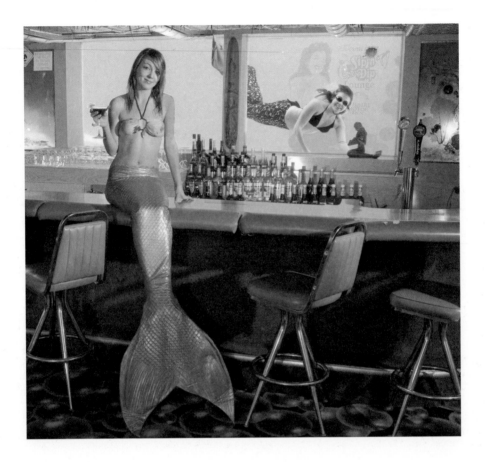

SIP 'N DIP ❧ The Sip 'n Dip Lounge is a classic 1960s tiki bar, where, four nights a week, mermaids swim in an underground outdoor pool adjacent to the bar and visible to guests through the bar windows. Though the bar itself has been around since the 1960s, it wasn't until New Year's Eve 1994 that its first mermaid arrived on the scene, after owners Sandra Thares and her mother, Jan Johnson, joked that it'd be funny to have a mermaid appear in the pool for the holiday. They rounded up one of the housekeepers, put her in a bathing suit, and duct-taped a green tablecloth to her legs, and a tradition was born. Now there are five mermaids on staff, and Sandy sews all the mermaid tails herself. Even Daryl Hannah has shown up, shimmied into a tail, and taken a dip in the pool.

ATLANTIS LOUNGE ❧ After Benny Buttigieg visited Dive Bar in Sacramento, he decided to open a mermaid bar of his own in Adelaide, Australia. "I've always had a fascination with the ocean," he says, "and decided to make my fantasy a reality with a mermaid aquarium." He bought an existing bar and did extensive renovations, and then had a grand opening in May 2016. This upscale bar features mermaids who blow kisses to the crowd and play rock-paper-scissors in a twenty-five-thousand-liter aquarium right in the middle of the floor. The tank is set up to house scuba divers and giant clams too. According to Buttigieg, "There's been a great response from patrons, especially women. It reminds them of their childhood growing up watching *The Little Mermaid*."

ABOVE: A mermaid sips a martini at the Sip 'n Dip Lounge in Great Falls, Montana.

Mermaids at Aquariums and Renaissance Fairs

IN THEIR BID TO take over the human world, mermaids have not only infiltrated the waters of local bars, but also started appearing at aquariums and Renaissance fairs around the world.

At Denver's Downtown Aquarium, the Mystic Mermaids put on one to four shows a day, teaching children about ocean 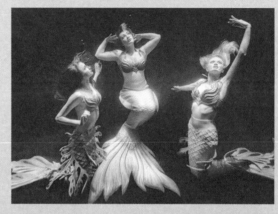 conservation while they hang out with barracudas, nurse sharks, sting rays, and other shimmery friends. They've appeared, too, at Ripley's Aquarium of Myrtle Beach; the Austin Aquarium; Adventure Aquarium in Camden, New Jersey; South Carolina Aquarium; Bristol Aquarium in the United Kingdom; the Dubai Aquarium and Underwater Zoo; and many more.

By 2012, mermaids had begun to attend Renaissance festivals, after Merbella's Live Mermaid Exhibit & Show made its debut at the Bay Area Renaissance Festival in Tampa Bay, Florida. Now dozens of Renaissance fairs feature mermaids regularly, usually in small sideshow tanks where they peer out at the audience. The biggest show is at the Arizona Renaissance Fair, where over eight weekends in February and March one can find the incredibly popular Sea Fairies, the "living mermaid exhibit" designed by artistic director/mermaid trainer Kathy Shyne. Mermaid lovers wait in long, snaking lines to enter the magical, custom-built space, where live mermaids perform in a massive tank and also lounge around in a giant seashell next to it for photo ops. Velvet curtains close and open dramatically as each new mermaid makes her debut, swimming elegantly, doing bubble tricks and backflips, and generally dazzling the audience with her ocean glamour as ambient music plays and the sound of bubbles echoes over the hushed crowd. Thousands of people visit the mermaids every day, happy to wait over an hour in line to spend just a few minutes with the magical beings.

ABOVE: "If there was a time people believed in mermaids," says Kathy Shyne, artistic director of the Arizona Renaissance Fair, "it was during the Renaissance, with the exploration and discovery, the sailing out into the great unknown."

The CONEY ISLAND MERMAID PARADE

EVERY SUMMER SINCE 1983, ON A SATURDAY IN June, throngs of New Yorkers dress up in their finest mermaid garb and take to the streets of Coney Island to march in the Coney Island Mermaid Parade, which has surpassed Independence Day as the top business day and attendance day during the entire Coney Island summer season. There are usually a few thousand participants, clad in outfits both outlandish and risqué, and hundreds of thousands more watching—old, young, and everywhere in between. Every year features a new King Neptune and Queen Mermaid; past kings and queens have included celebrities like Debbie Harry, Lou Reed, Laurie Anderson, David Byrne, Queen Latifah, and Harvey Keitel.

The ground was laid for the parade in 1980, when founder Dick Zigun founded a not-for-profit arts organization, Coney Island USA. The group did a couple of projects in the community but had no physical presence in the neighborhood. After a few years, they decided to do something big to establish that presence and to let everyone know what their arts organization was capable of. With a background in art, Zigun knew that ancient theater "emerged from parades and spectacle." He'd also grown up in P. T. Barnum's hometown of Bridgeport, Connecticut, where, once a year, a huge July 4 parade draws visitors from all over the world, and he took a cue from that, filing a permit to hold a July 4 parade on Coney Island. They "laughed at me because the Fourth of July was already the busiest day of the season," he says,

but told him he could pick any other day to hold a Barnum-style parade.

In Coney Island, the main drags are named Mermaid Avenue and Neptune Avenue. Part of Zigun's purpose was to bring pride and education to the neighborhood, so he was inspired to draw from that same ocean mythology that's embedded in the Coney Island map but that the locals might not necessarily be versed in. He did research, too, into the early days of Coney Island and Atlantic City, especially into the old-time Mardi Gras parades and the earliest versions of the Miss America pageant in Atlantic City, which stemmed, he says, from "mermaid competitions." Add to that his awareness of world culture and the tradition of offering gifts to the water spirits, like Mami Wata and Yemaya, around the time of

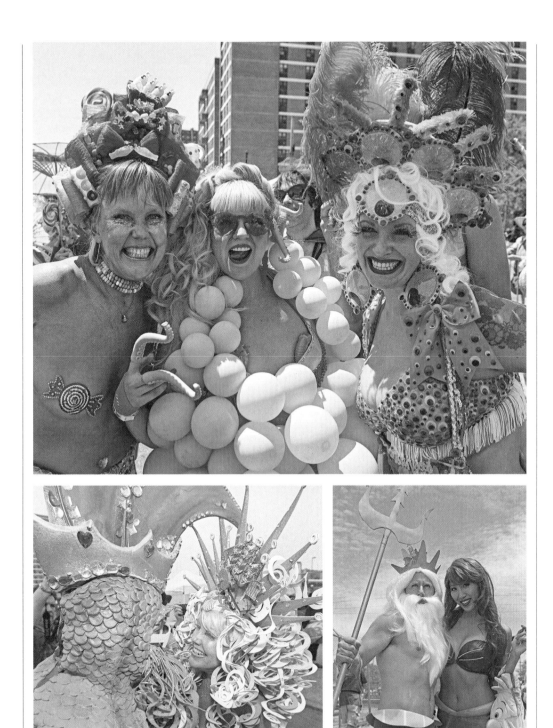

Top: Bambi the Mermaid, unofficial Queen of Coney Island, celebrates with friends. + *Bottom, left:* Bambi the Mermaid and Chuck Varga (of heavy-metal band GWAR fame) celebrated their 2017 wedding at the Coney Island Mermaid Parade. + *Bottom, right:* A Neptune and a Little Mermaid pose midparade.

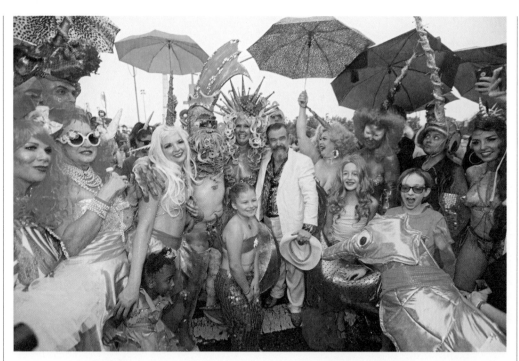

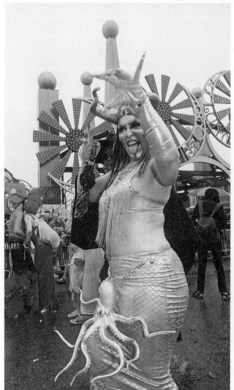

Top: Another shot of Bambi the Mermaid's 2017 wedding party.
Bottom, left: A sea witch reveler against the carnival-esque backdrop.
Bottom, right: A trio of mermaid-esque clowns stops to strike a pose.

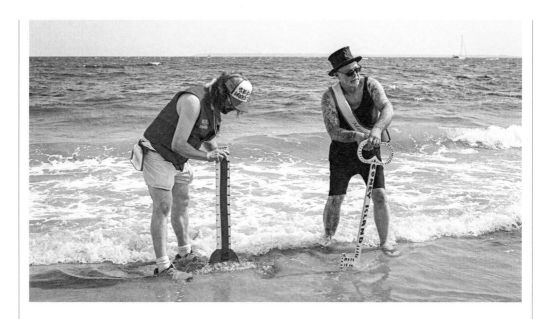

the summer solstice, and the initial idea for the Mermaid Parade started to take shape. His vision was to create a massive ocean-themed parade in which all New York artists could participate and that would be held every June on the Saturday that was closest to the solstice. Zigun loved the absurdity of holding a mermaid parade, too, as technically, mermaids don't have feet. "Great art," he says, "is often simple."

The mermaid parade is not a beauty contest, Zigun stresses, but open to everyone, and prizes are awarded for creativity rather than good looks: Best Mermaid Costume, Best Neptune Costume, Best Motorized Float, and Best Marching Group are some of the awards up for grabs. Some participating groups include up to fifty people who spend a whole year coming up with a theme and a corresponding float and costumes. Zigun was especially impressed by a krewe that drove a full-fledged yacht down Surf Avenue on a trailer. Some artists will rent flatbed trucks from which rock 'n' roll bands can perform, and one year a truck contained a miniature ice rink around which a winged lady

skated as the crowds cheered below her. Another year an elephant from the Ringling Bros. and Barnum & Bailey circus walked in the parade. There might be a mermaid with a costume made entirely of used Metro cards; there might be a "cork man" on a unicycle; couples have been married right in the middle of Surf Avenue.

It's the rare person "who gets to invent a holiday," Zigun says, but the Coney Island Mermaid Parade has become part of the way New York City celebrates summer, rain or shine, just as the season begins. In a neighborhood like Coney Island, "excess is never enough"; every year the parade culminates in a ribbon-cutting ceremony at the water, "our tongue-in-cheek version of the traditional world culture offering to water gods," says Zigun. Led in a procession by the king and queen down to the water, revelers carry baskets of fruit, which they hurl into the ocean as the king and queen cut through four ribbons representing the different seasons. Zigun himself, "unelected mayor" of Coney Island, turns a giant key in the Atlantic to "open" the sea for summer.

Above: Coney Island Mermaid Parade creator Dick Zigun "unlocks" the ocean
at the end of each year's parade.

Miss America Mermaids

IN 1920, ATLANTIC CITY hotel owner H. Conrad Eckholm proposed that the local Business Men's League sponsor a Fall Frolic at the end of September, to extend tourist season past its traditional end, Labor Day, and to make some serious cash. Initially, the Frolic was to include a boxing match, a marathon road race, and a parade—but it ended up being cut down to an International Rolling Chair Pageant, which featured 350 rolling wicker chairs with beautiful women sitting inside gliding down the board-walk and was, of course, a mass success.

The event was so successful that city officials decided to hold the Roll-ing Chair Pageant the next year as well, this time making it a weekend-long bash and renaming it the Atlantic City Fall Pageant. This time around, it included the rolling chair parade as well as a Bather's Revue, a "Night Spectacle with the Frolique of Neptune," and the Inter-City Beauty Contest. In one planning meeting for the beauty contest, Herb Test, a reporter for the *Atlantic City*

Daily Press, cried out, "And we'll call her Miss America!"

The first contest had only eight contestants, who came in from all over the Northeast and were treated like royalty. For the pageant itself, King Neptune, played by eighty-year-old smokeless-gunpowder inventor and local celebrity Hudson Maxim, arrived beachside in a yacht, carrying a trident in one hand and a Golden Mermaid trophy in the other, surrounded by a splendidly costumed entourage. King Neptune and his entourage then led the eight beauties to the Keith Vaudeville Theater, where they passed before a panel of judges. Sixteen-year-old Mary Pickford look-alike Margaret Gorman was named the first Golden Mermaid. Newspaper photos show her wearing a jutting shell crown and a sparkling dress, draped in an American flag.

In 1922, fifty-eight contestants showed up for an even larger spectacle, with King Neptune leading a parade of the beauties themselves plus twenty-one brass bands, two orchestras, and

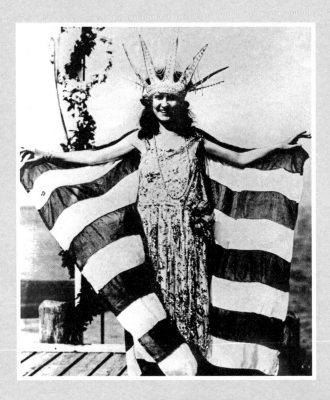

250 rolling chairs and floats. The *New York Times* reported that King Neptune "stood in his long robe and seaweeded crown with his trident, surrounded by his court of beauty, selected from Atlantic City girls, on an elaborately decorated barge, drawn by a launch, disguised as a dolphin. When the barge reached the wharf of the Atlantic City Yacht Club, a shower of scentless flowers was hurled at the old sea king [who was allergic to all fragrance] by the sixty or more intercity beauties, and by thousands of spectators who swarmed about them." Judges included Norman Rockwell and Flo Ziegfeld. In 1923, the contest had more than seventy contestants and more than three hundred thousand on-site spectators.

Many other pageants emerged over the next few decades in Atlantic City, including an annual Miss Mermaid contest, the winner of which would hold a giant key with the words "Key to the Atlantic Ocean" on it. Every Memorial Day she'd "unlock" the sea and tourist season would begin. As it happens, the 1953 Fellini film *I Vitelloni* opens with a Miss Mermaid beauty pageant in a town on the Adriatic coast, with a sash being placed around the thrilled winner just as a storm blows in.

Above: The first Miss America winner, Margaret Gorman, 1921.

A YOUNG MAN'S GUIDE *to* PICKING UP MERMAIDS

—LORD WHIMSY

I T SHOULD COME AS NO SURPRISE THAT THE relations between humans (Homo sapiens) and mermaids (Homo sirenus) have long been fraught with misunderstanding. After all, a mermaid's submerged perspective on life is bound to be alien to our own landlocked point of view. However wide the gulf may be between mermaids and humans, there is much that we can do to lessen the friction along our shared shorelines. In fact, there is a veritable shoal of extremely thick books on the finer points of etiquette and manners between humans and mermaids (Roger T. McBrine's *Guide to Manners and Customs Among the Pelagic Races* remains the definitive work on the subject).

So this topic, being well-trodden sand, does not require further elaboration by Yours Truly. And besides, my intentions in this case are not in the least bit honorable.

We're all adults here, so let's be honest: mermaids—with their winsome gaze, silvery complexions, and graceful curves—are sexy. You know it, and they know it. They don't call them sirens for nothing. Besides,

a tryst with a mermaid is the stuff of summertime daydreams, the memories of which will warm your feet in your old age, especially during those cold, dark winter days that await us all. To never have tried romancing a mermaid is to truly know the bitter taste of regret: you only go around once, after all.

It's a well-known fact that mermaids are a vain but sensitive lot; one often sees

them conspicuously perched on jetties and rocks in the middle of harbors, combing their long, lustrous curls. Although they may affect an aloof air, the mermaids know very well what they are doing: they love nothing more than to be admired. This girlish, coy tactic for attention is often misread as narcissism, but it is actually the result of insecurity. Indeed, the feelings of mermaids are easily hurt. Rude catcalls and vulgar turns of phrase shouted by passing fishermen have done untold harm over the years (as do their trawling nets, which have caused no end of instability in the mermaid real estate market).

When wooing a mermaid, persistence is key. Start with subtle gestures: a respectful tip of the hat will do, perhaps with a "G'day, miss" thrown in after a few encounters. Above all, remember to let her make the first move: if she wishes to make conversation, she will. In fact, mermaids can be quite chatty—in the most charming sense, mind you.

It helps to have something in common, so brush up on your marine biology, maritime lore, shipwrecks, tide tables, even shanties. Some gents have gone so far as to learn how to dive (mermaids especially like fellas who have mastered free diving). However, being a spear fisherman is a nonstarter; it's best not to even bring up the subject.

Once you've had a few friendly conversations, it's time to take things to the next level: ladies love a man who can cook. Offer to make lunch one day, and have a seaside picnic together. It doesn't have to be anything fancy: a bento box of sushi or some udon soup with seaweed broth is always a smart choice. Anything with terrestrial meats—chicken, pork, beef—is not a good idea. Keep it fishy: broiled scallops and clam chowder are irresistible comfort foods to mermaids. (A warning: mermaids are lactose intolerant, so no cheeses or ice cream, please. Don't force her to broach such an awkward topic.)

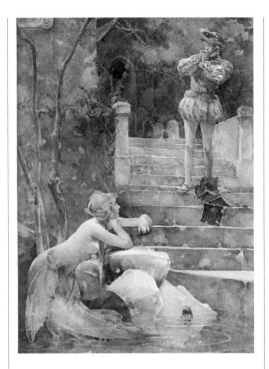

She will be flattered by small but thoughtful presents: Give her a new seashell comb that you've carved yourself. Or a seal pup. Or that scale polish that she likes so much. You know: the coconut-scented one.

Helping her with the less glamorous tasks, like getting fishing hooks out of her hair, will show her that you're committed to her happiness and comfort. In short: Treat your girl right. Listen to her. Appreciate her. Fuss on her. Let her know that she's your minnow, and that the tides of your heart flow only to her.

But before you start a relationship with a mermaid, it's important to realize that, sadly, these things don't last. There will be sun, fun, and sand, sure, but there will also be tearful good-byes. Just be sure that when the inevitable comes, both of you leave with fond memories. A bit sadder, yes—but wiser, perhaps even fulfilled. You will have learned firsthand that the most fleeting things are often the most beautiful.

OPPOSITE: Lord Whimsy pondering the habits of mermaids.
ABOVE: *The Mermaid of Zennor*, John Reinhard Weguelin, 1900.

IV. Food, Entertaining & Stories of the Sea

MERMAIDS
and
MANATEES

WHO CAN BLAME THOSE LONELY EXPLORERS and sailors, stuck at sea for months at a time, if they occasionally peered down into those deep swirling waters and happened to see a fair fish-tailed maid staring back at them?

Of course, the occasional mermaid may very well have taken pity on those lonely hearts or been driven by curiosity to pay them a visit or even entertain them with a tune or two—not all mermaids are bent on destruction, after all.

Sadly, sailors' reports throughout history have been debunked by jealous landlubbers who claim that, in their lonely, drunk, sea-sick, and not-having-seen-a-human-woman-in-months stupor, these sailors were in actuality espying manatees, dugongs, or even seals. Others balked at the idea that such ungainly creatures could be mistaken for glimmering sirens. In 1878, the *London Telegraph* printed an article, "The Manatee: Prosaic Basis of Mermaid Tales—An Un-Attractive Monster," in an attempt to put these claims to rest forever. It was reprinted in the *New York Times* on July 5, 1878:

ROYAL AQUARIUM,
WESTMINSTER.

THE
MANATEE,
OR,
WEST INDIAN MERMAID.

The animal just arrived is so rare as to be almost extinct, and is the second specimen only which has ever been brought to Europe.

The ancients, in their voyages to Eastern climes, gathered stories concerning the existence of strange creatures, half woman, half fish, chiefly frequenting the shores of Taprobane (Ceylon); and fancy, with oft-told but unchecked repetition of tales, soon lent a charm to the supposed beings, by conferring on these sea-nymphs imaginary flowing tresses, and sweet dulcet voices, by whose luring wiles the unwary mariner was entrapped, or led to destruction.

Howsoever ridiculous such notions may now be regarded, they are, nevertheless, to be satisfactorily explained, for the singular Manatee, with its fish-like tail, roundish head, and mammæ on its breast, has the habit of occasionally raising half of its body perpendicularly out of the water and clasping its young to its breast.

These actions have, doubtless, given a colourable pretext to all the fables of mermaids—those "missing links," which even yet our children delight in, when narrated in "The Little Mermaid," by the talented pen of a Hans Andersen.

G. Purss, Printer, 13 & 14, Tothill Street, Westminster.

PAGES 172–173: Horrors, my wife!, illustration by Webster Murray for *The Tatler*, April 11, 1928. *OPPOSITE: She Dived Deep Down Under the Water, Rising Again Between the Waves,* an illustration by Honor Charlotte Appleton for "The Little Mermaid," from *Fairy Stories by Hans Christian Andersen,* 1920. + *ABOVE:* Advertisement for the manatee, or "West Indian Mermaid," at the Royal Aquarium, in Westminster, London, June 1878.

THE MANATEE:

PROSAIC BASIS

OF

MERMAID TALES

—AN

UN-ATTRACTIVE

MONSTER

FOR EYES IT has circular apertures which can neither remain wide open nor shut up tight, but are constantly contracting and expanding, perhaps at the will of the manatee, though apparently of their own motion. For nose it has two holes with lids, and when it rises to the surface of the water for breath the lids open, and when it sinks again they shut. The ear-holes are too small to be seen without keen searching, and are simply such holes as might be made anywhere with a gimlet. For mouth it has an opening with a flap over it, convenient as preventing things from going down its throat when the owner is not hungry, but sufficiently ugly to make the manatee the most humble of creatures; and humble, indeed, it looks. Having no legs, it stands on its tail, and to keep its balance has to bend the head forward and bow the body. In this attitude of helpless humility the strange thing stands motionless many minutes together, and then, with a ghost-like dreadful solemnity it begins slowly to stiffen and straighten its tail, and thus gradually arising into an erect posture, thrusts its nostrils above the surface. But only for an instant, for ere it seems to have had time to take a breath, the great body begins to sink back into its despondent position, and the small paddling-paws drop motionless and helpless as before. The deliberate sloth with which the manoeuvre is executed has something of dignity in it, but otherwise the manatee is as ridiculous as it is helpless. The clumsy snout is constantly twitching like a rabbit's but the gesture that seems so appropriate in the nervous, vigilant little rodent is immeasurably ludicrous in the huge monstrosity. The eyes, again, now contracted to a pin's point, now expanded full to gaze at you with expressionless pupils, seem to move by a mechanism beyond the creature's control. Voiceless and limbless, the bulky cetacean sways to and fro, the very embodiment of stupid, feeble helplessness, a thing for shrimp to mock at and limpets to grow on.

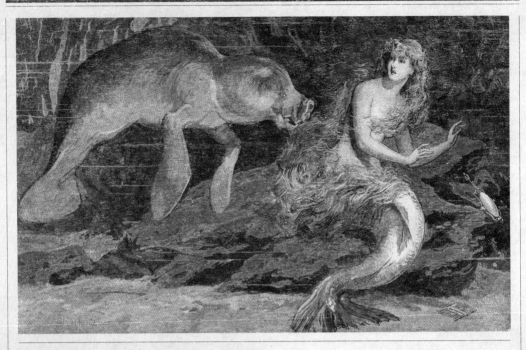

ABOVE: Real and Ideal, a Suggestion Which Occurred to Our Artist on Seeing the New Manatee at the Zoological Gardens. Illustration for *The Graphic*, artist unknown, May 18, 1889.

A CARCASS of such proportions, such an appalling contour, should, to satisfy aesthetic requirements, possess such stupendous villainy of character; should conceal under this inert mass of flesh such hideous criminal instinct. Yet this great shapeless being, this terror of the deep sea, is the most innocent of created things. It lives on lettuce. In its wild state it browses along the meadows of the ocean bed, cropping the sea-weeds just as kine graze upon the pastures of earth, inoffensive and sociable, rallying as cattle do for mutual defense against a common danger, placing the calves in the middle, while the bulls range themselves on the threatened quarter. These are the herds which the poets make Proteus and the sea-gods tend, the harmless beeves with whom the sad Parthenope shared her sorrows! These are the actual realities that have given rise to so many a pretty fiction, the dead carcass from which have swarmed the bees. The discovery is disappointing enough to those who cherish old-world fancies; but to science, the lazy, uncouth manatee is a precious thing. Science, indeed, has seldom had such a pleasing labor as the examination and identification of this animal, for, though so ludicrously simple in appearance, the manatee is a veritable casket of physiological wonders. It is the only creature known that has three eyelids to each eye and two hearts. In most of its points it bears a close affinity to the elephant, but in others of equal importance it is unmistakably a whale. Its "teeth," bones, and skin are all delightful studies to the naturalist, and he is thankful, therefore, that the manatee is what it is, and not the veritable mermaid that less prosaic minds would have it.

MERMAIDS *at* SEA

—*Stephen D. Winick, PhD*

AS MERMAIDS ARE AMONG THE MOST POPULAR of folklore's magical creatures, people often assume there are hundreds of folk songs and ballads about them. In fact, mermaid songs are rare, and if you want a genuine, traditional, English-language folk song about a mermaid, there aren't many choices. If you want one that has come down to modern times in the oral tradition, there's really only one: a ballad known simply as "The Mermaid," which has been in constant circulation, both orally and in print, since the seventeenth century. Mermaids weren't considered good luck at sea. On the contrary, seeing one almost always spelled disaster.

In "The Mermaid," a group of sailors see a mermaid sitting on a rock, a comb and mirror in her hand. They immediately begin to plan for their own deaths, and by the end of the song, they've been drowned. The great shipwreck ballad "Sir Patrick Spens" also tells the tale of a perilous sea voyage, which is doomed from the outset when the king chooses an unskilled captain. In some versions, before their inevitable shipwreck, the sailors see several signs warning them of their doom, including "the new moon with the old moon in her arms," a traditional sign of heavy weather. In a very few versions, they see the exact same apparition as the captain in "The Mermaid": "Then up did raise the mermaiden / With the comb and glass in her hand." Moreover, this mermaid directly voices the bad news, telling Sir Patrick: "You never will see dry land!"

Keep in mind, though, that the mermaid herself doesn't sink the ship. Nor does she entice the sailors to abandon ship, like the Greek sirens did. In "The Mermaid," as well as in "Sir Patrick Spens," a storm arrives just after she is sighted, and that's what causes the ship to go down. But if the mermaid is not a cause but a sign or symbol of the sailors' fate, why should a mermaid symbolize death at sea? Perhaps because, as land creatures who choose to live on the water, sailors constantly expose themselves to the danger of drowning. What could be a better reminder of this than a mermaid, a creature that seems to be human, but that has exactly what the sailor both needs and lacks: the natural ability to live in the water? The mermaid is a potent symbol of the danger of drowning, and it's only natural that she should be on men's minds when such danger arises.

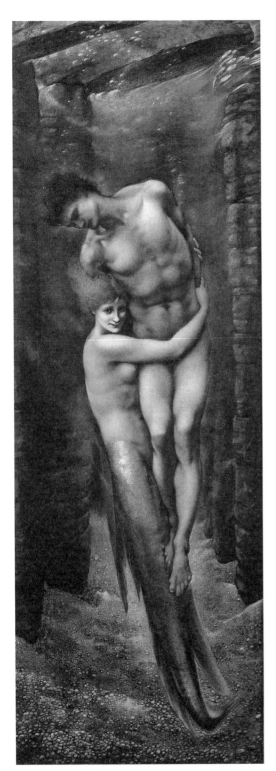

One Friday morning we set sail,
It was not far from Land,
Where I espied a Fair Mermaid,
With a comb and glass in her hand.

CHORUS:
For the stormy winds do blow,
And the raging seas do roar;
While we poor seamen go up to the top,
And the land lubbers lay down below.

The boatswain at the Helm stands,
Steering his course right well,
With the tears standing in his eyes,
Saying Lord how the seas do swell.

Then up spoke a boy of our gallant
 ship,
And a well speaking boy was he,
I've a Father and Mother in fair
 Portsmouth Town,
And this night they will weep for me.

—"The Mermaid"
 Author unknown, published on a
 broadsheet by Armstrong printers of
 Liverpool, England, between 1820 and 1824;
 transcribed by Stephen D. Winick, PhD

Above: The Depths of the Sea, Edward Coley Burne-Jones, 1886.
Pages 180–181: The Mermaid's Rock, Edward Matthew Hale, 1894.

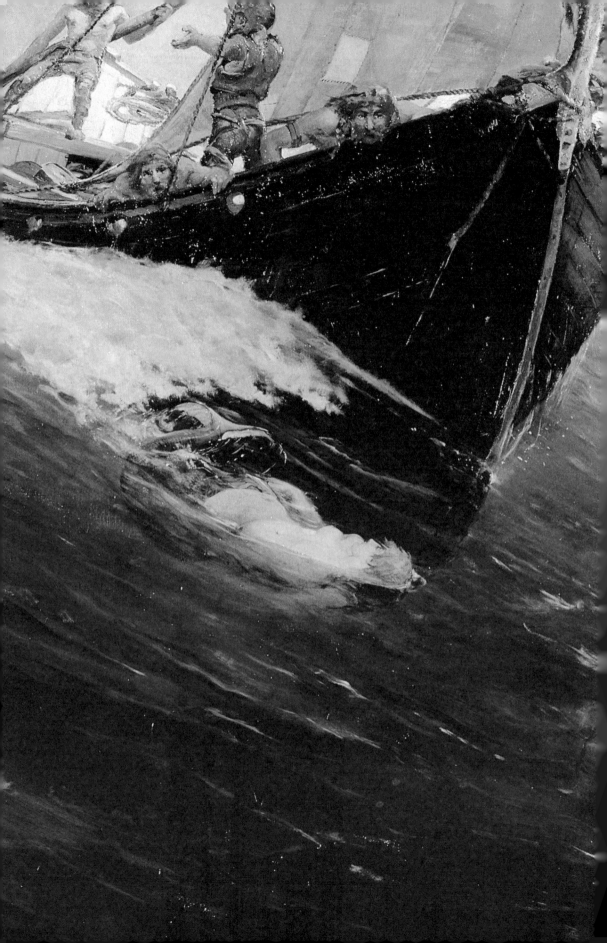

A mermaid found a swimming lad,

Picked him for her own,

Pressed her body to his body,

Laughed; and plunging down

Forgot in cruel happiness

That even lovers drown.

—WILLIAM BUTLER YEATS
"A Man Young and Old," 1926

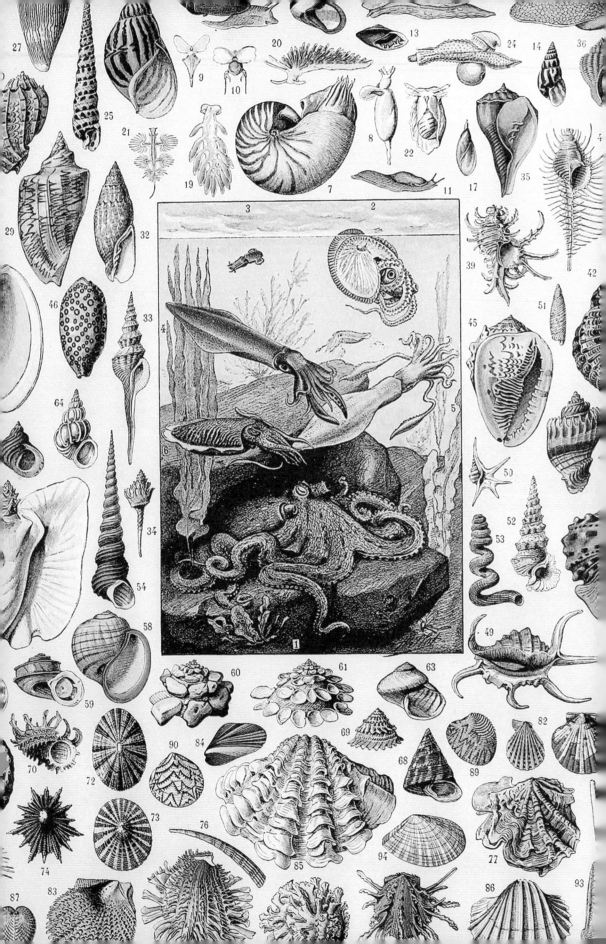

CONCHYLOMANIA

> The sea does not reward those who are too anxious, too greedy, or too impatient. One should lie empty, open, choiceless as a beach—waiting for a gift from the sea.
>
> —ANNE MORROW LINDBERGH
> *Gift from the Sea*, 1955

In the eighteenth century, ships from the Dutch East India Company brought back all kinds of wondrous items to Europe from the New World, including spices and porcelain, as well as exotic seashells from what is now Indonesia. The allure of these shells sparked a craze known as conchylomania, from the Latin "*concha*" for "shellfish," when frenzied collectors sought (and paid top dollar for) the most rare and delicate specimens and displayed them in private museums. At an auction in eighteenth-century Amsterdam, a single shell sold for 299 guilders, and another for 273 guilders; Vermeer's *Woman in Blue Reading a Letter*, on the other hand, sold for a measly 43 guilders. To put it into perspective, Vermeer paintings were in abundance and more or less readily available at the time, while shells from faraway lands were considered rarities and were highly collectible.

Conchylomania rivaled the Dutch obsession with collecting and cultivating tulip specimens the century before. In her book *Tulipmania*, Anne Goldgar tells the story of Dutch collector Abraham Casteleyn, who, upon his death in 1644, not only had enough tulip bulbs to fill a thirty-eight-page inventory (the tulips were "laid out in labeled drawers and little boxes" in his house), but also had

OPPOSITE: *Illustration of Seashells*, Adolphe Philippe Millot, c.1923. + ABOVE: Italian ballet dancer Fanny Cerrito performs in *Ondine* in this unattributed engraving from 1843.

2,389 shells that he'd stashed in a chest with three different locks. The three executors of his will each had a single key so that the chest could only be opened when all were present.

Shell collectors today are no less passionate. Florida's Sanibel and Captiva Islands, where shells wash ashore in glimmering heaps from the deep ocean and are so plentiful that they are sometimes layered four feet thick on the shore, are meccas for shell collectors worldwide. Sanibel has a unique crescent shape and a coastline running west to east rather than north to south; the wind can funnel more than three hundred varieties of shells there some days. Pam Rambo, resident of Sanibel Island, popular blogger, local "shellebrity," and author of *Pam Rambo's Guide to Speaking Shellanguage*, considers every visit to the beach a treasure hunt. An avid beachcomber since childhood, she says, "I'm tied to the sea. We [those of us who love shelling] feel like we're displaced mermaids. That's the draw.

And each shell is like a magical piece of art that washes right up to your toes." In her "shellaboratory," located in her garage, she keeps bin upon bin of specimens she's found, and she considers each new shell an opportunity to learn more about the ocean and its secrets. She calls sand dollars, sponges, starfish, and the like "beach bling" and has made shell art for years with it, including a mirror encrusted with more than one thousand shells that she refers to as "Shell-huly," after glass artist Dale Chihuly.

Since 2016, Sanibel's Lee County has declared the first day of summer National Seashell Day. Rambo was involved in the proclamation, dressed as a junonia shell and blowing into a conch shell. To commemorate the inauguration of the holiday, she wanted to do something spectacular and mobile—and came up with the idea to cover an entire car with shells to make the "biggest mobile sailors' valentine on the planet." The visitor's bureau

supported the idea, donating a Volkswagen Bug to the project. And with help from dozens of community members and shell enthusiasts—including the Sanibel Shell Crafters, "women used to gluing shells on stuff"—the Shell Love Bug was born after twelve hundred hours of labor. People donated shells—many of which came from personal collections with meaningful stories attached—to the project. Rambo also leads a twice-monthly shelling cruise that always sells out. A group of fifty or so enthusiasts take a pontoon boat out to various locations around Sanibel to hunt for shells and then compare and discuss their treasures. The *Scaphella junonia*, a white shell with almost geometric brown markings, is a rarity that's considered the pride of Sanibel. When Rambo first found the junonia, as it is called, she burst into tears. "I was head over heels," she says. She was just as moved when she and her husband traveled to Okinawa, Japan, and she found her first perfect sea marble—like sea glass but perfectly round, with a "sugary coating" that comes from being out at sea a long time.

"Once you feel the power of the ocean and the draw of the sea," Rambo says, "it never leaves you. You'll feel it for the rest of your life. And when you're given a gift from the sea, you can't get enough of it, and you go back again and again. So many people feel that and start collecting."

Finding Shell Treasures

Here are Pam Rambo's expert shelling tips.

❋ Check the tide charts. An hour before and after low tide is a great time to start your shelling trip.

❋ Look at the phase of the moon. The full moon and new moon have the most extreme tides, so this is a great time to look for shells.

❋ If you're vacationing, stay at a hotel or inn close to the beach. The odds of your putting more time into shelling are much greater if you have easy access to a beach early in the morning and during the evening.

❋ Look at the weather and wind direction for the days you plan to shell. Shelling after a storm, when winds are coming in from the sea, is usually shell-tastic!

❋ Research the local shells of the beach you'll be visiting to learn shell patterns, colors, and textures. That way you can recognize them in the sand or rocks, even if they're half buried.

❋ Clean the shells. This gives you a chance to marvel over them again and again. Take your time in the cleaning process. Start by rinsing the shell well with fresh water; then use a bleach solution (⅛ cup bleach mixed into ⅞ cup water) to soak the shells for a couple of hours. Rinse them again with fresh water until all the bleach is washed away. Let them dry inside on a paper towel or outside in the shade, then apply a light mineral oil coating, as the mineral oil draws out the natural color of the shells. Rub the oil onto the shell with your hands before patting the shell dry with a paper towel.

Above: The *Conus gloriamaris*, known commonly as the Glory of the Sea Cone, was once considered the rarest shell in the world. + *Opposite: A Still Life of Shells*, Adriaen Coorte, 1698.
Pages 188–189: Russian photographer Katerina Plotnikova is known for capturing uncommon pairings of animals and humans, but here she happens upon a bona fide mermaid.

TOP SHELLING DESTINATIONS

DEDICATED SHELLERS WILL TRAVEL ALL around the world to find far-flung treasures. Here are Pam Rambo's top ten spots, starting with her favorite:

* Sanibel, Florida
* Marco Island, Florida
* Okinawa, Japan
* Guantanamo Bay, Cuba
* Eleuthera, Bahamas
* Portsmouth Island, North Carolina
* Cape Romain, South Carolina
* Krabi, Thailand
* Middle Caicos and North Caicos, Turks and Caicos
* Ambergris Caye, Belize

A. Coorte. 1698

Now I sit around and watch
The mermaids sun themselves out on the rocks
They are beyond our touch
I watch and watch
Wave at me
They wave at me
They wave and slip
Back into the sea

All the ones who come
All the ones who go
Down to the water
All the ones who come
All the ones who go
Down to the sea

I believe in God
I believe in mermaids too
I believe in seventy-two virgins on a chain
(why not, why not)
I believe in the rapture
For I've seen your face
On the floor of the ocean
At the bottom of the rain.

— NICK CAVE, "Mermaids," 2013

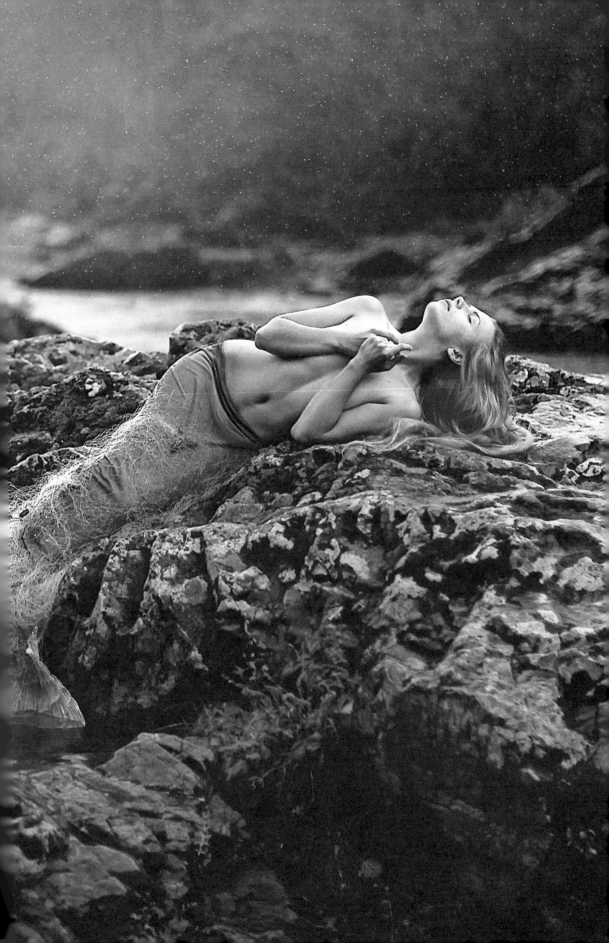

AN ALLURING MERMAID SOIRÉE

— TRICIA SAROYA

NOT ALL ASPIRING MERMAIDS CAN JUST SLIP into a tail and take to the ocean, but there are plenty of ways to bring the mermaid and all her mystery and magic alive in the human world. A mermaid soirée is the perfect way to celebrate the sea life on a balmy summer's eve, starting with a glittering aquatic table that might have been set on the ocean floor.

From the color palette to the foliage and aquatic props to linens, lighting, and the table itself, all it takes to create the perfect mermaid table are a few simple items and a little creativity. Here's how to do it.

CHOOSE YOUR COLORS WELL ❧

Give some thought to your color story. A deep-water palette of marine blues, aquas, purples, and greens is a natural choice, but you could also go with a lighter, more coastal palette that includes sea-foam whites, shell pinks, soft yellows, and touches of bright blue.

THE TABLE and LINENS ❧

If you have an old, weathered wood table that conveys the feeling of a pier, you don't need any linens. For a less ocean-friendly table, try a tablecloth with colors that tie in with your palette. Deep blues and aquas work well for a deep-sea feeling; sky blue, sand, or blush are good choices for creating a coastal atmosphere. To decorate multiple tables, make each one a different color, but use no more than three colors in total, or the overall effect will be messy. Place a long, narrow piece of wood as a runner on top of your tablecloth for an old-pier look, or place pretty pieces of driftwood among the shells.

Also see "Craft a Tabletop Coral Reef" on page 194.

PLANTS, FOLIAGE, and FLOWERS ❧

A key to your sea-creature setting is the foliage that re-creates the allure of the underwater world. Peruse books and online sources for guiding visual references. For instance, try unusual plants and flowers such as succulents that offer wonderful, otherworldly shapes and textures. Set pots in small stone mounds to camouflage. For a coastal look, consider blending different potted

OPPOSITE: Glittery branches create a mermaidy coral-reef effect in the fading light.

ornamental grasses tucked into mounds of sand to add a dunelike feeling to your table. These are just a couple of ideas to get you started, but go with your favorite inspiration.

You can order plants from a local florist or wholesale flower market. Plan in advance, as suppliers might need three or four weeks' notice. Looking for foliage and flowers in season helps you avoid paying high prices.

To keep your flowers and foliage fresh all through the event, arrange them in presoaked floral foam set on plastic. Use green Spanish moss to camouflage foam, plastic pots, LED light housing, and more. Shells and pebbles are another natural way to disguise undesirable visual elements. For specific ideas, see "Plant, Foliage, and Flower Suggestions for Table Settings" on page 195.

ƒINISHING TOUCHES

Wrap up the mermaid tabletop with finishing touches that will make the water-witch magic happen at your event:

For a nighttime party, use LED lights, tucking them in throughout the tabletop decor. LED is preferable to candles as it is cooler and more ocean-like. Glitter really sparkles in LED light as well. For candles, tone down the warm light by placing them in blue or green glass votive containers.

Add ocean-themed props like Japanese glass float balls, shells, stones, sea glass, driftwood, strings of pearls, and netting to the tablescape. Wrap napkins in faux pearl necklaces.

Create mini caverns within small arrangements of rocks and then tuck in an LED light and a special goodie, like a beautiful shell or a faux pearl in an open clamshell.

Use LED lights to illuminate the table, and stick some lights in conch- or clamshells or under glass fishing floats to create a lovely glow.

For assigned seating, consider writing your guests' names on shells put at each place setting. If you've got a sizable crowd, write guest names and seating assignments on shells, then arrange them in alphabetical order in an old sand-filled wooden box or treasure chest near the table.

You can also handwrite quotes from mermaid and seafaring literature onto card stock and cut it into shell shapes. Set a card at each place setting for a poetic touch.

Top: A glitter-covered manzanita branch that might have been plucked from the sea.
Bottom: Sea glass floats and a cabbage rosette add a romantic touch to a tabletop.

Above: Glitter adds a glow and an underwater vibe to rocks and shells, especially when mixed with green berzelia berries, green celosia, and glass floats at the base of a glittered manzanita branch .

Craft a Tabletop Coral Reef

SUMMON THE CORAL CREATIONS OF THE DEEP SEA TO YOUR tabletop with a few simple and natural supplies and a whole lot of sparkle and color.

SUGGESTED MATERIALS

+ Several cans of spray paint in the hues of your palette

+ Spray-on glitter, glitter gel, or standard glitter and glue in palette colors

+ Short, gnarled branches

+ Various seashells, faux pearls, sea glass, barnacles in palette colors

+ Hot glue gun

+ Various sizes of rocks and stones

+ Pots filled with rocks, sand, cement, or plaster of paris to support branches

+ Foliage, ferns, moss, and flowers in palette colors

+ Colorful glass globes, fish nets, and any other mermaid-themed items

NOTE: Purchase the sand from a hardware store, but make sure to buy sandbox sand, not the construction-use silica sand, which is dangerous to inhale.

DIRECTIONS

1. Spray-paint a few short, very gnarled branches in bright colors and coat them with glitter. You can use spray-on glitter or a glitter gel from a crafts store, or apply glue to the painted branches and then scatter glitter over it.

2. Add details to the "coral" branches by hot-gluing shells and other sea finds.

3. Use colored glitter gel to trace squiggles and spirals onto the branches to mimic the paths of tiny sea creatures.

4. Make rocks dusted with glitter your reef base. Create mounds and clusters with some open spaces in between, just as you would find in nature. In the clusters of rocks, nestle the branches in, propping them up with the rocks.

5. You can also sink the branches into pots filled with rocks or sand. Or try cement or plaster of paris for a very secure base for an outdoorsy tabletop decor.

6. Glue on more shells and barnacles to the rocks for added detail.

7. Just add glitter to give foliage, flowers, ferns, mosses, and more a spectacular oceanic glow.

8. Collect colorful glass globes, fishnets, and any other marine-y props that catch your fancy and capture the spirit of a deep-sea soirée.

OPPOSITE: A closeup of the "coral reef": purple blooming artichokes, green Kermit and spider mums, green hanging Chinese spinach, and glittered rocks. + *PAGES 196–197*: Illustration by Armand Vallée in *La Vie Parisienne*, July 25, 1914.

Plant, Foliage, and Flower Suggestions for Table Settings

- **ALLIUM** plants—garlic, shallots, and leeks—that have gone to seed produce tight little balls of flowers similar to seascape starbursts.

- **ARTICHOKE** blooms have a lovely, spiky, bright purple top, which, when combined with the artichoke body, looks delightfully odd. Even grocery store artichokes look great in a coral reefscape.

- **BERZELIA** are upright, wire-stemmed, evergreen shrubs, some with a tight covering of small balls on top.

- **CHINESE SPINACH** (*Amaranthus dubius*) is a green dreadlock-like flower that drapes over rocks and shells like a lovely sea creature.

- **CHRYSANTHEMUMS** in chartreuse green make a stunning statement, as do **KERMIT MUMS**, which are bright green button mums.

- **COCKSCOMB** (*Celosia cristata*) is a chartreuse domed plant that is a floral knockoff of coral.

- **HEATHER** spears can add spots of color.

- **HORSETAIL** (*Hippuris vulgaris*), arranged into clusters, are dead ringers for sea urchins.

- **PINE-NEEDLE BOUGHS** or **JUNIPER BRANCHES** can be useful in creating branchy, coral-like plants.

- **VARIEGATED COLEUS** comes in a variety of beautiful colors that bring a soft and lovely touch to the table.

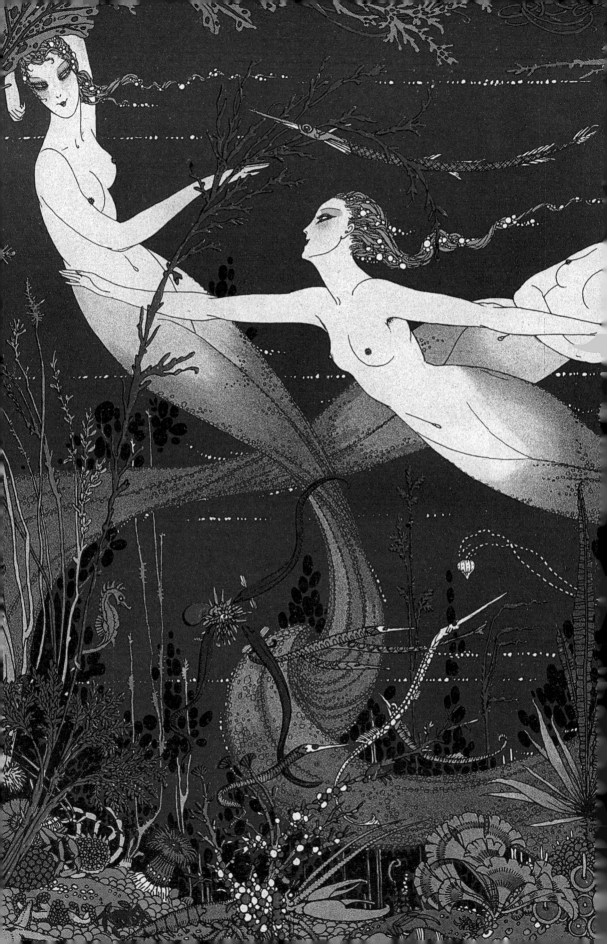

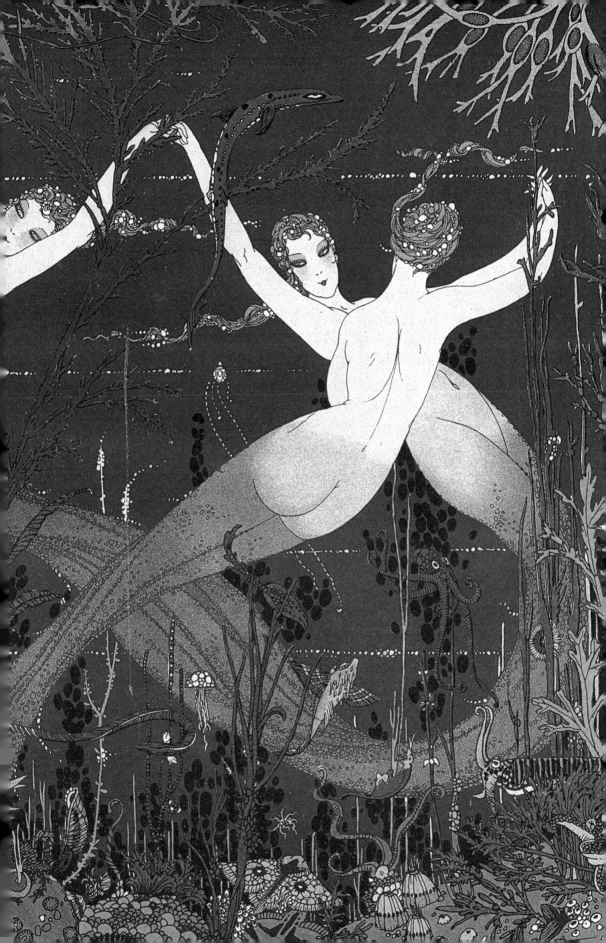

Make Edible Sea Glass Candy

—LAURA RUSSELL

TRANSPORT YOUR GUESTS TO THE OCEAN BY MAKING gorgeous edible sea glass candy! The process is similar to that for making homemade lollipops, but without the molds. Try serving the candy along with chocolate seashells on a bed of brown sugar and graham cracker crumbs mixed together to look like sand. You can also wrap it in boxes to give as gifts. Be careful, though, as some of the edges can be a bit sharp. As with all hard candy, it can be a choking hazard, so don't give this edible sea glass to very young children. You can store it for up to a week in an airtight container.

This recipe makes one baking sheet of thin glass.

INGREDIENTS

- **2 cups sugar**
- **1 cup water**
- **½ cup light corn syrup**
- **1 teaspoon oil flavoring, in mint or desired flavor**
- **Food color in blues and greens** (regular food color or gel food color both work well)
- **Powdered sugar**

DIRECTIONS

1. Spray a light coat of cooking spray onto a metal baking sheet with sides.

2. Combine sugar, water, and corn syrup in a large saucepan over medium heat. Stir until the sugar is dissolved. Continue stirring and cook to the hard-crack stage (300°F). Make sure that the temperature reaches 300°F, or the candy will not harden properly.

3. Remove from the heat and add flavor and coloring. Stir for about two minutes to make sure they are evenly distributed. (Note: When you add the flavor, it's a good idea to turn your head away. These oils are very strong and create smoke when they hit the hot candy mixture.)

4. Carefully pour the mixture onto the baking sheet and set aside to cool.

5. Once it has cooled and hardened, cover the pan with a dishcloth and use a hammer to break up the candy. Try to get the pieces to be the same size as actual sea glass so they look realistic. (Don't go too crazy with the hammer, or your candy will get crushed and the pieces will be too small.)

6. At this point, the candy will look very shiny and sharp. To make it look more realistic, rub some powdered sugar onto each piece to give it the frosted look of sea glass that has been tumbled by the ocean waves.

7. Use a dishcloth to smooth and sand down the edges so the pieces aren't too sharp.

OPPOSITE: Colorful and easy to make, edible sea glass candy makes a great gift.

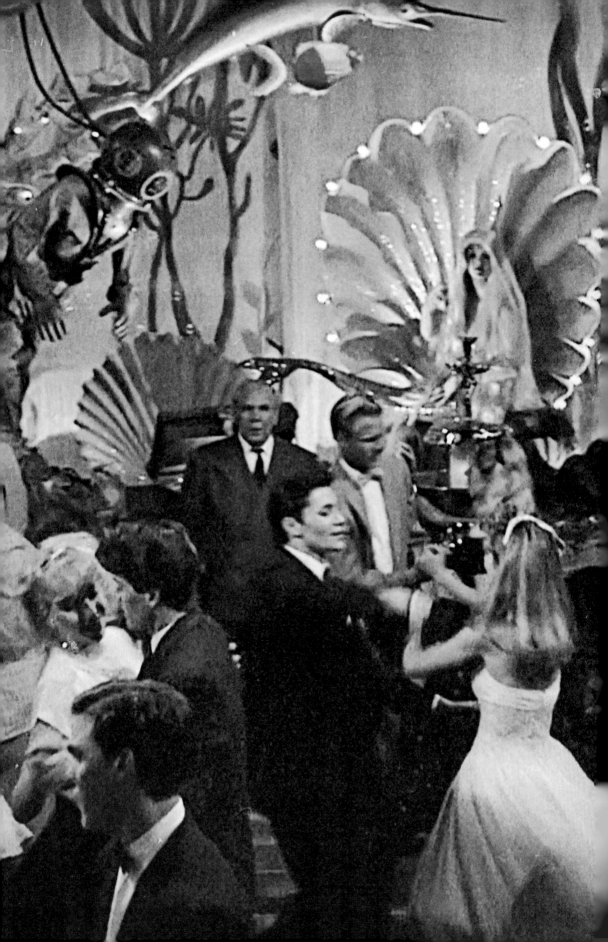

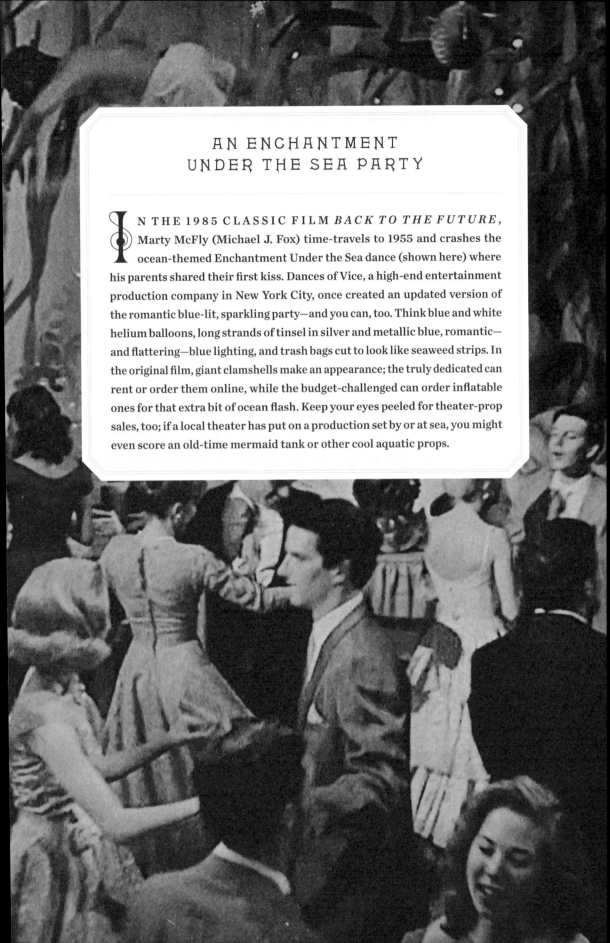

AN ENCHANTMENT UNDER THE SEA PARTY

I N THE 1985 CLASSIC FILM *BACK TO THE FUTURE*, Marty McFly (Michael J. Fox) time-travels to 1955 and crashes the ocean-themed Enchantment Under the Sea dance (shown here) where his parents shared their first kiss. Dances of Vice, a high-end entertainment production company in New York City, once created an updated version of the romantic blue-lit, sparkling party—and you can, too. Think blue and white helium balloons, long strands of tinsel in silver and metallic blue, romantic—and flattering—blue lighting, and trash bags cut to look like seaweed strips. In the original film, giant clamshells make an appearance; the truly dedicated can rent or order them online, while the budget-challenged can order inflatable ones for that extra bit of ocean flash. Keep your eyes peeled for theater-prop sales, too; if a local theater has put on a production set by or at sea, you might even score an old-time mermaid tank or other cool aquatic props.

Blue Sea Cocktail

—FLORENTINA DURAN

THIS REFRESHING BLUE COCKTAIL, WITH ITS COMPLEX herbal notes, can bewitch even the wiliest mermaid. Be careful—the curaçao is extremely sweet: a little goes a long way.

Makes 1 cocktail

INGREDIENTS

+ **1 ½ ounces white rum**
+ **1 ounce Blue Curaçao**
+ **½ ounce Suze**
 (or any aperitif)
+ **½ ounce Luxardo Maraschino Liqueur**
+ **½ ounce simple syrup**
+ **Dash fresh lemon juice**
+ **Ice cubes**

DIRECTIONS

1. Combine all the ingredients in a shaker.

2. Shake until well chilled.

3. Strain into a cocktail glass, on the rocks, and serve immediately.

Seductive Siren Cocktail

—FLORENTINA DURAN

FRESH, RIPE BERRIES GIVE THIS DRINK THE TASTE OF summer while a float of blue champagne evokes the season's sunny effervescence.

Makes 1 cocktail

INGREDIENTS

+ **3 blackberries and 1 large strawberry, plus additional berries for garnish**

+ **2 ounces rye whiskey**

+ **½ ounce Canton liqueur** (or any ginger liqueur)

+ **½ ounce fresh lemon juice**

+ **¼ ounce lavender-infused simple syrup** (recipe below)

+ **Ice cubes**

+ **Blue champagne**

Lavender-infused Simple Syrup

INGREDIENTS

+ **1 tablespoon lavender leaves**

+ **1 cup water**

+ **1 cup sugar**

DIRECTIONS

1. Place lavender, water, and sugar into a saucepan. Bring to a boil, then let simmer for a few minutes.

2. Let mixture cool for 30 minutes, then strain with a mesh strainer or fine sieve.

3. Store in an airtight container in the refrigerator. The syrup keeps for about two weeks.

DIRECTIONS

1. Muddle berries (save some for garnish) in the bottom of a shaker.

2. Add spirits, lemon juice, syrup, and ice cubes, shaking until well chilled.

3. Strain into a martini glass, or leave the pulp, and serve on the rocks.

4. Top with blue champagne.

5. Garnish with a strawberry and blackberries.

Make Shell Cocktail Glasses

—TRICIA SAROYA

ECORATE BARGAIN-BASEMENT OR THRIFT STORE cocktail glasses with shells for a more mermaid-like feel. All you need is some hot glue, favorite seashells, and a little creativity to make a proper "sea glass" for your guests.

TOOLS AND MATERIALS

- **Inexpensive cocktail glasses** (can be mismatched)

- **Shells from a craft store or your own collection—look for various-size shells with surfaces that will allow for better adhesion, such as heart cockle, purple clam, pearly umbonium, and rose cup shells.**

- **Hot glue gun**

- **Optional: glitter gel, glass paint, sea glass, faux pearls**

DIRECTIONS

1. Map out a design by either sketching a pattern or arranging shells on a flat surface before applying to glass. Make sure that you leave room to grip the glass. Cluster shells at the base of the glass and at the top.

2. Different glasses can carry different amounts of shells. You can cover the glass as much or as little as you like, using a hot glue gun to secure the shells. You can also add glitter gel or paint patterns on the glass, or add accents with colored sea glass or fake pearls from inexpensive thrift store necklaces.

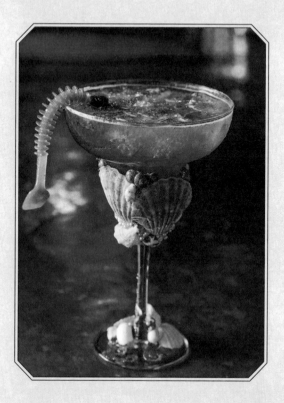

Make Mermaid Cocktail Glass Adornments

—Tricia Saroya

OLORFUL SILICON FISHING LURES, AVAILABLE AT FISHING or sporting-goods retailers, can doll up mermaid cocktail glasses. It's easy to re-create reusable mermaid tails and more with these inexpensive supplies.

TOOLS AND MATERIALS

+ **A variety of light, soft silicone lures, 1½ to 3 inches long**

+ **Toothpicks** (short or long)

+ **Hot glue gun and glue sticks**

+ **Fresh fruit garnishes** (pineapple, cherries, etc., depending on the cocktail)

DIRECTIONS

1. Before assembling these decorations, wash them thoroughly in warm sudsy water and let dry.

2. Poke a toothpick into the lure's flat end, making a small hole.

3. Remove the toothpick and place a drop of hot glue on the hole. Re-insert the toothpick into the hole. Let the glue harden.

4. Skewer garnishes of your choice onto the toothpick. Set the skewer into the cocktail glass at an angle, with the tail side hanging over the rim.

Opposite: A drink worthy of a mermaid queen, served in a cocktail glass covered in glitter and shells and adorned with a cocktail pick. + *Above:* Mermaid tail cocktail picks in a range of sea colors.

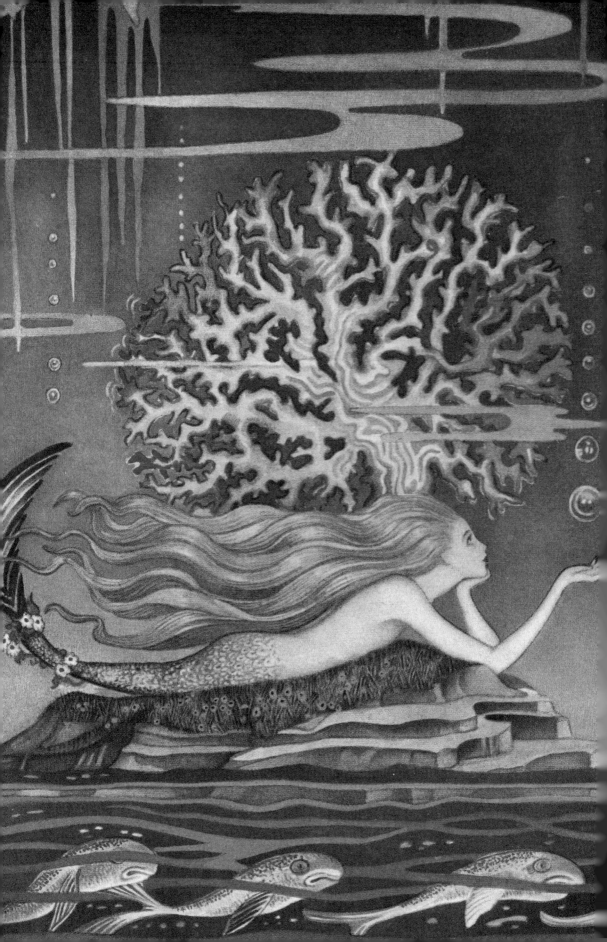

MERMAID REPASTS

> Vela grabbed Lenia's hand and the two swam together, through the long hallway where sea plants streamed around them, filled with small phosphorescent creatures that lit up the dark. In front of the palace, in the main family garden, the rest of the sisters waited: Bolette, Nadine, Regitta, who was holding her son, and the oldest sister, Thilla, who was carrying a platter of baby softshell crabs left over from the birthday feast.
>
> Lenia swam over and popped one in her mouth, liking the feel of the shell as it cracked between her teeth. She reached for another, suddenly starving.
>
> "Didn't you find anything to eat [in the upper world]?" Thilla asked, laughing.
>
> —CAROLYN TURGEON, *Mermaid*, 2011

Health-conscious mermaids love the vegetables of the sea, and many are fond of fresh fish or a crunchy crustacean. Both poke bowls and ceviche are inventive dishes that can be made in countless combinations to highlight ocean delights—and are sure to satisfy any mermaid guest.

Poke bowls as they are known today were first made in the Hawaiian Islands in the 1970s with cutoffs from the daily catch. The fish is sliced and seasoned with sea salt, roasted and ground candlenut, seaweed, and limu (a type of brown algae). It is eaten raw as a highly nutritious snack. Poke bowls have been adapted by other cultures and are now most commonly made with yellowfin tuna. In Japan, they are seasoned with soy sauce, furikake, chili pepper, green onions, and sesame oil. Opportunities for experimentation abound.

Try tossing in a handful of toasted macadamia nuts, different dried or fresh seaweed (see options on pages 219–222), a little kimchi, wasabi, or soy-pickled jalapeños.

Nearly two thousand years ago, ceviche (or seviche) originated in Peru, during the Incan empire. Fresh white saltwater fish is the best choice for this raw dish; the fish is actually cured in a citrus-based marinade. In Peru, ceviche is made with key lime juice, chilis, and onions. In Ecuador, shrimp ceviche is made with a tangy tomato sauce, and in Cuba, ceviche is made with mahi-mahi, lime juice, salt, onion, habanero pepper, and a dash of allspice. Ceviche is generally accompanied by rice, tostadas, tortilla chips, or soda crackers. Nearly every country that eats fish has at least one version of the dish.

OPPOSITE: *"Far out at sea, the water is as blue as the prettiest corn-flower, and as clear as the purest crystal,"* illustration by Jennie Harbour for "The Little Mermaid," *Hans Andersen's Stories*, c.1940s.

Tuna Poke

with Quinoa and Mango

—SARA GHEDINA

THIS LIGHT YET FILLING DISH IS ESSENTIALLY A COMPOSED salad, with each element requiring a separate preparation. Despite the several steps, it is easy to make, comes together quickly, and makes a beautiful presentation.

Serves 4

INGREDIENTS

- ¾ cup quinoa
- 2 Persian cucumbers
- 2 jalapeños
- ½ cup rice vinegar
- 2 tablespoons sugar
- 4 tablespoons soy sauce
- 2 tablespoons toasted sesame oil
- 3 tablespoons mirin
- Juice of 2 limes
- 1 teaspoon sesame seeds
- 2 green onions, sliced
- Pinch of crushed red pepper
- 1 pound tuna, sashimi grade
- 1 cup shelled edamame
- 1 large mango, cut in cubes
- 2 cups cherry tomatoes, halved
- 1 cup seaweed salad (optional)
- Salt

DIRECTIONS

1. Rinse quinoa thoroughly with cool water for about 2 minutes. Toast it for a few minutes in a saucepan, until the water evaporates. Add 1½ cups of water and a pinch of salt and bring to a boil. Lower the heat and cook, covered, for 15 minutes. Remove from the heat and let stand for another 5 minutes, then fluff with a fork and set aside.

2. Pickle cucumbers and jalapeños: Thinly slice cucumbers. Cut jalapeños in half, discard seeds, and thinly slice. Toss cucumbers with a pinch of salt, then squeeze slices gently to eliminate excess water. Set aside. In a bowl, whisk together rice vinegar, sugar, and 4 tablespoons water. Add the cucumber and jalapeño slices to the brine and let sit about 1 hour at room temperature.

3. Prepare the poke sauce: Whisk together soy sauce, toasted sesame oil, mirin, lime juice, sesame seeds, green onions, and crushed red pepper.

4. Cut tuna into ½-inch cubes and place in a large bowl. Add poke sauce and toss to coat. Refrigerate for 5 minutes. Remove tuna from marinade and reserve poke sauce.

5. In each bowl, arrange a bed of quinoa, then top it with marinated fish, edamame, mango, cherry tomatoes, seaweed salad (if using), and pickled cucumbers and jalapeños. Dress with an additional 2 to 3 tablespoons of poke sauce, if desired.

OPPOSITE: This fetching dish is as nutrition-packed as it is delicious—
perfect for health-conscious mermaids.

Salmon Poke

with Wild Rice, Pineapple, and Macadamia Nuts

— SARA GHEDINA

HIS HEALTHY DISH IS RICH WITH SALMON AND AVOCADO. Thanks to pineapple and macadamia nuts, it's also a crunchy and delicious expression of traditional Hawaiian flavors.

Serves 4

INGREDIENTS

- ¾ cup wild rice
- ¾ cup macadamia nuts
- 4 tablespoons soy sauce
- 2 tablespoons mirin
- 2 tablespoons toasted sesame oil
- Juice of 1 lime
- Juice of 1 lemon
- 1 tablespoon sesame seeds
- 1 green onion, thinly sliced
- Pinch of crushed red pepper
- 1 pound salmon fillet
- 2 small avocados, peeled, pitted, and sliced in wedges
- 1½ cups fresh pineapple, cubed
- 2 carrots, julienned
- 2 Persian cucumbers, sliced
- Freshly ground black pepper

DIRECTIONS

1. Place wild rice in a fine-mesh strainer and rinse under cold water for about 2 minutes. In a saucepan, combine rice with 3 cups of water and a pinch of salt and bring to a boil. Lower the heat and simmer, covered, for about 45 minutes. Pour into a strainer to drain off any remaining liquid, then fluff with a fork and set aside.

2. Toast macadamia nuts in a pan for 2 to 3 minutes, stirring occasionally, until they are golden brown.

3. Prepare the poke sauce: Whisk together the soy sauce, mirin, toasted sesame oil, citrus juices (about ¼ cup), sesame seeds, green onion, and a pinch of red pepper.

4. Cut salmon into ½-inch cubes and place in a large bowl, then add poke sauce and toss to coat. Refrigerate for at least 15 minutes to allow flavors to meld. Remove salmon from marinade and set aside; reserve the sauce.

5. In each bowl, arrange a bed of cooked wild rice and top it with salmon, avocado, pineapple, carrots, cucumber, and macadamia nuts. Dress with an additional 2 to 3 tablespoons of poke sauce, if desired.

OPPOSITE: Serving poke bowls buffet-style lets guests experiment with new tastes.

Tuna and Shrimp Ceviche
with Papaya and Coconut Milk

—SARA GHEDINA

USE THIS VERSATILE RECIPE AS A TEMPLATE TO EXPERIment with all kinds of seafood for a variety of appetizers. Try different fish and shellfish to come up with your favorite combinations.

Serves 4 as an appetizer

INGREDIENTS

+ **7 ounces coconut milk**
+ **3 tablespoons freshly grated ginger** (divided)
+ **1 jalapeño pepper** (divided)
+ **½ pound sashimi-grade tuna**
+ **5 to 6 tiger prawns**
+ **Juice of 2 limes**
+ **½ Hawaiian papaya**
+ **½ small red onion**
+ **½ cup cilantro leaves**
+ **Salt and pepper to taste**

DIRECTIONS

1. Place coconut milk, 2 tablespoons ginger, and half of the jalapeño, seeded and sliced, in a small saucepan. Gently bring to a boil, then simmer for about 12 to 15 minutes, until the mixture thickens. For a thinner sauce, simmer for about 10 minutes; for a thicker sauce, simmer for 15 minutes or more.

2. Place the mixture in a blender or food processor and purée until it is smooth and without lumps. Add a pinch of salt, stir, then cool completely.

3. Cut tuna into ½-inch cubes. Shell and devein prawns, then cut into small pieces. Place the seafood in a small bowl with a pinch of salt and the lime juice. Refrigerate and let marinate for about 20 minutes.

4. Peel papaya, discard the seeds, and cut into ½-inch cubes. Slice onion very thinly. Mince cilantro leaves.

5. Drain about half the juice from the marinated fish and discard it. To the marinated fish mixture add coconut mixture, papaya, onion, remaining 1 tablespoon ginger, cilantro, the other half of the jalapeño (sliced), and freshly ground black pepper.

6. Gently toss everything together and serve immediately.

OPPOSITE: This traditional Peruvian dish makes a light appetizer or a healthy midday snack.

Seashell Fortune Party Favors

—Karima Cammell

For enchanting party favors, this decorative seashell with a message hidden inside is just the ticket. Oysters may take forever to grow a pearl, but these seashell fortunes are quick and easy to make. The stretchiness of the crepe paper helps achieve a shell with a natural curve. Shells come in all shapes and sizes; experiment and make the seashell fortunes your own—and add whatever secret messages (or love notes) you like inside.

Spun-cotton beads are readily available online and at craft shops.

Makes one 4-by-4-inch shell

MATERIALS

- Pencil
- Templates for shell shapes (see page 216); **these are provided at their full size**
- Metallic crepe paper for outer shell
- Pastel-colored florist crepe paper for inner shell
- Scissors
- 18-inch length of floral wire
- 1-inch length of thin ribbon
- Tacky glue
- Glue brush
- Spun-cotton bead, ½ inch in diameter
- Wooden skewer
- Small pot of pearlescent paint
- ¼-inch paintbrush
- Strip of paper, ½ inch wide by 4 inches long, for fortune

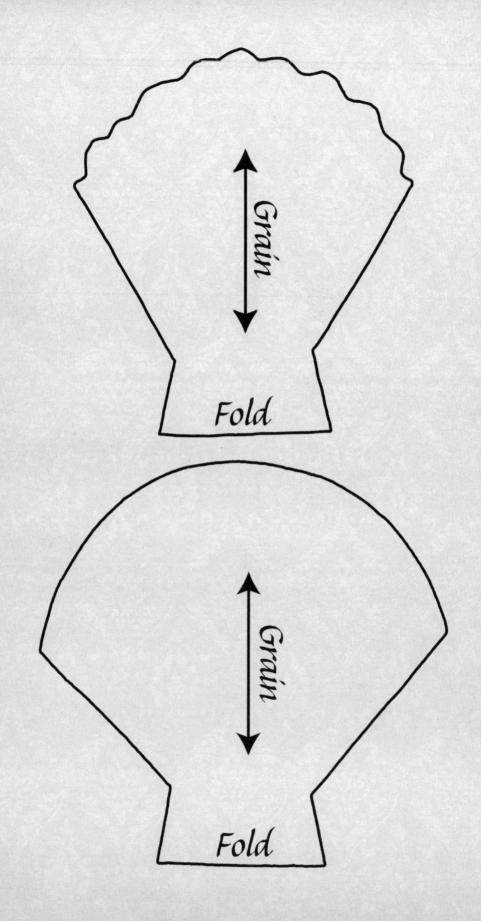

Grain

Fold

Grain

Fold

1

2A

2B

2C

3

4

DIRECTIONS

1. Fold a piece of metallic crepe paper against the grain, then place the smaller, scallop-edged template over it on the fold. Trace and cut out the shape on the fold. Repeat this with the pastel crepe paper and the larger, smooth-edged template.

2. Fold the wire in half and loop both ends to the center, twisting them in place to make a figure eight. Center the wire loop on the duller side of the metallic crepe paper and brush glue outward from the wire toward the edge. Keep the center of the wire loops free from glue. Press the pastel crepe paper onto the glue to sandwich the wire inside.

3. Fold the stack in half, then fold the two halves of the shell outward from the narrowest part, making a hinge. Secure the hinge by tying your ribbon around the "waist" of the shell.

4. Trim the pastel crepe paper to give it a scalloped edge matching the outer shell. In the center of each wire loop, pinch and pull the paper counter to the grain, bubbling it up until you have given the paper a proper clamshell shape, leaving the outer edge of the shell flat. To ruffle the edges, pinch and bend the paper back and forth along the outside of the wire loop.

5. Skewer the spun-cotton bead and paint it with the pearlescent paint, leaving one hole open. Once it dries, remove the skewer and poke one end of your fortune paper into the pearl. Use glue to ensure the paper stays.

6. Write a message on the fortune paper; tuck it and the pearl into the shell. Your seashell fortune favor is now complete! Keep your message safely inside the shell, or share it with a sweet mermaid friend.

How deep is your love?

Splash. Sparkle. Repeat.

5

6

The MERMAID'S GUIDE to SEA VEGETABLES

—Massie Jones

UMANS HAVE BEEN FORAGING FOR SEA VEGE-tables since ancient times in China, Greece, Iceland, and many other countries. This is not surprising since these plants spend their days in the extravagant mineral bath that is the ocean, soaking up iodine, magnesium, iron, zinc, potassium, and antioxidants until they are bursting with vitality. Sea vegetables—including seaweeds, seeds, flowers, roots, rhizomes, and stalks—are unsung nutritional heroes. Seaweeds, in particular, are purported to have antiviral, anticancer, and antiparasitic properties, in addition to being nutrition-packed powerhouses that are often incorporated into beauty treatments.

You can find some of the more common sea vegetables at the local grocery or health food store. They can be dried in strips or sheets; crushed into flakes and powders; fresh, frozen, or freeze-dried; and made into teas, jellies, and wine.

Seaweed is used in a variety of ways to add saltiness, ocean flavor, vitamins, and mermaid magic to more mundane earthly dishes. Try mixing dried crumbled seaweed with salt and toasted sesame seeds for use as a condiment on top of salad, fish, soups, and rice.

ARAME ❧ A dark brown seaweed with a mild sweet flavor, arame is very high in iodine.

It can usually be purchased at Asian grocers or health food stores and is delicious sautéed with winter squash, butter, and onions.

CHLORELLA ❧ This chlorophyll-based, protein- and mineral-rich superfood can be found at health food stores in powdered form. Chlorella cells bind to heavy metals that the body accumulates and remove them, making chlorella a potent chelating agent. It also increases white blood cell count, crucial to people fighting cancer. Add it to smoothies, sprinkle it on zucchini noodles, or blend it with fresh herbs for a green-goddess-style salad dressing.

OPPOSITE: Various specimens of seaweed are depicted in this illustration for *Science for All*, edited by Robert Brown, c.1890.

DULSE ❧ Readily available at health food stores, dulse is a ruby-red seaweed that is delicious sautéed with butter and garlic. It's high in iron, vitamin B6, potassium, and sodium. Try sprinkling dried, powdered dulse on popcorn for a salty, mermaid-friendly treat.

HIJIKI ❧ Hijiki is a silky black seaweed with a strong marine flavor. High in iron, vitamin K, and iodine, it has ten times the calcium of milk. The dried form is available at most health food stores and Asian grocers. Try cooked hijiki in a rice bowl with carrots, sautéed bok choy, and Napa cabbage; toss with soy sauce and chili oil.

KELP ❧ Kelp is the superstar of the seaweed family. It includes some thirty varieties, all with an impressive nutritional résumé. Just one-quarter teaspoon of powdered kelp contains seventy vitamins, minerals, enzymes, trace elements, and protein. Kelp is available at health food stores, Asian grocers, and some mainstream grocers, and comes in dried sheets or as a vitamin supplement. Soak dried kelp ribbons until soft, then stir-fry them with sesame oil and ginger.

KOMBU ❧ Kombu is a deep greenish-brown seaweed cultivated mainly in the seas of Japan and Korea. In the ocean, kombu looks like long, wavy lasagna noodles. It's available dried into thick sheets at health food stores and Asian grocers, and can be sliced into ribbons and boiled as nutrient-rich noodles.

NORI ❧ Nori is red algae that is commonly sold in thin, dried sheets at Asian grocers, health food stores, and sometimes your local supermarket. It has a sweet, mild flavor and is most commonly used to wrap sushi. It also makes an excellent wrap for tuna salad and can be baked into crisp, salty crackers.

SEA MOSS ❧ This red algae is common on the Atlantic coastlines of North America and Europe. Dried forms are available at West Indian grocers. It's rich in fiber, zinc, magnesium, calcium, copper, riboflavin, and iron. Boil into a thick syrupy liquid; add a dram of rum, a pinch of vanilla, and cinnamon; and top with warm milk for a comforting bedtime drink.

SEA SPAGHETTI ❧ Found only in the east Atlantic, from Portugal to Norway, sea spaghetti is available in dried form from online distributors. In the wild, it resembles greenish-brown fistfuls of pasta. It has a light, nutty flavor and eight times the magnesium of spinach. Boil the dried form lightly and toss with olive oil, lemon, basil, and tomato.

ABOVE: An illustration of algae from the Botany Library Plate Collection at the Natural History Museum, London, date unknown. + *OPPOSITE: The Little Mermaid before a Statue in the Sea,* illustration by Ivan Yakovlevich Bilibin for *Album du Pere Castor,* 1937.

SPIRULINA ❦ Spirulina is a blue-green algae found wild in the lakes of Mexico and Africa. It is grown commercially worldwide for its immune-boosting, antifungal, antibacterial properties and as a protein-rich source of omega-3 fatty acids. The dried and powdered form is available in any health food store. It can be added to smoothies and stirred into yogurt, or mixed with broccoli in a frittata.

SWEET FLAG ❦ This wild water plant, also known as calamus, is native to India, Russia, Siberia, and Central Asia, but can be ordered from nurseries and cultivated at the edges of small lakes and marshes. The leaves can be eaten raw but are better sautéed; the spicy rhizomes make a unique substitute for ginger, cinnamon, or nutmeg.

WAKAME ❦ This dark green seaweed grows in the ocean in large rafts. It is available fresh or dried in health food stores and Asian grocers. Native to the oceans of Japan and Korea, wakame has spread to the oceans of the United States, Britain, France, New Zealand, Belgium, Spain, Italy, Mexico, and Australia. Sauté chicken breasts with wakame, garlic, and mushrooms, or use it to make a salad with ginger-carrot dressing.

WATER LILY ❦ The origin of the water lily is unknown. It's an aquatic herb whose flowers, seeds, roots, and rhizomes are all edible. Look for it at an Asian grocer or order online. It is delicious cooked with fish, lemon, garlic, and onion.

ABOVE: Illustrated plates by Emile Belet from *La Vie sous Marine*, late nineteenth century.
OPPOSITE: *Ophelia*, John William Waterhouse, 1894.

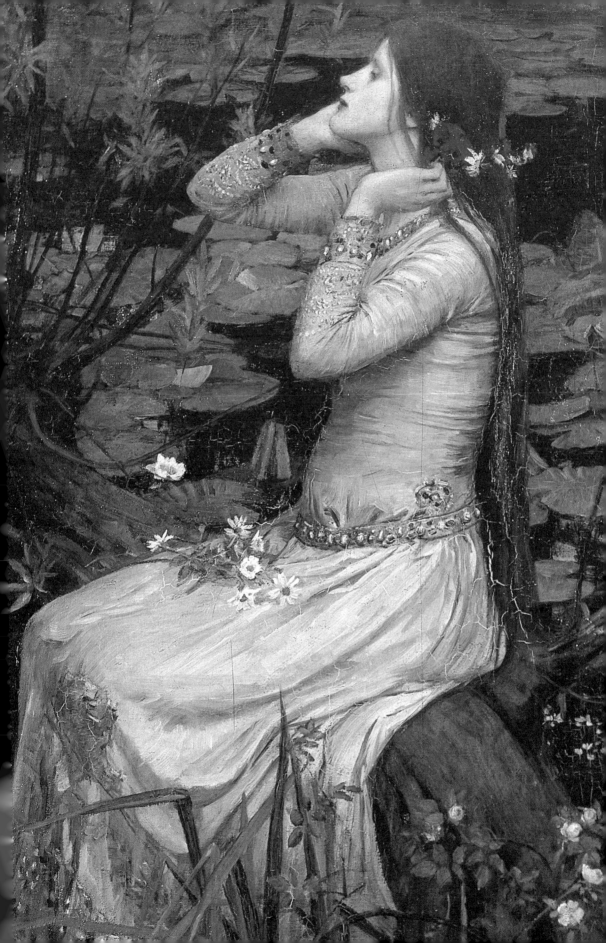

Savory Sesame Seed and Seaweed Cookies

— SARA GHEDINA

THE SEAWEED FLAVOR IN THESE DELICIOUS, SAVORY COOKies is very subtle but can be increased to taste. Serve them as a snack with a glass of beer or prosecco. They will keep for a few days in an airtight bag or container.

Makes 16 medium cookies

INGREDIENTS

- **7 tablespoons unsalted butter, cold**
- **1 cup all-purpose flour**
- **1 cup grated Parmesan**
- **2 tablespoons sesame seeds**
- **3 tablespoons chopped dried seaweed**
- **Pinch of salt**
- **1 egg yolk**

DIRECTIONS

1. Cut the butter into small pieces and set aside.

2. Place flour, Parmesan, sesame seeds, seaweed, and salt into the bowl of a food processor. Pulse two or three times to combine. Add the butter and the egg yolk, then pulse the mixture until the dough just comes together to form a ball. If needed, add a few drops of cold water.

3. Wrap the ball tightly in plastic wrap, and refrigerate for at least one hour, or up to two days.

4. When ready to bake, preheat the oven to 350°F. Line a baking sheet with parchment paper and set it aside.

5. Lightly flour a work surface and roll the dough into a rectangle about ¼ inch thick. Using a cookie cutter, cut the cookies into the desired shape. Place them on the prepared baking sheet, about 2 inches apart, and bake for 12 to 15 minutes, or until golden brown. Transfer the cookies to a wire rack and allow them to cool completely before serving.

OPPOSITE: These treats have a texture similar to shortbread cookies but have a salty, seaworthy flavor.

MERMAID COOKIES

—TERI PRINGLE WOOD

THEREAL, FANCIFUL, AND DELIGHTFULLY MAG-ical, mermaids no doubt subsist on equally exotic fare. Pay tribute to their underwater realm with a dazzling array of sea-inspired treats in the shape of shells, sea horses, and starfish (order these special cookie cutters online). You can have great fun decorating these traditional honey gingerbread and sugar cookies with appropriately elaborate marine designs created with royal icing fit for a mermaid queen. Use the honey gingerbread cookie—which was adapted by Teri Pringle Wood from traditional Russian, German, and Slovakian recipes—for heartier cookies that can last indefinitely as keepsakes. You can even frame ones you're especially proud of. The sugar cookies are less sturdy and should be consumed more quickly.

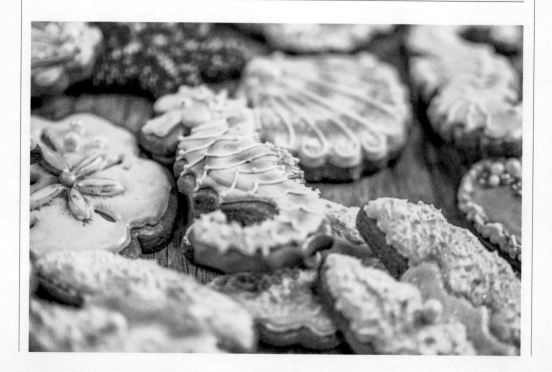

Honey Gingerbread Cookies
with Royal Icing

Makes 30 cookies

INGREDIENTS

- **8 ounces unsalted butter**
- **1½ cups granulated sugar**
- **2 cups good-quality honey**
- **2 teaspoons baking powder**
- **4 teaspoons ginger**
- **4 teaspoons cinnamon**
- **1 teaspoon cloves**
- **1 teaspoon nutmeg**
- **½ teaspoon salt**
- **⅓ cup cocoa powder** (optional)
- **3 large eggs**
- **9 cups all-purpose flour**
- **1 large egg, lightly beaten and mixed with 1 teaspoon water**

DIRECTIONS

1. Melt the butter in a medium-size saucepan over medium-low heat. Add the sugar and stir until mostly dissolved, then pour in the honey and stir to combine. Cook until very hot and mixture is smooth, but *do not boil*. Remove from heat.

2. Sift together baking powder, ginger, cinnamon, cloves, nutmeg, and salt. Add up to ⅓ cup cocoa powder, depending on color desired. Add to the warm butter mixture and stir until well combined. Set aside to cool to room temperature.

3. Transfer the mixture to the bowl of an electric mixer and add 3 eggs, beating until combined. Gradually add in flour, beating all the while.

4. When all flour is absorbed, divide the dough in half and wrap in several layers of plastic wrap.

5. Store in a cool place for at least 24 hours, or up to a week in the refrigerator. If the dough is refrigerated, bring it to room temperature before proceeding.

6. When ready to bake, preheat the oven to 375°F. Unwrap the dough and place on a well-floured work surface. Knead flour into the dough until it is very smooth, pliable, and not sticky. Roll out to ¼-inch thickness for small cookies, a little thicker for larger cookies.

7. Use cookie cutters to cut cookies into mermaid-friendly shapes.

8. Bake 6 minutes, checking to see if any bubbles form. If they do, gently smooth with a spatula and continue to bake until done, about 9 minutes total for medium cookies and up to 14 minutes for larger ones. Remove to a wire rack and use a pastry brush to apply a coat of the lightly beaten egg. Cool completely.

9. Decorate with royal icing (see recipe on page 229).

Sugar Cookies
with Royal Icing

Makes 24 cookies

INGREDIENTS

- **1 cup unsalted butter, slightly softened**
- **1½ cups granulated sugar**
- **1 large egg**
- **2 teaspoons vanilla or flavoring of choice**
- **3 cups all-purpose flour**
- **1 teaspoon baking powder**
- **¼ teaspoon salt**

DIRECTIONS

1. Preheat the oven to 350°F.

2. With an electric mixer or by hand with a wooden spoon, cream butter and sugar until light and fluffy. Beat in egg and vanilla.

3. In a separate bowl, combine dry ingredients, then gradually incorporate into the butter mixture.

4. Transfer to a lightly floured board and roll out to ¼-inch thickness. Cut into desired shapes and place on a baking sheet. Chill in the freezer for 2 to 3 minutes.

5. Bake for approximately 10 minutes or until lightly golden.

6. Decorate with royal icing.

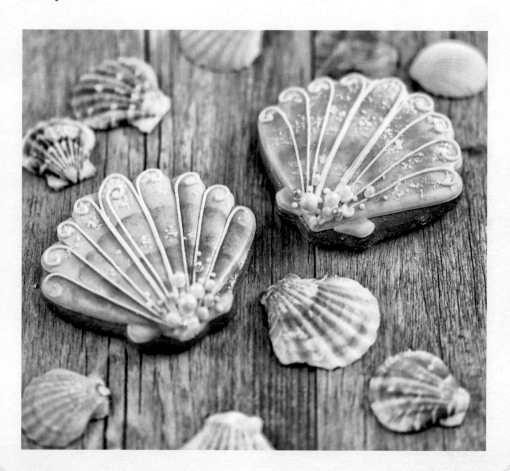

Royal Icing

THE EGG WHITE IN THIS VERSATILE ICING, A CLASSIC OF decorative baking, is what allows it to firm up. The icing can be "flooded"—to create a smooth covering—or swirled and peaked into a great variety of shapes and designs. Traditionally made with raw egg whites, the pasteurized version is advisable when serving children, pregnant women, or anyone with a compromised immune system.

For approximately 30 cookies

INGREDIENTS

+ **2 pounds powdered sugar**

+ **½ teaspoon cream of tartar**

+ **1 to 2 teaspoons vanilla extract**

+ **10 tablespoons liquid pasteurized egg whites**

DIRECTIONS

1. Combine powdered sugar, cream of tartar, vanilla, and pasteurized egg whites in the bowl of a stand mixer and beat at high speed with the paddle attachment for 4 to 5 minutes.

2. Store in an airtight container in the refrigerator. Thin with water as needed for different techniques.

TIPS FOR WORKING WITH ROYAL ICING

1. Use the royal icing as your main decorating tool, adding more and more water to vary the consistency (you'll have to experiment to see what works best). The recipe here makes for thick icing, suitable for roses and other flowers. Add a tiny bit more water for the right piping consistency; as you stir it, the icing should make soft peaks that immediately fall away. For thin layering on the cookies, add even more water so that the icing is thin and easy to spread over the cookies. Spreading a flat layer of icing over the top of a cookie is referred to as "flooding" the cookie. It is usually done to create a surface for decoration.

2. Test the icing texture by running a toothpick through the center. The icing should naturally fill back in—but not too quickly; it should need some encouragement to come back together completely.

3. Use toothpicks to slowly add color. Start with a small amount since it's easier to add more color than to remove it. Note that the color will darken as the icing sits.

4. You'll need icing bags, couplers, icing tips, icing bag ties, and icing tip covers to pipe the icing onto cookies. Have icing tips for each color so you don't constantly need to switch out the tip. The ties and covers are important to keep the icing from drying out, which can clog the tips. If that does happen, use a toothpick to unclog them.

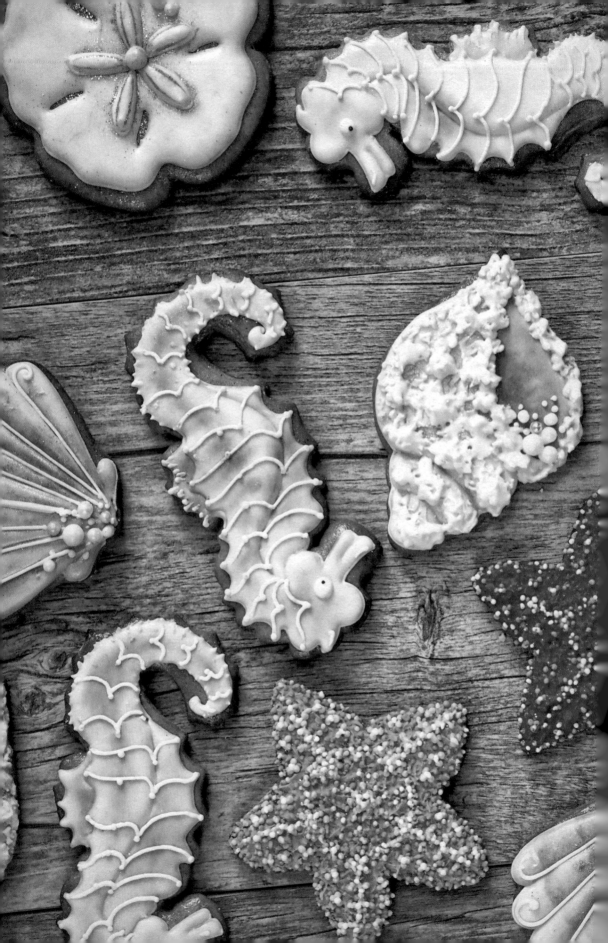

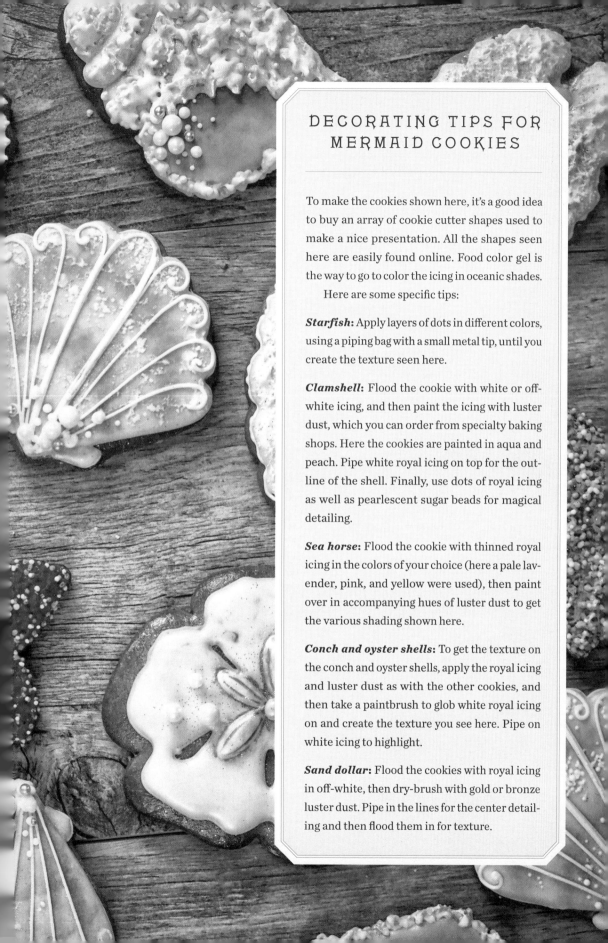

DECORATING TIPS FOR MERMAID COOKIES

To make the cookies shown here, it's a good idea to buy an array of cookie cutter shapes used to make a nice presentation. All the shapes seen here are easily found online. Food color gel is the way to go to color the icing in oceanic shades.

Here are some specific tips:

Starfish: Apply layers of dots in different colors, using a piping bag with a small metal tip, until you create the texture seen here.

Clamshell: Flood the cookie with white or off-white icing, and then paint the icing with luster dust, which you can order from specialty baking shops. Here the cookies are painted in aqua and peach. Pipe white royal icing on top for the outline of the shell. Finally, use dots of royal icing as well as pearlescent sugar beads for magical detailing.

Sea horse: Flood the cookie with thinned royal icing in the colors of your choice (here a pale lavender, pink, and yellow were used), then paint over in accompanying hues of luster dust to get the various shading shown here.

Conch and oyster shells: To get the texture on the conch and oyster shells, apply the royal icing and luster dust as with the other cookies, and then take a paintbrush to glob white royal icing on and create the texture you see here. Pipe on white icing to highlight.

Sand dollar: Flood the cookies with royal icing in off-white, then dry-brush with gold or bronze luster dust. Pipe in the lines for the center detailing and then flood them in for texture.

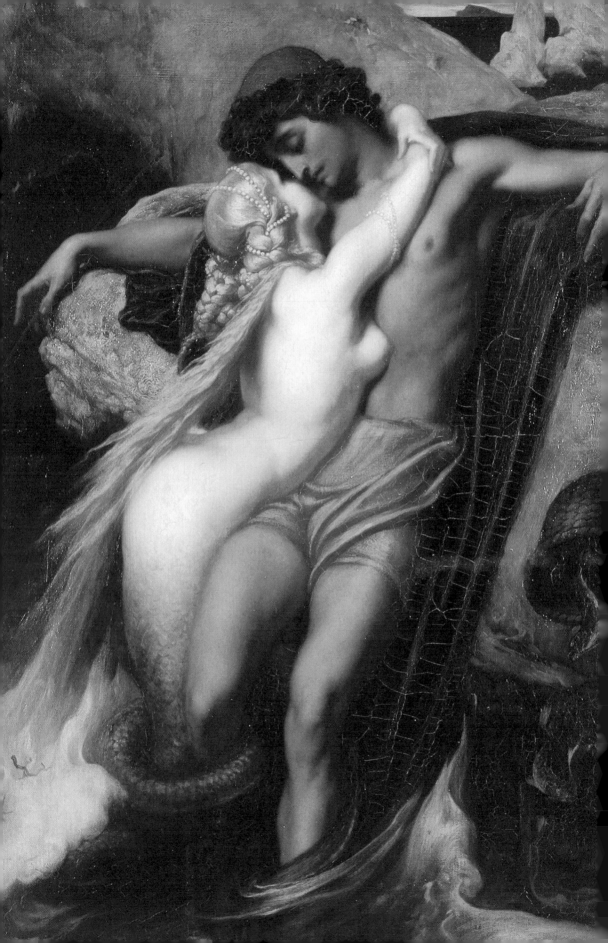

I KNOW not whence it rises,
This thought so full of woe;
But a tale of times departed
Haunts me, and will not go.

The air is cool, and it darkens,
And calmly flows the Rhine,
The mountain-peaks are sparkling
In the sunny evening-shine.

And yonder sits a maiden,
The fairest of the fair;
With gold is her garment glittering,
And she combs her golden hair:

With a golden comb she combs it;
And a wild song singeth she.
That melts the heart with a wondrous
And powerful melody.

The boatman feels his bosom
With a nameless longing move;
He sees not the gulfs before him,
His gaze is fixed above.

Till over boat and boatman
The Rhine's deep waters run:
And this, with her magic singing,
The Lore-lei has done!

—HEINRICH HEINE, "The Lore-Lei," 1824, anonymous translation

ACKNOWLEDGMENTS

I want to thank Elizabeth Sullivan at HarperCollins for suggesting this book and bringing me back to mermaids—with all their power and kitsch and dazzling, glittering incomparability—as well as for being an engaged and whip-smart editor throughout. I'd also like to thank the team at Harper Design: art director Lynne Yeamans, designer Raphael Geroni, and production director Susan Kosko.

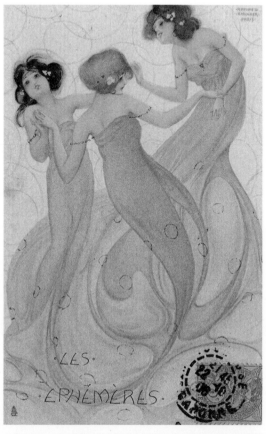

I also want to thank Steve Parke for all his stunning photography and for being willing to drop everything to photograph shell crowns and bejeweled eyelids and all manner of other shiny things to make this book that much more lovely. This book and *The Faerie Handbook*, too, would have felt impossible without his tireless help wrangling images.

Thank you also to: Massie Jones, for helping to research various mermaidy things. Tricia Saroya, for conjuring all sorts of mermaid-friendly wonders and making the world more beautiful generally. Kathy Shyne and Julie Komenda, for helping with some key decision making and planning. Karima Cammell and Clint Marsh of Castle in the Air, for their always stunning crafts. Sara Ghedina, for her always sumptuous recipes, no matter what I ask her to conjure. Vintage Roadside, for sharing their supercool midcentury expertise. Laura Silverman, Karin Strom, and Amber Eden, for whipping the recipes and tutorials into shape. The Corner in Baltimore, for allowing us to shoot mermaid drinks and glassware on its gleaming bar. All the mermaids and tail makers who agreed to speak with me, and to everyone else who contributed: Jill Andrews (and her daughter Jewel), Rona Berg, Sonalii Castillo, JoEllen Elam Conway, Allen Crawford, Ruut DeMeo, Florentina Duran, Laura Russell, Timothy Schaffert, Nikki Verdecchia, Melissa Wimbish, Stephen Winick, and Teri Pringle Wood.

All those who love mermaids, the ocean, and the insides of shells.

And, as always, thank you to my father, mother, and sister.

PAGE 232: *The Fisherman and the Syren: From a Ballad by Goethe*, Frederic Leighton, 1857.
ABOVE: *Mayflyes*, Raphael Kirchner, 1904.

SELECT BIBLIOGRAPHY

BOOKS

Alexander, Skye. *Mermaids: The Myths, Legends, & Lore.* Avon, MA: Adams Media, 2012.

Allen, Rev. A. W. Cornelius H., ed. *The Scottish Antiquary, or, Northern Notes & Queries.* Edinburgh: T. and A. Constable, 1886.

Andersen, Hans Christian. *Hans Andersen's Fairy Tales.* Translated by Mrs. H. B. Paull. London: F. Warne, 1898.

Arnold, Matthew. *The Strayed Reveller, and Other Poems.* London: B. Fellowes, 1849.

Baker, Thomas Jerome. *Myths, Monsters & Love from the South of Chile.* CreateSpace Independent Publishing Platform, 2015.

Bane, Teresa. *Encyclopedia of Giants and Humanoids in Myth, Legend, and Folklore.* Jefferson, NC: McFarland, 2016.

Barber, E. J. W. *The Dancing Goddesses: Folklore, Archaeology, and the Origins of European Dance.* New York: W. W. Norton & Company, 2013.

Benwell, Gwen, and Arthur Waugh. *Sea Enchantress: The Tale of the Mermaid and Her Kin.* New York: Citadel Press, 1965.

Briggs, K. M. *An Encyclopedia of Fairies: Hobgoblins, Brownies, Bogies, and Other Supernatural Creatures.* New York: Pantheon Books, 1976.

Broome, Dora. *Fairy Tales from the Isle of Man.* Douglas, IoM: Norris Modern Press, 1970.

Bulfinch, Thomas. *Bulfinch's Mythology: The Age of Fable.* Boston: S. W. Tilton & Co., 1855.

Byron, George Gordon. *Hebrew Melodies.* London: John Murray, 1815.

Cadet, J. M. *The Ramakien: The Thai Epic.* Tokyo: Kodansha International, 1971.

Cullen, Frank, Florence Hackman, and Donald McNeilly. *Vaudeville, Old and New: An Encyclopedia of Variety Performances in America.* New York: Routledge, 2006.

D'Arras, Jean. *Mélusine; or, The Noble History of Lusignan.* University Park: Penn State University Press, 2012.

Dennison, Walter Traill. *The Orcadian Sketch-Book.* Kirkwall, SCT: W. Peace and Son, 1880.

Desai, Santosh N. *Hinduism in Thai Life.* Bombay: Popular Prakashan, 1980.

Douglas, George. *Scottish Fairy and Folk Tales.* London: W. Scott, 1901.

Drewal, Henry, ed. *Mami Wata: Arts for Water Spirits and Its Diasporas.* Los Angeles: Fowler Museum at UCLA, 2008.

Evans-Wentz, Walter. *Fairy-Faith in Celtic Countries.* New York: Citadel Press, 1994. First published in 1911 by H. Frowde, London.

Fouqué, Friedrich de la Motte. *Undine.* Translated by F. E. Bunnett. London: Griffith & Farran, 1885.

Froud, Brian, and Alan Lee. *Faeries.* New York: Harry N. Abrams, 1978.

Gachot, Theodore. *Mermaids: Nymphs of the Sea.* San Francisco: Collins Publishers, 1996.

Gibson, Emily, and Barbara Firth. *The Original Million Dollar Mermaid: The Annette Kellerman Story.* Crows Nest, NSW: Allen & Unwin, 2005.

Gregor, Walter. *Notes on the Folk-Lore of the North-East of Scotland.* London: Pub. for the Folk-lore Society by E. Stock, 1881.

Hall, Manly P. *The Secret Teachings of All Ages.* San Francisco: H. S. Crocker, 1928.

Haney, Jack V. *An Anthology of Russian Folktales.* Armonk, NY: M. E. Sharpe, 2009.

Harrison, Jane. *Prolegomena to the Study of Greek Religion.* Cambridge University Press, 1903.

Hill, Colleen. *Fairy Tale Fashion.* New Haven, CT: Yale University Press, 2016.

Hilton, Alison. *Russian Folk Art.* Bloomington: Indiana University Press, 1995.

Homer. *The Odyssey.* Translated by Samuel Butler. New York: Dutton, 1900.

Hunt, Robert. *Popular Romances of the West of England: The Drolls, Traditions, and Superstitions of Old Cornwall.* London: Chatto & Windus, 1903.

Keightley, Thomas. *The Fairy Mythology, Illustrative of the Romance and Superstition of Various Countries.* London: George Bell & Sons, 1892.

Kellerman, Annette. *How to Swim.* New York: George H. Doran Company, 1918.

Kendall, Laurel, and Mark A. Norell, with Richard Ellis and the American Museum of Natural History Exhibition Department. *Mythic Creatures: And the Impossibly Real Animals Who Inspired Them.* New York: Sterling Signature, 2016.

Kennedy, Patrick. *Legendary Fictions of the Irish Celts.* New York: Macmillan, 1891.

Lee, Henry. *Sea Fables Explained.* London: W. Clowes and Sons, Ltd., 1883.

Levi, Vicki Gold, and Lee Eisenberg. *Atlantic City: 125 Years of Ocean Madness.* New York: Clarkson N. Potter, 1979.

Lindbergh, Anne Morrow. *Gift from the Sea.* New York: Pantheon, 1955.

Luchs, Alison. *The Mermaids of Venice: Fantastic Sea Creatures in Venetian Renaissance Art.* Turnhout, Belgium: Harvey Miller Publishers, 2010.

MacKillop, James. *A Dictionary of Celtic Mythology.* Oxford University Press, 2004.

Madeira, Grace L. *Sailors' Valentines: Their Journey Through Time.* Atglen, PA: Schiffer Publishing, 2006.

Marwick, Ernest. *The Folklore of Orkney.* Edinburgh: Birlinn Limited, 2011.

Milliken, Roberta. *Ambiguous Locks: An Iconology of Hair in Medieval Art and Literature.* Jefferson, NC: McFarland & Company, Inc., 2012.

Milton, John. *Comus: A Mask.* London: Humphrey Robinson, 1637.

———. *Paradise Lost.* London: G. Routledge, 1887.

Morrison, Sophia. *Manx Fairy Tales.* London: D. Nutt, 1911.

Pedersen, Tara E. *Mermaids and the Production of Knowledge in Early Modern England.* New York: Routledge, 2015.

Pelland, Maryan, and Dan Pelland. *Images of America: Weeki Wachee Springs.* Charleston, SC: Arcadia Publishing, 2006.

Phillpotts, Beatrice. *Mermaids.* London: Russell Ash/Windward, 1980.

Raina Mermaid. *Fishy Business Handbook for Mermaids.* Halifax: Halifax Mermaids, 2016.

Roberts, Russell, and Richard Youmans. *Down the Jersey Shore.* New Brunswick, NJ: Rutgers University Press, 1993.

Rose, Carol. *Giants, Monsters, and Dragons: An Encyclopedia of Folklore, Legend, and Myth.* New York: W. W. Norton Company, 2000.

Rossetti, Dante Gabriel. *Ballads and Sonnets.* London: F. S. Ellis, 1881.

Shakespeare, William. *A Midsummer Night's Dream.* Edited by Stephen Greenblatt. New York: W. W. Norton, 1997.

———. *The Comedy of Errors.* Edited by Stephen Greenblatt. New York: W. W. Norton, 1997.

South American Mythology. Memphis, TN: Books, LLC, 2010.

Tennyson, Alfred. *Poems, Chiefly Lyrical.* London: Effingham Wilson, Royal Exchange, 1830.

———. *Poems.* London: Edward Moxon, 1842.

Turgeon, Carolyn. *Mermaid.* New York: Broadway Books, 2011.

Vinycomb, John. *Fictitious and Symbolic Creatures in Art.* London: Chapman and Hall, Limited, 1906.

Wilde, Oscar. *A House of Pomegranates.* London: Methuen & Co. Ltd., 1891.

Wood, Reverend J. G. *Trespassers: Showing How the Inhabitants of Earth, Air, and Water Are Enabled to Trespass on Domains Not Their Own.* New York: Thomas Nelson & Sons, 1875.

Yeats, William Butler. *Collected Poems: Definitive Edition, with the Author's Final Revisions.* New York: Macmillan, 1956.

———. *Fairy and Folk Tales of the Irish Peasantry.* London: Walter Scott, 1888.

ARTICLES

Bender, Marylin. "Norell Likes Capes, Black for Dresses and an Elongated Torso." *New York Times*, July 17, 1963.

Bowles, Hamish. "Rodarte Spring 2015 RTW." *Vogue*, September 9, 2014. http://www.vogue.com /fashion-week-review/1067765 /rodarte-spring-2015-rtw.

Chandler, Charlotte. "My Dinners with Federico and Michelangelo." *Vanity Fair*, March 2012. http://www .vanityfair.com/hollywood/2012/03 /federico-michelangelo-201203.

Conniff, Richard. "Mad About Seashells." *Smithsonian*, August 2009. http://www.smithsonianmag .com/science-nature /mad-about-seashells-34378984.

Crowther, Bosley. "THE SCREEN IN REVIEW; 'Million Dollar Mermaid,' With Esther Williams as Annette Kellerman, at Music Hall." *New York Times*, December 5, 1952. http://www .nytimes.com/movie /review?res=9a01e2dc1f3ce23bb c4d53dfb4678389649ede. Accessed March 5, 2017.

Drewal, Henry. "Mami Wata: Arts for Water Spirits and Its Diasporas" (exhibition preview). *African Arts* 41, no. 2 (Summer 2008). http://www .mitpressjournals.org/doi/abs/10.1162 /afar.2008.41.2.60.

Long, April. "The Truth About Crème de la Mere." *Elle*, August 24, 2016. http://www.elle.com /beauty/makeup-skin-care/a37936 /la-mer-the-dream-cream.

Metropolitan Museum of Art. "'Oyster' Dress, *Irere*, spring/summer 2003." *Alexander McQueen: Savage Beauty.* Accessed July 16, 2017. http://blog .metmuseum.org/alexandermcqueen /oyster-dress-irere.

Miss America. "Our History." Accessed July 15, 2017. http://missamerica.org /our-history/.

Morris, Bernadine. "A Talk with Normal Norell." *New York Times*, October 15, 1972.

———. "Styles Through History: Roots of New New Look." *New York Times*, August 7, 1976.

Mower, Sarah. "Spring 2008 Couture: Jean-Paul Gaultier." *Vogue*, January 22, 2008. http://www.vogue.com /fashion-shows/spring-2008-couture /jean-paul-gaultier.

New York Times. "King Neptune Opens Seashore Pageant." September 7, 1922. http://nyti.ms/2uDayNb.

New York Times. "The Manatee: Prosaic Basis of Mermaid Tales—An Unattractive Monster." July 21, 1878.

Saroya, Tricia. "A Magical Midsummer Night's Dream Party." *Faerie Magazine*, Summer 2014.

Schoeneman, Deborah. "Mermaids Past and Present Keep Things Real." *New York Times*, January 6, 2008. http://www.nytimes.com/2008/01/06 /fashion/06mermaids.html.

Turgeon, Carolyn. "Carmindy and Mermaid Makeup." *I Am a Mermaid*, March 14, 2011. https://iamamermaid .com/2011/03/14 /carmindy-and-mermaid-makeup.

———. "Destination Snapshots." *Faerie Magazine*, Winter 2013.

———. "Eric Ducharme, the Mertailor." *Faerie Magazine*, Winter 2013.

———. "'Former' Weeki Wachee Mermaid Vicki Smith." *I Am a Mermaid*, June 7, 2011. https://iamamermaid .com/2011/06/07/former-weeki -wachee-mermaid-vicki-smith.

———. "Henry Drewal Talks About Mami Wata, Sacred Water Spirit." *Faerie Magazine*, Winter 2013.

———. "Life Underwater." *Faerie Magazine*, Winter 2013.

———. "Tim Gunn Talks About Mermaids." *I Am a Mermaid*, January 23, 2011. https://iamamermaid .com/2011/01/23 /tim-gunn-talks-about-mermaids.

INTERVIEWS

Brusso, Andrew. Telephone interview, March 21, 2017.

Buttigieg, Benny. E-mail interview, July 9, 2017.

Ducharme, Eric. Telephone interview, March 23, 2017.

Gaultier, Jean Paul. E-mail interview, June 27, 2017.

Georgiadis, Bonnie. Telephone interview, July 3, 2017.

Hankins, Virginia. Telephone interview, March 1, 2017.

Rambo, Pat. Telephone interview, March 14, 2017.

Roberts, Abby. Telephone interview, April 29, 2017.

Short, Robert. Telephone interview, March 8, 2017.

Shyne, Kathy. Telephone interview, April 28, 2017.

Smith, Rachel. Telephone interview, March 23, 2017.

Smith, Vicki. E-mail interview, April 16, 2017.

Sutter, Raven. E-mail interview, May 6, 2017.

Wolbert, Linden. Telephone interview, June 23, 2017.

Zigun, Dick. Telephone interview, March 2, 2017.

WEBSITES

Schiaparelli. Accessed March 1, 2017. http://www.schiaparelli.com.

Weeki Wachee Springs State Park. Accessed April 15, 2017. http://weekiwachee.com.

ABOUT THE CONTRIBUTORS

JILL ANDREWS, a graduate of New York's Fashion Institute of Technology, has built costumes for Broadway, film, television, and regional theater. She runs her own custom-design business, Jill Andrews Gowns, in Baltimore, Maryland.

RONA BERG is a wellness and sustainable lifestyle expert. She has served as editorial director of *Elle* and deputy lifestyle editor of the *New York Times Magazine.* Currently editor in chief of *Organic Spa Magazine,* she is the author of the bestselling books *Beauty: The New Basics* and *Fast Beauty: 1,000 Quick Fixes.*

KARIMA CAMMELL is the founder of Castle in the Air, a shop, classroom, and online community supporting artists worldwide. She publishes books under her own imprint, Dromedary Press.

JOELLEN ELAM CONWAY is a fantasy costume designer based in Los Angeles who specializes in couture bridal gowns and accessories through her labels, Firefly Path and Firefly Path Bridal.

ALLEN CRAWFORD wrote, designed, and illustrated his book *The Affected Provincial's Companion, Volume One* under the nom de plume Lord Breaulove Swells Whimsy, and illustrated his award-winning book, *Whitman Illuminated: Song of Myself.*

FLORENTINA DURAN works as a bartender in Baltimore, Maryland.

SARA GHEDINA is a food blogger and food photographer.

MASSIE JONES is a fiber artist and gemologist. She is pursuing a degree in cellular and molecular biology.

STEVE PARKE is an award-winning illustrator, designer, and photographer as well as the photo editor of *Faerie Magazine.* His photography work with Prince has been published in numerous magazines, including *People, Rolling Stone,* and *Vogue.* His book *Picturing Prince* was published in 2017.

LAURA RUSSELL is the owner and creator of the blog *Make Life Lovely,* which features craft tutorials, party tips, and DIY projects.

TRICIA SAROYA is a fine artist whose work is represented by several galleries. She is also a floral and event designer.

TIMOTHY SCHAFFERT is the award-winning author of five novels, most recently *The Swan Gondola.* He is also a professor of English at the University of Nebraska–Lincoln.

NIKKI VERDECCHIA has been styling and coloring hair for more than twenty years. She is the owner of NV Salon Collective in Baltimore, Maryland.

VINTAGE ROADSIDE (the husband-and-wife team of Jeff Kunkle and Kelly Burg) has worked to preserve, share, and raise awareness of America's midcentury roadside history for more than a decade.

STEPHEN D. WINICK, PhD, is a folklorist, writer, editor, and singer. He edits the blog *Folklife Today* at the American Folklife Center at the Library of Congress and has written numerous articles on music and folklore.

TERI PRINGLE WOOD is a longtime decorative artist and teacher whose elaborately decorated cookies are displayed all over the world.

PHOTOGRAPHY *and* ILLUSTRATION CREDITS

Alamy: 8: Lebrecht Music and Arts Photo Library/Alamy Stock Photo; 34–35: AF archive/Alamy Stock Photo; 39, left: PA Images/Alamy Stock Photo; 63: World History Archive/Alamy Stock Photo; 76: Paul Fearn/Alamy Stock Photo; 95: imageBROKER/Alamy Stock Photo; 102: Lebrecht Music and Arts Photo Library/Alamy Stock Photo; 103: Lebrecht Music and Arts Photo Library/Alamy Stock Photo; 110: Pictorial Press Ltd/Alamy Stock Photo; 113, clockwise from top left: Everett Collection, Inc./Alamy Stock Photo, SilverScreen/Alamy Stock Photo, Everett Collection, Inc./Alamy Stock Photo, Everett Collection, Inc./Alamy Stock Photo; 127: LOC/Alamy Stock Photo; 131: FOX PICTURES/Ronald Grant Archive/Alamy Stock Photo; 133: AF archive/Alamy Stock Photo.

Art Renewal Center: 179, left.

Arthur Rackham Society: 108, courtesy of the Arthur Rackham Society.

B Ocean Resort: 156, courtesy of MeduSirena.

Belinskaya, Ekaterina: 58–59.

Benjamin Hines Photography: 20.

Bridgeman Images: 2: Delaware Art Museum, Wilmington, USA/Gift of the Children of Howard Pyle/Bridgeman Images; 4–5: Private Collection/Photo © Peter Nahum at The Leicester Galleries, London/Bridgeman Images; 10: Private Collection/Photo © Christie's Images/Bridgeman Images; 30–31: Private Collection/Artothek/Bridgeman Images; 72: Private Collection/Photo © The Maas Gallery, London/Bridgeman Images; 73: Nottingham City Museums and Galleries (Nottingham Castle)/Bridgeman Images; 74–75; Private Collection/Photo © Whitford & Hughes, London, UK/Bridgeman Images; 78–79: Galleria degli Uffizi, Florence, Tuscany, Italy/Bridgeman Images; 81: Private Collection/Bridgeman Images; 82: National Gallery of Victoria, Melbourne, Australia/Bridgeman Images; 83, top: South African National Gallery, Cape Town, South Africa/Bridgeman Images; 83, bottom: The Trustees of the Weston Park Foundation, UK/Bridgeman Images; 86: Manx National Heritage (Isle of Man)/Bridgeman Images; 87: Zentralsparkasse-Bank, Vienna, Austria/Bridgeman Images; 88: Mermaid on the rocks at Port Soderick, Isle of Man, August 1961 (b/w photo)/Bridgeman Images; 89: Private Collection/The Stapleton Collection/Bridgeman Images; 90: Musee des Beaux-Arts, Quimper, France/Bridgeman Images; 91: Pictures from History/Bridgeman Images; 104: Bibliotheque de l'Heure Joyeuse, Paris, France/Archives Charmet/Bridgeman Images; 106: Bibliotheque des Arts Decoratifs, Paris, France/Archives Charmet/Bridgeman Images; 107: Private Collection/Photo © Christie's Images/Bridgeman Images; 109: Photo © Ronny Behnert/Bridgeman Images; 116: Fogg Art Museum, Harvard Art Museums, USA/Gift of Grenville L. Winthrop, Class

of 1886/Bridgeman Images; 118–119: Kunstmuseum, Basel, Switzerland/Bridgeman Images; 120: Minneapolis Institute of Arts, MN, USA/Gift of Curtis Galleries, Minneapolis, MN/Bridgeman Images; 169: Bridgeman Images; 174: Private Collection/Bridgeman Images; 175, left: Private Collection/© Look and Learn/Peter Jackson Collection/Bridgeman Images; 177: Private Collection/© Look and Learn/Illustrated Papers Collection/Bridgeman Images; 180–181: Leeds Museums and Galleries (Leeds Art Gallery) U.K./Bridgeman Images; 182: Private Collection/Prismatic Pictures/Bridgeman Images; 185: Manchester Art Gallery, UK/Bridgeman Images; 187: Private Collection/Johnny Van Haeften Ltd., London/Bridgeman Images; 206: Private Collection/Bridgeman Images; 218: Private Collection/© Look and Learn/Bridgeman Images; 220: Natural History Museum, London, UK/Bridgeman Images; 221: Private Collection/Archives Charmet/Bridgeman Images; 222: Bibliotheque des Arts Decoratifs, Paris, France/Archives Charmet/Bridgeman Images; 223: Private Collection/Photo © Christie's Images/Bridgeman Images; 232: Bristol Museum and Art Gallery, UK/Given by the Hon. Mrs Charles Lyell, 1938/Bridgeman Images.

The British Library on Flickr Commons: 160; 179, right.

Brummett, Grant: 16–17.

Brusso, Andrew: 54, 55, 69, 124, 125.

Cammell, Karima/Castle in the Air: 214, 216–217.

Capili-Wilkie, Wendy: 150.

Cheshire Visions: 19.

Conway, JoEllen Elam: 64–65, photographs 1–6.

Crumley, Chris: 26–27.

Drewal, Henry John: 84: courtesy of Henry John Drewal.

Finfolk Productions LLC: 52–53.

Fuertez, Cassie: 67 © Jessica Dru.

Georgiadis, Bonnie: 140: courtesy of Bonnie Georgiadis.

Ghedina, Sara: 208, 211, 212, 224.

Grafton, Carol Belanger:117: From A Treasury of Art Nouveau Design and Ornament by Carol Belanger Grafton. Mineola, NY; Dover Publications, 1980.

Howell, Dan: 165–166.

In Focus Studios: 190, 192, 193, 195.

J. Berendt Photography: 51.

Kotak, Bella: 57.

Lagerberg, Ted: 135, courtesy State Archives of Florida.

Lights' View Photo: 163.

Mary Evans Picture Library: 14: © Illustrated London News Ltd/Mary Evans;

18: Mary Evans Picture Library; 70: © Illustrated London News Ltd/Mary Evans; 123: Mary Evans Picture Library; 171: Mary Evans Picture Library; 172–173: © Illustrated London News Ltd/Mary Evans; 183: Mary Evans Picture Library; 196–197: Mary Evans Picture Library.

McEvoy, Emma: Front book cover.

Muñoz, Agustin: 151.

Nantucket Sailors' Valentines: 97–99.

Origins Digital Curio/Creative Market: 175, 176.

Parke, Steve: 22–25; 29; 60; 62; 65, lower right; 115; 145; 202–203; 204–205, 215, 226, 228, 230–231.

Plotnikova, Katerina: 188–189.

Rambo, Pam: 184, courtesy Pat Rambo.

Robert Short Productions/Karen Kubeck: 43; 44; 45, top.

Russell, Evan: 161.

Russell, Laura: 199.

Santos, Simon: 93.

Saroya, Tricia: 61.

Savannah Kate Photography: 50.

Schmidt, Kristian: 148.

Schumacher, Sparky: 139, courtesy of State Archives of Florida.

Scott Photography: 162.

Shutterstock.com: 45, bottom: Barashkova Natalia/Shutterstock.com.

Simms, Anthea: 36–37, 38, 39, right; 40–41.

Smith, Vicki: 68: courtesy of Vicki Smith.

Stanley, Brett: 147.

State Archives of Florida: 134, 138.

State Library of New South Wales: 128–129.

Stumpf, Brenda: 152.

Sutter, Tyler: 12–13.

Turgeon, Carolyn: 141: Author's personal collection.

Universal Studios Licensing LLC: 200–201, courtesy of Universal Studios Licensing LLC.

Venturella, Angelina: 21, 47, 48–49.

Victoria and Albert Museum: 33: © Victoria and Albert Museum, London.

Vintage Roadside: 142–143, 154–155, 157–159, 160, top.

Whimsy, Lord: 170.

Weeki Wachee Springs State Park: 136, 137.

Wikiart.org; 234.

Wikimedia Commons; 92, 101, 112, 121, 186.

Wolak, Filip: 167.

First published in 2018 by
Harper Design
An Imprint of HarperCollins *Publishers*
195 Broadway
New York, NY 10007
Tel: (212) 207-7000
Fax: (855) 746-6023
harperdesign@harpercollins.com
www.hc.com

Distributed throughout the world by
HarperCollins *Publishers*
195 Broadway
New York, NY 10007

ISBN 978-0-06-266956-8
Library of Congress Control Number: 2016952331

Book design by Raphael Geroni
Front cover photograph by Emma McEvoy

Printed in China
First Printing, 2018

"Mermaids" by Nick Cave, copyright © Mute Song Limited
Reprinted with the permission of Mute Song Limited.

About the Author

CAROLYN TURGEON has been editor in chief of *Faerie Magazine* since 2013. She is the author of *The Faerie Handbook* (Harper Design, 2017) as well as five novels: *Rain Village* (Unbridled, 2006), *Godmother* (Crown, 2009), *Mermaid* (Crown, 2011), *The Next Full Moon* (Downtown Bookworks, 2012), and *The Fairest of Them All* (Simon & Schuster, 2013). Her books have been optioned for film by Sony Pictures, Random House Films/Focus Features, and Gaumont Film Company, and published in the United Kingdom, Brazil, China, Korea, Spain, and Portugal. She has published short fiction in *Fairy Tale Review* and the anthology *Haunted Legends* (Tor, 2010) as well as essays in *Allure*, the *Hairpin*, and the *New Inquiry*, among other publications. She lives in Baltimore, Maryland. Read more of her work at www.carolynturgeon.com.